VAN GOGH

PIERRE CABANNE

VAN GOGH

TERRAIL

Cover:
Van Gogh
Self-Portrait [detail]
Autumn 1887
Oil on canvas
47 x 35 cm
Paris, Musée d'Orsay

Editorial Directors
Soline Massot and Anne Zweibaum
Layout
Abès Méziani
Iconography
Hélène Orizet
Translation
John Tittensor
Copy editor
Elizabeth Ayre
Lithography
L'Exprimeur, Paris

© **FINEST S.A./ÉDITIONS PIERRE TERRAIL, PARIS 2002**
25, rue Ginoux - 75015 Paris

Publication Number: 297
ISBN: 2-87939-248-9
Printed in Italy
October 2002

© FINEST SA / ÉDITIONS PIERRE TERRAIL, PARIS 2002
25, rue Ginoux, 75015 Paris - FRANCE

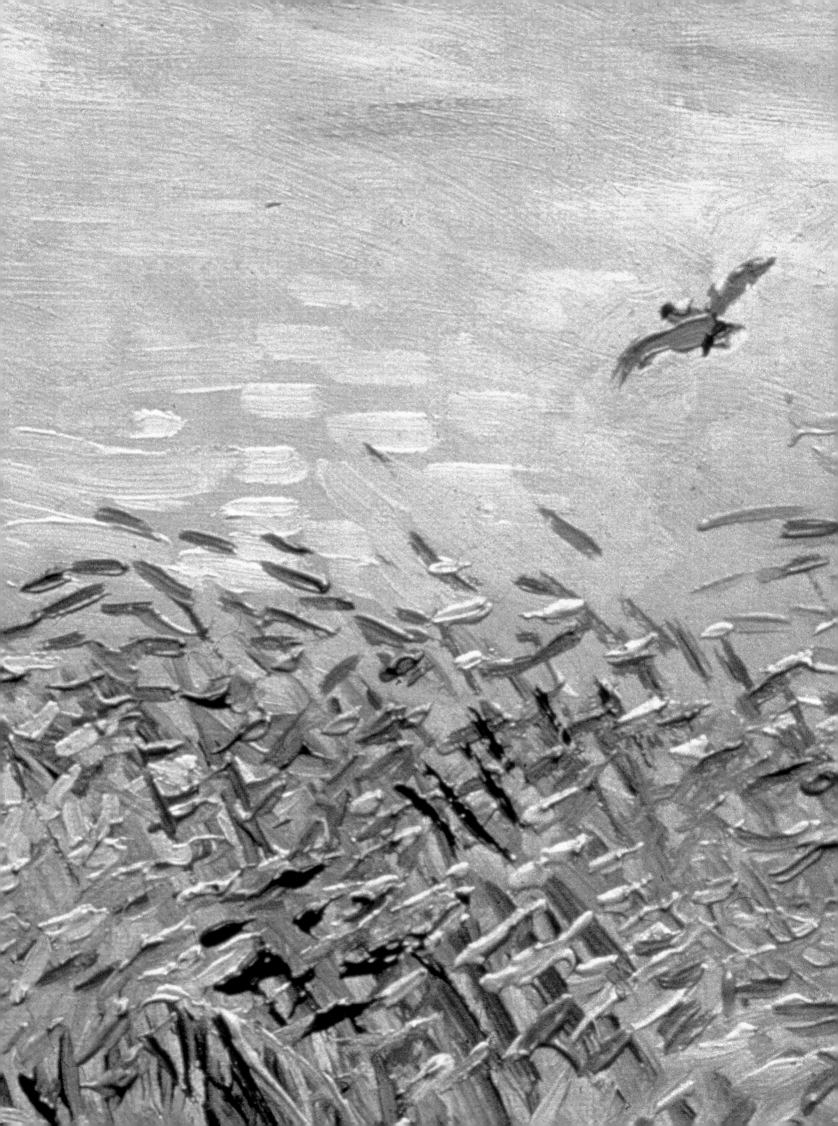

Contents

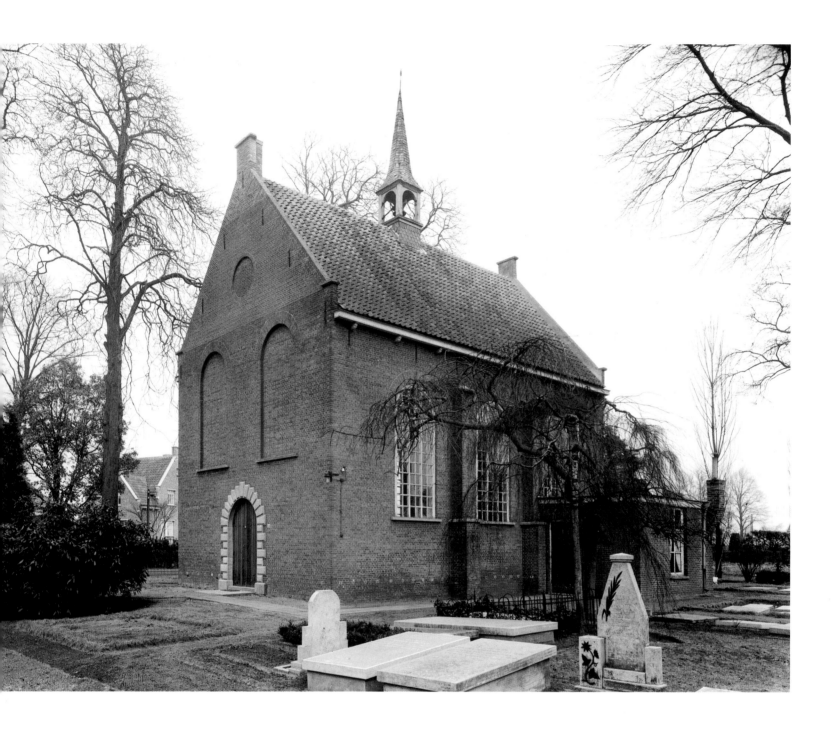

The little church and graveyard
at Zundert

Van Gogh Museum, Amsterdam

A wild child

Every Sunday the family, clad in black and bearing flowers, set off to the little cemetery at Groot-Zundert, where they went directly from the gate to a grave marked "Vincent Wilhelm Van Gogh 1852." A single date to mark a birth and a death, for this was the grave of a child six weeks old. As the father, mother, two sons and three daughters prayed, the eldest of the boys – also called Vincent Wilhelm – stared intensely at the gravestone and the name, his brother's, that was also his own.

The young Vincent Wilhelm was born on March 30, 1853, a year to the day after the death of his brother. Was his destiny to be that of an earthly replacement for the child now lying at his feet beneath the slab of gray stone? To take the place of another? Or was he himself the other whose identity he had usurped?

Each Sunday, little Vincent Van Gogh – the new Vincent – asked himself the same question, not daring to look at his mother with her hands joined and her eyes brimming with tears. Whom was she praying for? The dead child? Or for Vincent himself, the substitute? As they silently made their way home, Vincent, troubled and riven with doubt, stayed huddled against his younger brother Theo, born on May 1, 1857, with whom he was very close. The dismal ritual was repeated every Sunday for years. Every March 30, they celebrated Vincent's birthday, but who were the celebrations really for? The dead child or the boy who was now ten years old? The death of a child has a notoriously disruptive effect on the way the brothers and sisters are brought up. Vincent had been conceived barely three months after the death of the family's first-born and the mother's mental image of the child to come took shape during the early period of grieving; a time when she was haunted by contradictory feelings, torn between her attachment to the dead child and her hopes for the child to come. It was all but inescapable that the "replacement" should be compared to the idealized image of his predecessor. All his life Vincent would struggle against a brother more insistently present than if he had actually been alive, as his parents inevitably measured him against the virtues they attributed to the lost child. This was to explain his dual character as a "substitute": on the one hand affirming life and his own identity, and on the other sliding into withdrawal, submission, humiliation and rejection.

In addition to Vincent, the eldest, the village parsonage of Reverend Theodorus Van Gogh and his wife, Anna Cornelia Carbentus, was home to Theo and three daughters, Anna, Elizabeth-Huberta and Wilhelmina. A third son, Cornelius, would be born later.

As time went by, the Sunday visits to the cemetery became less frequent, but each time Vincent passed the gate he dared not push open, his mind filled with thoughts of that other self. Taciturn by nature, he sometimes worried his father with his abruptness and his long periods of nervous exhaustion. Sometimes he set off alone to walk in the countryside, or made drawings and clay models that he hid as soon as anyone noticed what he was doing. Perhaps he truly was that "stranger to himself" his sis-

Photograph
of Anna Cornelis Van Gogh

Photograph of Theodorus Van Gogh

Amsterdam, Van Gogh Museum

ter Wilhelmina was to write about, yet he was also capable of enjoying the warmth and conviviality of family life: the evening Bible readings by the *dominie*, as preachers were called in the Dutch Brabant, were a moment of tranquillity for the whole family.

"What survived in me was a touch of the austere poetry of the authentic moorland," he would later write to his painter friend Ridder van Rappard. And after one of his fits in Arles, he wistfully recalled "every room of that house in Zundert, every pathway, every plant in the garden, the views round about, the fields, the neighbors, the cemetery, the church, the kitchen garden in back – even the magpie's nest in a tall acacia beyond the cemetery."

There was therefore the Dutch Brabant is mournful countryside, yet its heather-covered moors and endless expanses under a low sky dotted with fleecy clouds give it a wild, moving poetry. There can be no understanding Van Gogh without venturing into it, without musing on all the immensity which, as he wrote a number of times, marked him for life. There Van Gogh gathered plants, studying and classifying them like a true botanist, as Cézanne would do on Mont Sainte-Victoire.

The closed world of the family, then; and all around a natural world brimming with discoveries, summoning the meditative boy to intense communion with the seasons, the spring flowers, the damp soil, the snow and the long winter nights.

The preacher was the very image of Christian rigor, of intellectual and moral uprightness, but of generosity too: a modest man whose lack of ambition and strictly average abilities combined to keep him in the dreary little village of Zundert, near Breda on the Belgian border. Here he strode through the surrounding countryside preaching the gospel to the local farmers. His wife was stubborn, determined and more assertive, but like the dominie, she inhabited a mental world with no place for imagination, adventure or thoughts of social advancement. At school Vincent was rebellious, quick-tempered and sometimes aggressive. His unattractive features, close-cropped red hair and deliberate surliness drew the mockery of classmates who saw him as "old". But what they missed in the depths of his gaze – in eyes that were "sometimes blue, sometimes greenish according to the light", his sister Elizabeth would write – was the glow his family sometimes detected after his bouts of anger, a tenderness for things and people that could not readily express itself and betrayed an over-developed sensibility. The boy was already – and would remain – a hypersensitive mass of contradictions, seesawing between withdrawal and elation. From the Carbentuses of his mother's side, he had inherited the outbursts of violence followed by exhaustion and fits of torpor; indeed, there were cases of mental illness in the family. By contrast, his father's example gave him the urge to get closer to others, particularly people of humble extraction, if they showed a similar interest in him. Then he could show himself gentle and accommodating; his face would light up and his resentment vanish.

His favorite among his brothers and sisters was Theo, four years younger and a companion whose fondness and understanding could calm his irri-

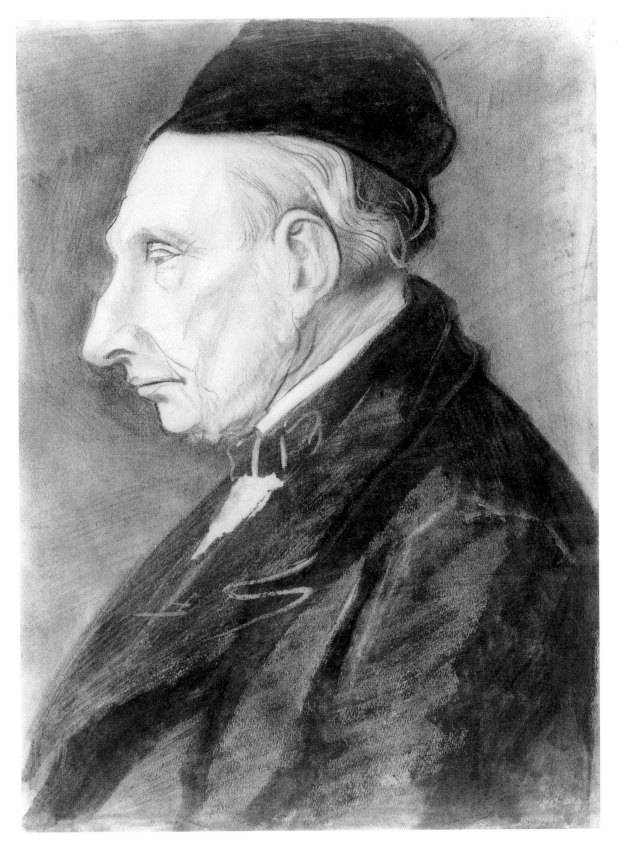

Van Gogh
The artist's grandfather
1881
drawing
Amsterdam, Van Gogh Museum

Photograph
of Vincent Van Gogh
aged about 11

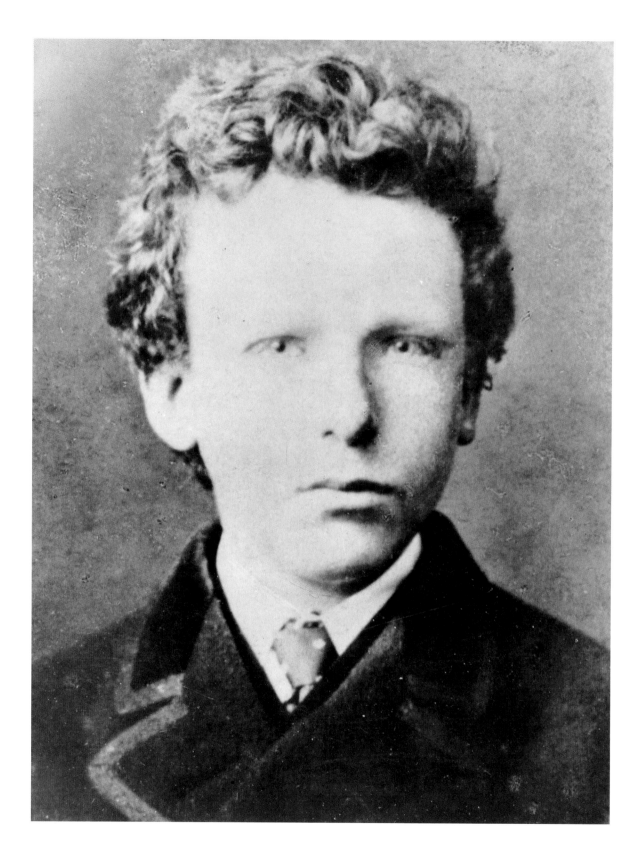

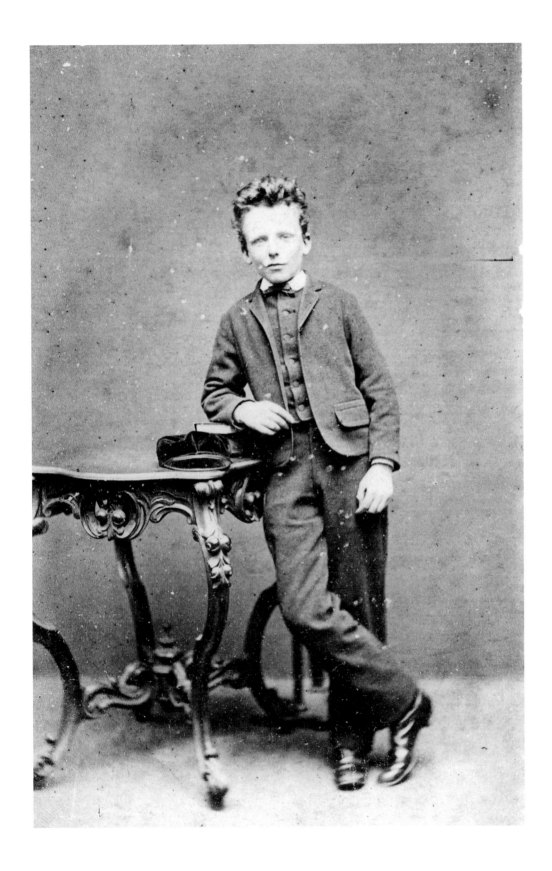

Photograph of
Theo Van Gogh
at the age of 13,
January 1875

tation and bursts of anger. Theo's birth may not have freed Vincent from the haunting feeling of being a "replacement", but the younger brother's empathy helped ease the lasting burden of the "other" who had died and through whom he lived.

At age eleven came the break with the village of Zundert, the family's little house and garden, the moors and woodland; Vincent left the sheltered world of childhood for Jan Provily's boarding school in the neighboring town of Zerenbergen. Set apart by his odd physique and strange behavior, he took solace in reading and thinking. The idea of having fun was all but unknown in this strictly Calvinist setting, especially for a boy who found contact with others unbearable. Back home for the holidays, he would resume his long walks and his lively discussions with Theo.

At Princenhage, not far from Breda, lived their father's older brother – also called Vincent and known in the family as Uncle Cent. Once an art dealer in The Hague, on retiring he had sold his business to the famous Goupil art publishing concern, based in Paris. The walls inside his handsome house were decorated with all sorts of paintings, notably works of the Barbizon school and landscapes of The Hague: grazing cattle, shepherdesses spinning as they watched over their flocks, riverbank mills and sunsets throwing church spires into high relief. These were the first paintings Vincent ever saw and we can readily imagine this nature-lover spellbound by their revelation of a world beyond Zundert.

In September 1866, he left the Provily school for a similar one at Tilburg, where he stayed two years. On his return to Zundert, he spent fourteen months at his parents", reading and idling and, for a fifteen-year-old, showing little interest in his future. Uncle Cent suggested getting him a job with his friend and successor Mr. Tersteeg at Goupil's branch in The Hague, where Vincent set about selling the public the kind of paintings it liked: genre paintings, battles, edifying scenes and the like. He turned out to be good at his work, but Mr. Tersteeg expressed his concern about Vincent's lethargy to the boy's family.

At this time, the preacher and his family left Zundert; the *dominie* had been appointed to Helvoirt, another village in the Brabant, and Vincent was never to see his birthplace again. In the summer of 1872, he visited Theo at Oisterwijk, where he was studying. The few days they spent together brought them even closer and on parting they resolved to write to each other

The desolated countryside in the Brabant

John Constable
Landscape
1820-1822
Oil on canvas
50.5 x 76.2 cm
Bayonne, Bonnet Museum

John Constable
Landscape with River
Oil on canvas
Madrid, Lazaro Galdiano Museum

Photograph of Vincent Van Gogh
in 1871

often; so began the long, dramatic series of letters that would keep their lives entwined until the end. Already disturbed by his brother's over-assertiveness, Theo first became his confidant and later the witness to his passionate, painful quest for the absolute.

A good salesman, Vincent came up for promotion and was appointed to Goupil's London branch, at the same time as Theo began working for the company in Brussels; the two brothers found themselves doing the same job in different places, but the paintings they were selling were more or less interchangeable. Vincent's knowledge of art was scanty, but he was willing to learn and when he began visiting museums he advised Theo to do the same. In their closeness to nature, he found England's landscape painters, especially John Constable, very different from those of The Hague and Barbizon, and he began collecting engravings of landscapes.

At the same time he was reading widely, recommending to Theo to read as many art books as possible, and particularly the *Gazette des Beaux-Arts.* He suggested Jules Michelet and Dickens as well, hunting down traces of the latter in the workingclass areas along the Thames and the drab buildings of London's dockland. What the great novelist had seen and felt, Vincent also saw and felt, putting into his letters to Theo the things he would one day begin to draw. He had found lodgings with a Mrs. Loyer, a pastor's wife, whose clean, orderly home was a kind of family haven after a day's work and the long trek through the swarming city from the gallery at 17 Southampton Street, off the Strand. Mrs. Loyer had a pretty daughter, Ursula, and Vincent, for whom love was another consuming passion, made the mistake of asking her to marry him. Something of a flirt, the young woman laughed outright at the absurdity of a proposal from this awkward, ill-dressed boy with his lined features and his expectation that she would bring him to the "fullness of true life." Ursula's amused rejection shattered his illusions: already engaged to a former lodger in her mother's house, she had simply played with his affections. Suffering as only a twenty-year-old can, he was further haunted by the feeling of being irremediably different, unimpressive and a little odd. This first wound to Vincent's heart tied him forever to those years in London where, lost and humiliated, he began to curse the city with its endless movement and the noise of its crowds. From October to December 1874, he was sent to work at Goupil's headquarters in Paris, but the hoped-for rebirth eluded him: bored, Vincent asked to return to London in the hope of seeing Ursula and persuading her to change her mind. Once again, however, she refused to leave his rival and mockingly rebuffed his advances.

There was a profound duality in Vincent, and this new defeat plunged him into a kind of mystical exaltation: God was seeking to punish him for his sins, he believed, and his duty was to atone through acts of charity and fraternity. His isolation and despair gave rise to hallucinations and he began to wallow in the idea of himself as a man rejected for all eternity. Ursula, then, was the right hand of the destiny that condemned him to live in a state of perpetual torture.

When he visited his parents for Christmas 1874, they were appalled at his state of nervous exhaustion. He shut himself in his room, chain-smoking, drawing, writing and meeting their questions with silence. Yet he did confide in his sister Elizabeth and Uncle Cent, who did their best to convince him that at his age a disappointment in love was not the end of the world. How little they understood him: the rest of his life would revolve around this first setback, this destruction of his hopes for "true life".

"I think," he wrote to Theo on July 21, 1874, "that a man and a woman can become a single being. By that I mean a single, entire being and not just two halves side by side."

Letter by Vincent to Theo,
Auvers-sur-Oise, 1890

1 Painter or pastor?

The first year in Paris

When Vincent arrived in Paris on May 15, 1875, he settled in a still rural Montmartre, with open-air cafes, market gardens and mills; a Montmartre still marked, too, by the Paris Commune, the 1871 uprising. He spent little time there, however, even when not working at Goupil's in the Rue Chaptal: plunging down the steep streets, he headed for the Louvre or the Luxembourg, the "modern" art museum with the kinds of frightful canvases that also turned up at the Salon. Visiting the Corot exhibition – the artist had just died – he was impressed by the landscapes. He papered his room with reproductions of Millet, Richard Parkes Bonington, Jacob van Ruysdael – and Rembrandt, whose *Reading of the Bible* reminded him of those evenings at Zundert. Maybe he got wind of the "Impressionists," whose exhibition the year before had triggered an enormous scandal, but at Goupil's, the tone was highly academic and there was no place for their pointless daubs.

Art at the time for Vincent was another manifestation of his burning love for Ursula, of the feelings of exaltation induced in him by nature, of the passionate readings of Scripture he undertook with the young Harry Gladwell, a rough diamond from England who worked with him at Goupil's. Inevitably, he became obsessed with the divine, reading pell-mell Heine, Keats, Longfellow and George Eliot, whose *Scenes of Clerical Life* was at his bedside for weeks.

Thus the young man with emaciated features and cropped hair set about preaching charity, brotherhood, kindness to the poor and love of one's neighbor; he claimed to feel the pain of others, one fiery declaration succeeding another in a constant raving that was never put into practice.

In a letter to Theo on September 12, 1875, he spoke of
"Wings to glide above life
Wings to glide above the tomb and death…
Wings are what we need and I'm beginning to see how to acquire them. Did not Father have them? And do you know how? Through prayer and the fruits of prayer – patience and faith – and through the Bible, which was a light on his way and a lamp to guide his feet."

He advised Theo to give up the works of Michelet and Renan, those despisers of God, suggesting in their place such pious texts as *The Imitation of Christ,* the Gospels, the Epistles and the Psalms. "Search for true light and freedom," he wrote to his brother on October 14, "and do not plunge too deeply into the mire of this world."

Absorbed in his reading and ardent meditation, Vincent was living in a chronically heightened state: the dreary stuff he was selling for Goupil's came to seem like a reflection of a hypocritical world that was hiding its corruption and squalor behind these skillful but soullessly conventional and flattering images. Boussod and Valadon, who were Goupil's successors, were not especially appreciative of their employee's behavior and strange talk. During the course of a discussion in which Vincent described their trade as "organized thievery," he was shown the door. He left Paris on April 1, 1876.

Van Gogh
Houses at Isleworth
1876
drawing
14.4 x 14.7 cm

The plunge into poverty

A further defeat, then, a further crushing blow from destiny. Uncle Cent was furious and Vincent's parents were in a state of shock, but for Vincent himself, the love that had been snatched away, the collapse of his career and the hypocrisy of which he saw himself the victim were all proof of the hostility of the world around him. Was he doomed to a marginal, solitary existence, cut off from his fellows? Resigned and self-less, Theo pressed him to choose as an outlet the painting that so attracted him, but Vincent refused: his duty was to make up for his fail-ures by self-sacrifice, to overcome fate and achieve redemption by offer-ing up himself and all he had. Chancing on a newspaper advertisement, he applied for a job as an assistant teacher in a boarding school for poor children at Ramsgate, in Kent, and was accepted by the Reverend William Stokes, the principal. Before leaving yet again for England, Vincent went to see his parents, now living in Etten, but not wanting to be a burden stayed only a short time. Reaching London, he continued on to Ramsgate, arriving on April 16. Did he still cherish the hope of seeing Ursula again? What he did not know was that fresh suffering awaited him, for the young woman was now married.

Ramsgate is a wellknown beach resort and port situated between Dover and London. "Along the seafront," he wrote to his parents, "most of the houses are made of yellow stone and all have gardens planted with cedars and dark evergreen trees." He often noted the natural setting in this way, revealing a sharp awareness of color. "On our right was the sea, as calm as a pond reflecting the delicate gray of a sky in which the sun was setting…"

He was calmer now, and more relaxed – but could it last? "To tell you the truth," he wrote to Theo, "this is a happy time for me, yet I do not entirely trust this happiness, this tranquillity."

The newcomer's task at the school was to teach languages – French, which he of which he had a relatively poor grasp, and German – but he went on long walks too, discovering not far from Ramsgate the small town of Broadstairs, where Dickens had lived and written *David Copperfield*. By an astonishing coincidence, fate had made Vincent the teacher of children like those portrayed by his favorite author. When the Reverend Stokes moved his school to Isleworth, a working-class Thameside district not far from London, Vincent was charged with col-lecting his pupils' unpaid fees; it was then that he discovered to his hor-ror the deprived neighborhoods of the East End, with their sordid dwellings and the wretched existence of exploited workers whose money he could not bring himself to demand.

He said as much to Stokes, for whom the distress of his students' families meant nothing as long as he got his money; and finding himself with a soft-hearted teacher incapable of taking the necessary measures, the principal fired him.

This hit Vincent hard. The misery, pain and desolation he had witnessed had moved him profoundly: how could it be that creatures

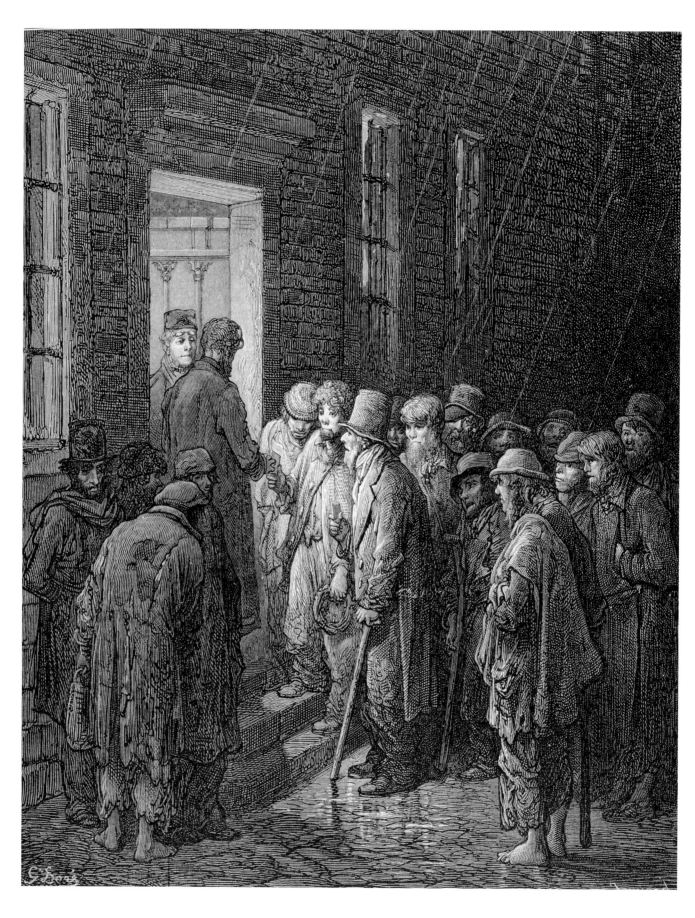

Gustave Doré
Asking to Be Let In: London Night Shelter
1872
etching

made in the image of God – the God of mercy and love – should have to live such implacably pitiless lives, bereft of even the faintest glimmer of hope? His own distress and feeling of revolt led him to a fresh insight: he would become the brother of these unfortunates, helping them and teaching them – through the reading of the Scriptures – that all was not lost to those who loved God and followed his counsel. Vincent offered his services to Mr. Jones, a Methodist minister who ran a school similar to Stokes's in Isleworth; here he could give of himself, and he was taken on as a lay preacher. Full of his morally instructive reading and the example of his father, he feverishly set about the enormous task of bringing the Word of God to society's outcasts. He prepared sermons, learned hymns: "In spite of everything I'm in better spirits now," he wrote to Theo, but the parishioners, simple people with little real grasp of religion, were hard put to understand a message couched in such strange language.

Offering them Jesus as a model, he told his baffled congregation that "sadness was better than joy": sadness was fertile, he said, while joy was sterile and illusory, mere empty deception. His excessive behavior astonished them, too, notably one Sunday when he threw his gold watch into the collection plate.

Gustave Doré
Bible Reader in a London Night Shelter
1872
etching

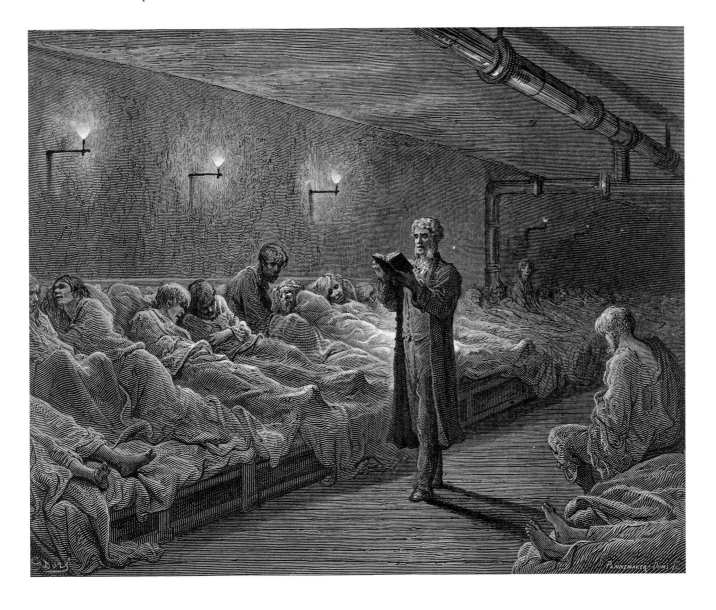

He's crazy, people said, and it was true: he was crazed with devotion, self-denial and brotherhood. He wore himself out, eating little, depriving himself of essentials, praying endlessly and preaching without convincing or instructing his hearers. When he fell ill, he took this fresh ordeal as a sign that God was bringing him closer to the weak, the deprived and the rejected. He saw himself becoming a missionary, but Reverend Jones knew the task was beyond his strength – and knew he was of no help to the local people either. When the despairing Vincent decided to move on, Jones felt real relief at being rid of a helper whose burning, visionary gaze sometimes frightened him.

Gustave Doré
Under the Bridges, London
1872

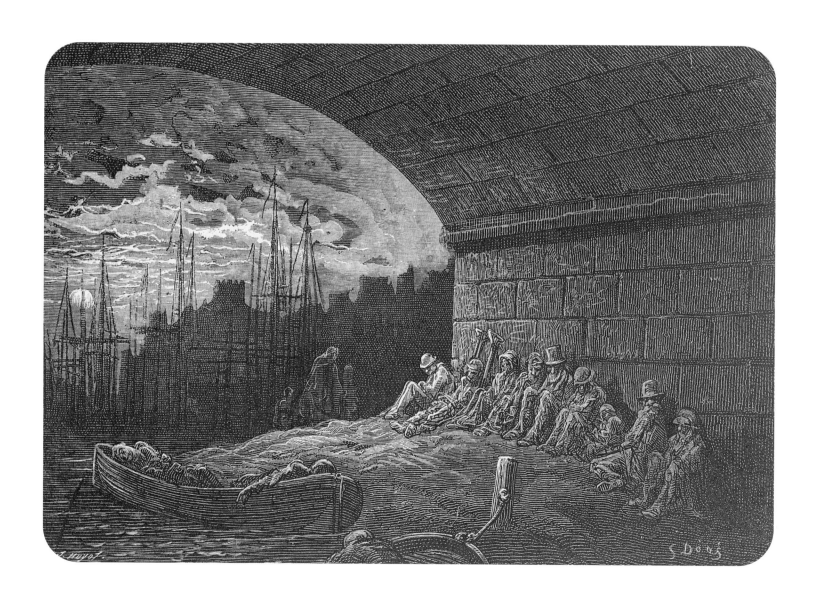

First "little drawing"

When he returned exhausted to his parents, it was Uncle Cent who once more set out to save the day, finding him a job as a clerk in the Van Braam and Blusse bookshop in Dordrecht. "Working in a bookshop instead of trying to teach boys would be a real change for the better," he wrote to Theo. Again he threw himself wholeheartedly into his new job, but without abandoning his missionary vocation, for he had a "yearning for God."

Although he was happy selling books and chatting with the customers, Vincent saw the position as no more than a break before returning even more intensely to his evangelical task. What he wanted was "to serve," but how was he to become an effective helper for others? How was he to be worthy of them, understand them, truly come to their assistance? He spent his free time praying, reading and spreading the good word among the bookshop's other clerks: they all ate together in the same boarding house on the Tolbrugstraat, on the banks of the Meuse, but the others were openly wary of him.

Vincent began looking for role models among writers, philosophers and even painters like Ary Scheffer, a tediously declamatory Romantic from Dordrecht whose religious works he admired. "I see the calling of painter or artist as a noble one," he wrote to Theo, "but I believe the calling of my father to be holier. I should like to be like him." On another occasion he wrote that "I'm not alone; God is with me and I want to be a preacher." Learning of this, his father was skeptical and called a family meeting; it was decided that Vincent could pursue his vocation, but only if he studied seriously and entered a seminary to take the necessary exams. Another uncle, Johannes, took him in in Amsterdam when Vincent arrived on May 9, 1877. He was twenty-four years old.

During his studies, he undermined his health with self-imposed penances and hardships, while holding fast to the idea of bringing divine truth to his fellow men: "I devote myself to the task with the patience of a dog gnawing a bone," he wrote to Theo, and confided on June 12 that "As I write I automatically do little drawings. One from this morning shows the prophet Elias in the desert under a stormy sky with hawthorn bushes in the foreground. Sometimes I actually see what I draw and I pray that this will be so later on."

However he nourished no artistic ambitions: his destiny lay elsewhere. His room, as usual, was decorated with reproductions: Rembrandt, naturally, but especially nature painters like Jean-François Millet, Jules Dupré and Charles Jacque, the Belgian realist Charles de Groux, and Jules Breton, whose little rural scenes were very popular at the time.
Later Vincent would go to Courrières where Breton lived; but disappointed by the comfortably middle-class look of the studio –"organized on Methodist lines" – he went his way without even knocking.

Once again reduced to a state of exhaustion, the trainee minister had to give up his plans and return to his family. By now he had realized that his character and way of behaving were far removed from the

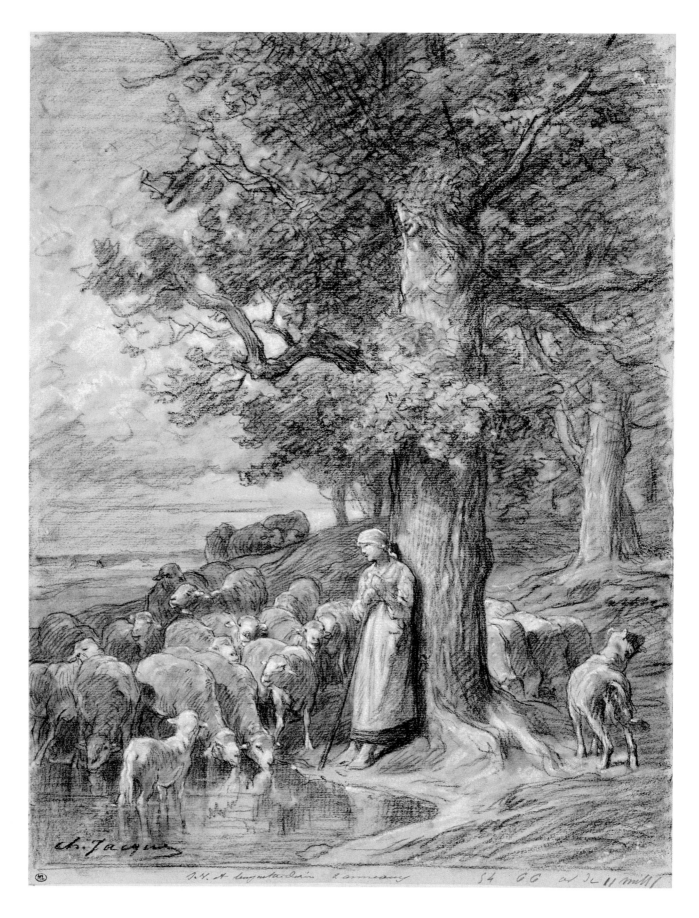

Charles Jacque

Shepherdess

Black pencil and wash

Paris, Louvre (Orsay Collection)

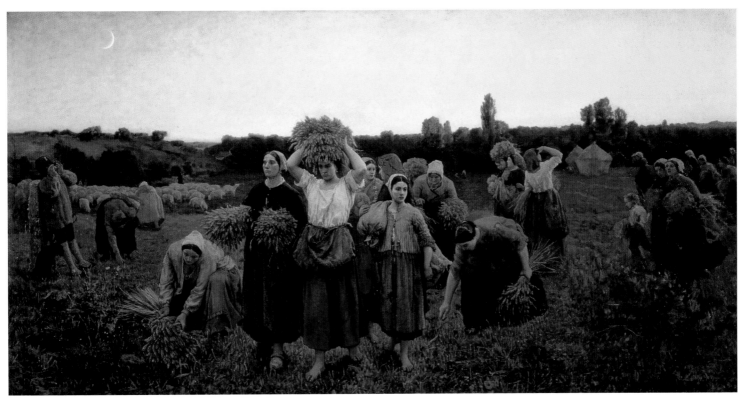

Jules Breton
Recall of the Gleaners
1859
Oil on canvas
90 x 76 cm

Paris, Musée d'Orsay

Charles de Groux
Saying Grace
Oil on canvas

Paris, Musée d'Orsay

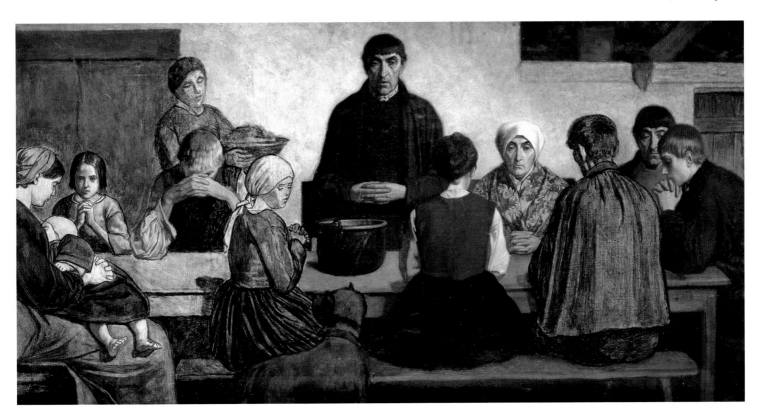

demands made by theological training: he was a man of action, not a bookworm. Together with a Mr. John, a visitor to Etten, his father made one last effort, having him admitted as a student lay preacher to the Reverend Bockma's evangelical school in Laeken-Brussels, where missionaries were trained for deprived areas.

On the evening of November 15, after spending the day with Theo, he sent him a "little drawing" that was "nothing special really" and had been "done without thinking" near Laeken. It shows a wretched little bar, "Au Charbonnage," that he had spotted after leaving his brother on the towpath of the canal. "And above is a stormy sky; it is a dark, bitingly cold day…" This was the countryside to which Vincent came as a missionary once his training was finished.

Van Gogh
Café "Au Charbonnage"
1878
pen and ink on paper,
14 x 14,5 cm

Amsterdam, Rijksmuseum,
Vincent Van Gogh

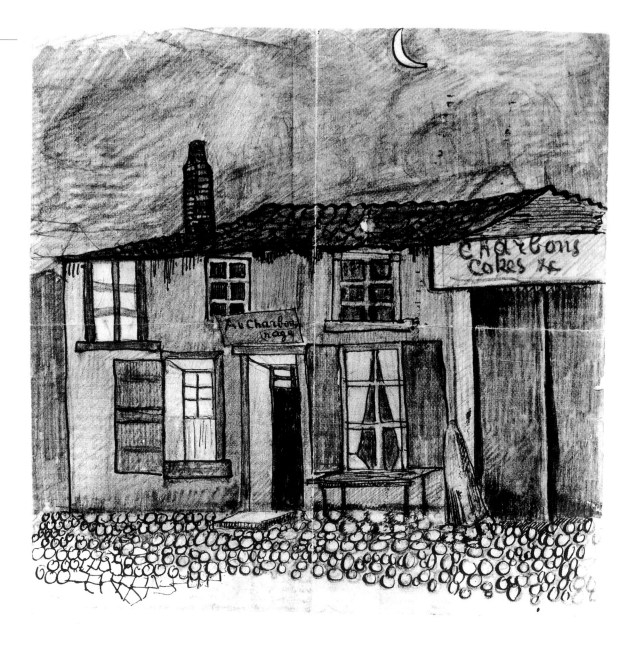

The apostle of the Borinage

The train he had taken from Brussels pulled into the little station at Pâturages, a pretty name in the midst of the desolate landscape of the Hainaut mining country. Carrying only a bundle, he gazed at the terrifying metal structures – the pitheads – rising starkly out of the countryside like pyramids in the desert and topped with enormous wheels turning with an endless, hellish sound. Black as chimney sweeps, ghostlike men and children slowly emerged in long, silent lines from the depths of the earth and marched in tight columns toward the village. This was the scene Vincent would outline to Theo in his staggering "Letters from the Borinage":

"Here and there you still see roofs covered with moss and at night the panes of the little windows have a welcoming glow. As in our Brabant, the gardens and fields are surrounded with bramble hedges, thickets and oak scrub, and in Holland with pollarded willows. The snow that has fallen these last few days makes it all look like a sheet of paper covered with writing, like the pages of the Gospel… I hope with all my heart that, with the grace of God, I shall find a stable job here." In January 1879, the Evangelization Committee appointed him to Wasmes, near Pâturages. There Vincent was to assist the resident preacher, from the nearby town of Warquignies, and his joy knew no bounds.

Poverty was everywhere here, and even worse than in London. With a selflessness that nonplussed the villagers, Vincent shared their poverty, discarding his own clothes for pitiful rags, letting his beard grow, living in a desolate cottage and giving away his stipend. His father urged him to find better accommodation, but he clung to the hovel he used "solely as a studio and study. I've decorated the wall with prints and all sorts of things."

To give his sermons he hired an enormous room used for dances and meetings and inexplicably known as "The Baby's Room." "They listened attentively," he wrote more than once to his family, and the local people saw him as "a good man". Regardless of wind and snow, Vincent endlessly crisscrossed the countryside, not content simply to preach, but visiting the disabled and offering comfort and consolation.

"I spent six hours down a mine…This is a depressing place and at first glance everything round about looks dreary and doom-laden…Most of the workers are skinny and pale from illness, they look

Van Gogh
Coalman
1879
drawing
Otterlo, Rijksmuseum Kröller-Müller

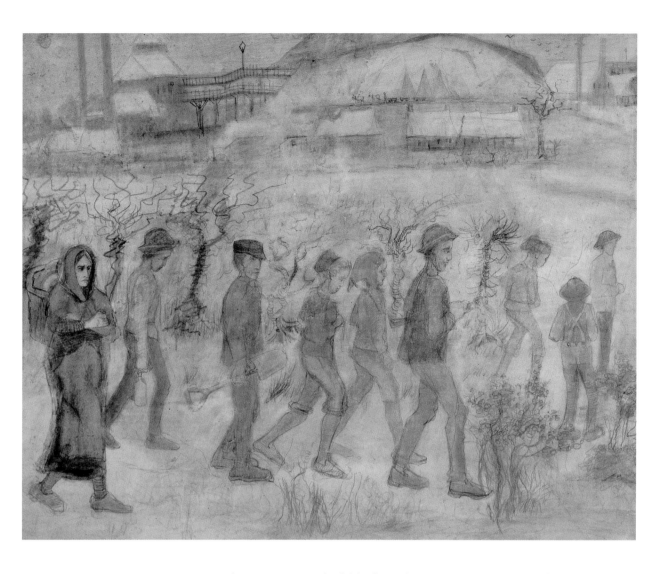

Van Gogh
Miners
1880
drawing
Otterlo, Rijksmuseum Kröller-Müller

tired, worn out and old before their time. And most of their women, too, are wan and wilted. Around the pit are wretched miners huts and a few dead, smoke-blackened trees…I'll try to sketch it soon to give you an idea." Vincent's description of the mine and of the soul-destroying work done by the men, the children – girls and boys alike – and the aging horses has a terrifying ring of truth to it, like a Zola novel with a dose of emotion added. The villagers, he said, "are driven by a deep, fierce hatred and an instinctive mistrust of anyone who attempts to pull them into line." Having written this, Vincent put down his pen to go out and visit the sick.

In his writings he compares the mining country to the paintings and drawings of Rembrandt, Ruysdael and such contemporaries as Jacob Maris, Antoine Mauve and Joseph Israels. His time in Paris and London and his visits to the museums there had done little for his knowledge of art; often it was his reading that unleashed his bursts of enthusiasm, mostly directed toward nature and working people. When he drew, his subjects were usually farmers, villagers or miners; but he gave these sketches away and they have all been lost or destroyed.

Dating from 1881, the pencil, pen and brush work *Miners, Wives Carrying Sacks* looks back to the sketches and watercolors of the Borinage he had shown his parents. His letters to Theo are full of draw-

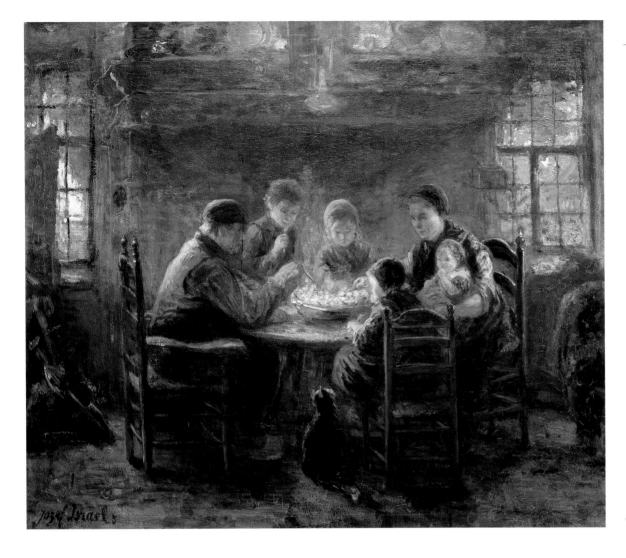

Joseph Israels
Around the Table
1889
Oil on canvas
130 x 150.3 cm

Private collection

Joseph Israels
Returning from the Fields
1878
Oil on canvas
97.5 x 199.5 cm

Tel Aviv, Art Museum

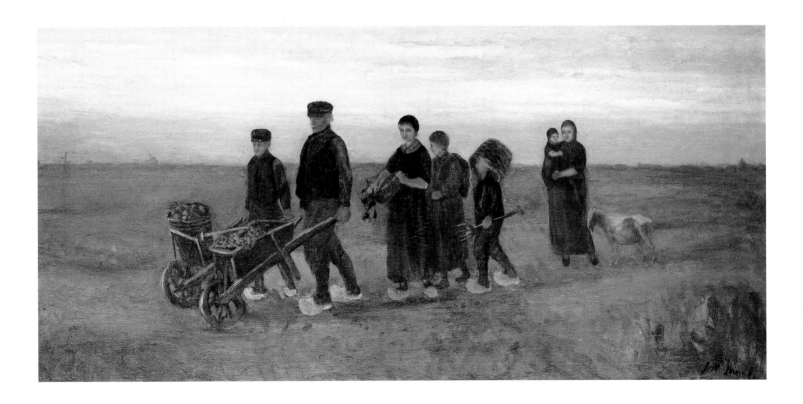

Jacob Maris
The Port of Amsterdam
1875
Oil on canvas
80 x 148 cm

The Hague, Gemeentemuseum

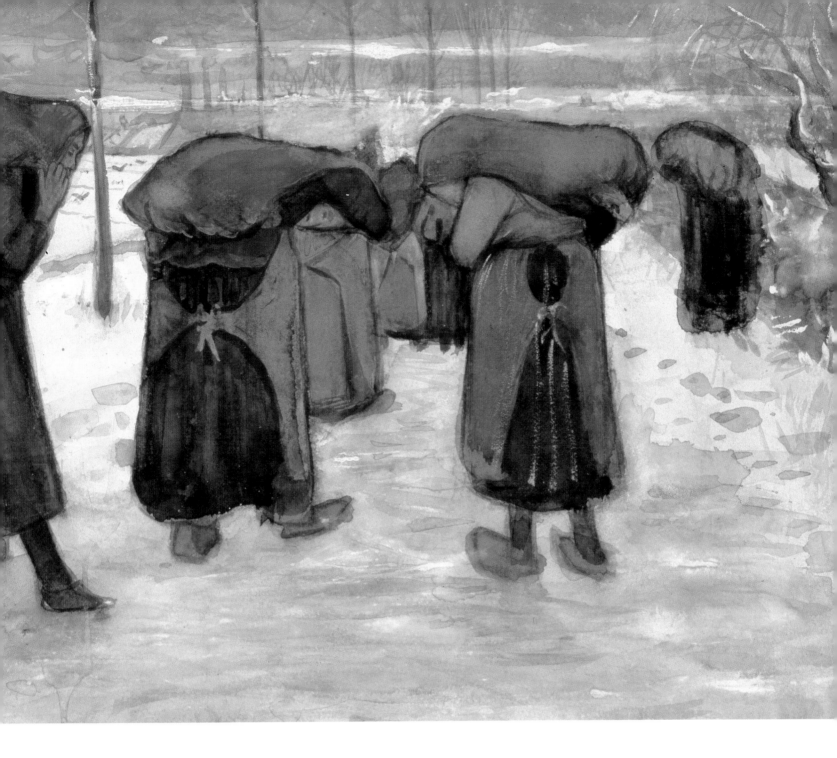

Van Gogh
Miners' Wives Carrying Sacks
1881
drawing

ings: "As I write I'm in the midst of drawing and eager to get back to it…I've scribbled a thing showing men and women going to the pit in the morning in the snow, along a pathway lined with hawthorn bushes: they are mere shadows, barely visible in the half-light…"

Vincent put everything he had into these reports, certain of the accuracy of his observations "from life". He was everywhere, taking care of everybody, but his excited state bothered his superiors: the Evangelization Committee had no doubts as to his good intentions, but finally let him go on the grounds that he lacked the "speaking skills" required for someone leading a congregation. Too worn out to react, he simply turned like a wounded beast and went home again. "Without wanting it so," he wrote in a long letter to Theo – the first in French – in July 1880, "within the family I'm some kind of impossible,

suspect being…someone not to be trusted. What could I do that might somehow make me useful to somebody?"

"This is why," he continued, "I can't help thinking that the best and most reasonable thing to do would be to go away and stay away, and become like someone who doesn't exist."

In the course of this confession he summed up his life so far: "It's true I could have done better, it's true that I've wasted time barely earning my living…But I have to continue on down the path I've taken; if I do nothing, don't study, don't keep searching, I'm lost. And then…"

He mentioned his artistic and literary interests too, for "the love of books is as sacred as the love of Rembrandt. My God, Shakespeare is so beautiful! Who else offers that kind of mystery? But one has to learn to read as one learns to see, and to live…"

Although his father had promised to help out financially, it was Theo who sent him the fifty-franc gifts Vincent considered not so much a handout as an encouragement to follow his chosen path. He had failed in everything he had tried, while his brother was a thorough professional success: but when in 1881, Theo was made manager of the Goupil Gallery on the Boulevard Montparnasse in Paris, Vincent's congratulations were warm and sincere.

For months he wandered aimlessly, with no work or money. His revolt against the wretchedness of the world was over and his attitude was now one of resignation and apathy. Gone too were his religious convictions and his urge to take the gospel to the poor, for a fresh vocation was dawning: he had come to see that painting and drawing were not mere products of observation, but immediate reactions to emotional shock. So, liberated from his past, he set out to conquer a future he would approach differently but with the same passionate commitment. His need now was to find self-fulfillment in communicating with pencil, pen and brush. On August 20, 1880, he confided to Theo that he had "knocked out some big drawings", giving his current address as c/o Charles Ducrucq, 3 Rue du Pavillon, Cuesmes. He made copies of Millet's *Les Heures du jour*, the ten *Travaux des Champs* and, working from an etching Theo had sent him, *Evening Prayer*. "As for *The Sower*, I've drawn it five times, two small versions and three big ones; and it's so much on my mind that I'm ready to do it over and over again." He devoured books on anatomy and perspective, following the same pattern as in his attempts to become a preacher: a sudden flash of inspiration followed by dogged perseverance.

A further abrupt impulse led him to leave Cuesmes for Brussels, where he found lodgings in a busy neighborhood on the Boulevard du Midi. Fortunately a small allowance from his father now allowed him to live decently. He began to visit museums again, but with as little discernment as before, quoting Bacon's phrase "Ars homo additus naturae" (Art is man added to nature) as justification for a hodgepodge of interests that included Rembrandt, Jakob Maris, Charles Meryon, Dürer, Millet, Israels and "gothic architecture drawn by Victor Hugo". He read and studied a great deal, but still in the same disorganized, frenetic way.

Van Gogh
The Sower
1881
drawing
Otterlo, Rijksmuseum Kröller-Müller

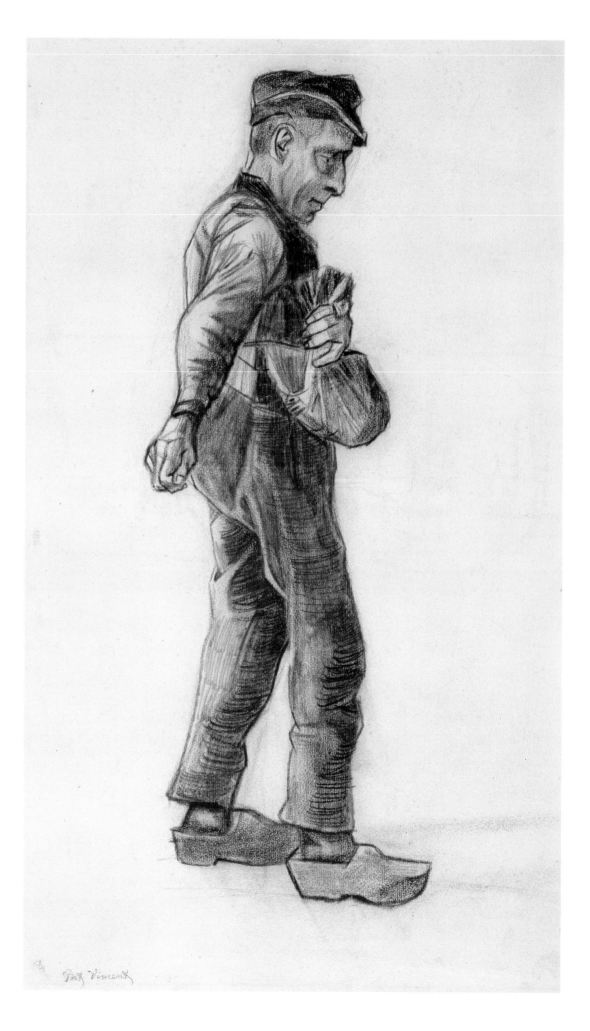

A young painter named Schmidt advised him to apply to the art school, but Vincent refused. Theo introduced him to a Dutch artist, Roelofs, who agreed to give him a few pointers, and he also visited another Dutch painter, Ridder van Rappard, who had known Theo in Paris. He was favorably impressed by this well-off aristocrat, who painted peasant life and scenes of work in the fields. Van Rappard, although somewhat taken aback by his visitor's immoderate manner, jumbled ideas and rapid verbal delivery, consented to talk with him in his studio.

"There are laws governing proportion, light and shade, and perspective, and you have to know them to be able to draw," wrote Vincent to Theo. He also wanted to study anatomy. Van Rappard realized that he and this odd character shared the same tastes and social concerns: "We seek our subjects in the hearts of the people and also have in common the same need to paint from life, to work with reality." They were to remain close friends for five years, and wrote frequently to each other.

Vincent was encouraged by Van Rappard's welcome, the interest he showed and the advice he was prepared to give. Apparently sensing a likeable strangeness in his guest, the young Dutch aristocrat was the first person to take him seriously, to understand his inner struggles, his suffering and the demands he made on himself. Writing to Vincent's mother after the painter's death, he spoke eloquently of his "characteristic silhouette…surrounded by a somewhat sad but bright light."

Van Rappard's hospitable, sympathetic manner brought Vincent an unaccustomed warmth. All he had ever heard in his moments of bitter disillusionment, in his rages and rejections, in people's reactions to the way he dressed and lived, was the word *mad*. Mad – were they right? They must be, he thought, having learned from Theo that his parents had wanted to "place him under guardianship" in Gheel, near Antwerp, where there was a psychiatric hospital. To reassure them, he wanted to work, to "find a well-paid job", and while searching he sent Theo "three scribbles": "They're still clumsy, but they'll give you an idea of the progress I'm making."
In mid-April 1881 Vincent left Brussels for Etten.

2 Art as redemption

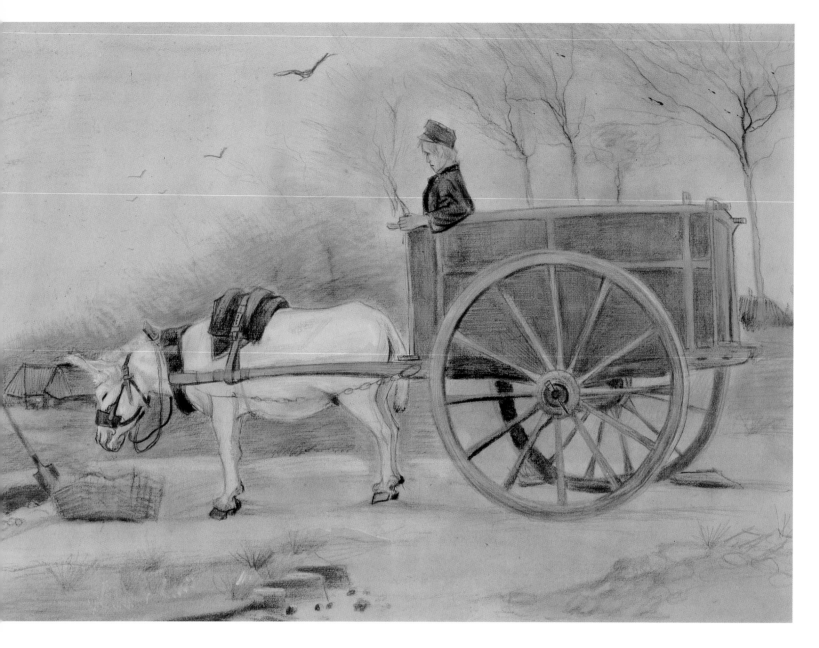

Van Gogh
Donkey and Cart
1881
drawing

Amsterdam, Rijksmuseum, Vincent Van Gogh

"An enormous emptiness settled into my heart"

Etten was the Reverend Van Gogh's new parish, a little village northwest of Breda and in the same impoverished province as his earlier postings. As soon as he had moved back in, Vincent set to work and, as usual, read enormously. He was very touched by the loyalty shown by Van Rappard, who came to see him in August, and the two went on long walks, talking endlessly. This was a time of calm and self-confidence, but it was not to last.

Full of grays and blacks, Vincent's drawings had a certain harshness about them. Wanting to become a peasant painter like Millet or Maris, he chose the same kinds of subjects, but showed what he saw without concessions while still betraying a clear sympathy for simple, down to earth characters. He worked in charcoal and black pencil with white highlights, as in *The Donkey Cart*, the *Girl Gardening* and the *Peasant Digging* of the fall of 1881. *Windmill near Dordrecht* mixes watercolor, pencil, black and green chalk and white highlights.

Antoine Mauve, the landscape painter and Vincent's cousin, invited him to his house in The Hague and encouraged him. Vincent worked hard, but never knew peace of mind for long. His young cousin Kee, daughter of his Uncle Stricker and recently widowed, came to spend a few days at the parsonage in Etten, where Vincent at once fell in love with her and asked for her hand. Unsettled by the haste of this strange cousin, Kee refused him, saying she intended to remain faithful to the memory of her husband. "A terrible battle then began in my heart," he wrote to Theo. "Should I resign myself to her "No, never", or not give up and cling to some faint hope?

Once more passionately in love, he did not give up; he set out to prove his sincerity to Kee, but the young woman found his insistence wearing and returned to Amsterdam, where Vincent sent her endless letters. Shocked by his son's behavior, the pastor rebuked him sharply, calling this latest infatuation "incestuous". Now regarded as depraved by the people of the village, Vincent could no longer bear to stay; leaving for Amsterdam he arrived without warning at the Strickers', where a horrified Kee took flight. In a state of crazed exaltation, Vincent held his hand over the flame of a candle, declaring he would keep it there until she returned, but Reverend Stricker wrenched the candle away and threw him out of the house. Of this incident Vincent wrote to Theo that "An enormous emptiness settled into my heart."

He saw the pain of his burned hand as a kind of propitiatory sacrifice, a defiance of the forces of evil that were assailing him and preventing him from attaining "true life". His rejection by Ursula, then by Kee, was a sign: Vincent did not deserve to be loved and with the same unjustified violence he had been made a social outcast. What he had undergone was less an affront than a punishment. But for what? And why? God Himself – in the person of his father, who represented Him – had abandoned him. Only art remained. Vincent said as much in his letters to Van Rappard and Theo, and threw himself in headlong.

Weighed down by solitude and the crushing disapproval of his family, haunted by the suspicions of a village where rumor had it that he was mad, Vincent left Etten in late December 1881 and took refuge with the Mauves in The Hague. There he wrote letter after letter to Theo, justifying and vindicating himself and warning his brother of his break with the family.

Vincent then proceeded to transfer his love for his father to Mauve, a mediocre painter but a good man ready to take in an unfortunate so full of gratitude and admiration. Vincent confided in him, hoping to benefit from his counsel. His drawings of the time, although revealing a capacity for accurate observation, lacked warmth; the figures proportions were wrong and their movements awkward. So Mauve found him a place in an art school where he could draw from life.

He also introduced him to young painters of the "1880 Movement," a modernist group with naturalist and symbolist leanings. Vincent saw Mr. Tersteeg, his old boss from Goupil's, again, and got together with other artists to swap ideas – but as always he became heated and aggressive, wore himself out, suffered from headaches and toothache, and begged Theo to send a little money so he could see a doctor.

Things did not go well with the Hague painters. Vincent could not bear their vanity, their competitiveness, their need to flatter the public – all notions that were utterly foreign to him. Keeping to himself, he haunted the museums or went to the Maurithuis to spend hours admiring Rembrandt and Franz Hals. Things were becoming strained with Mauve, too: when the painter advised him to work from classical models, Vincent smashed the plaster statues and threw the pieces into the coal bucket.

The break with Mauve was followed by one with his painter friends. Mr Tersteeg accused him of having taken in a prostitute, a woman Vincent had nicknamed Sien who had moved in with him in January 1882. This "family" generated disapproval or outright repulsion in Vincent's circle, especially when, a few months later, she gave birth to another man's child. Vincent continued to send Theo long letters about artistic circles in The Hague, about his work and his problems, but also about the commissions he was hoping for and the progress he was making. The letters often arrived accompanied by drawings.

It was not long before he had to speak of the change that had taken place in his life. In an undated letter of May 1882, he wrote to his brother:

"Last winter I met a pregnant woman who had been abandoned by the father of her child. A pregnant woman wandering the streets and trying to earn a living in a way you can easily imagine. I took her on as a model and worked the whole winter with her…The baby is due in June. It seems to me that any man worthy of the name would have done the same. At present she is as attached to me as a pet dove, and since I can only marry once, what would be better than to marry her? This is the only way I can keep on helping her, otherwise poverty will force her back on to the path that leads to the precipice. She has no money, but helps me earn some through my work."

Vincent was well aware that Sien – her real name was Clasina Maria Hoornik – was a human wreck, but he saw her above all as a victim of society, of greed and blind desire. He knew, too, that neither young nor beautiful, she was ravaged by disease and alcohol; but she had the life force within her. After his rejection by the women he had fallen in love with, there remained only this poor unfortunate to bring him hope: by saving her from prostitution and beggary, he might find the warmth of a shared household. His evangelical spirit paid no heed to the reproaches, disapproval and contempt showered on this fallen woman; and she was to inspire, after a number of preliminary sketches, his first major work, the lithograph *Sorrow*.

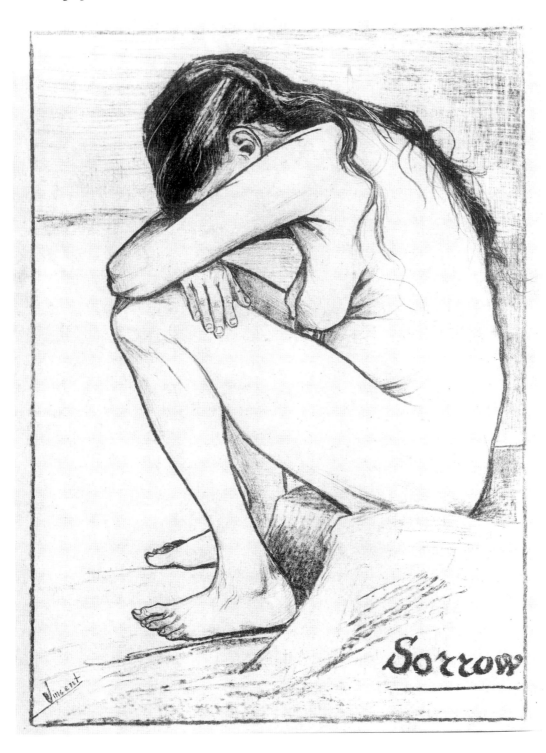

Van Gogh
Sorrow
drawing
Private collection

Sien's mother was also his model, posing for *The Widow*(7), in which Vincent gives poignant expression to the enslavement of the working classes, a subject close to his heart.

Theo was appalled by his brother's moral decline. Fearing a scandal, he threatened to come to The Hague and put a stop to a relationship that Vincent – harking back to the historian and writer Jules Michelet, for whom motherhood was "woman's great mission in this world" – saw as an act of charity that would bring him a child. One day he fired back at Theo, "You can give me money, but you can't give me a wife and child!" He was now a changed man, determined and confident. Paradoxically so, but Vincent's inner logic was all his own as he deluged Theo with letters in praise of Sien, the woman and model that his family wanted to separate him from – he the failed painter they had cut off without a penny. Sien herself smoked and drank constantly and, it appears, only waited for the birth of her child to return to her old life.

Van Gogh
Sien with Cigar Sitting on the Floor near Stove
1882
black pencil, black chalk, pen, brush
45.5 x 47 cm

Otterlo, Rijksmuseum Kröller-Müller

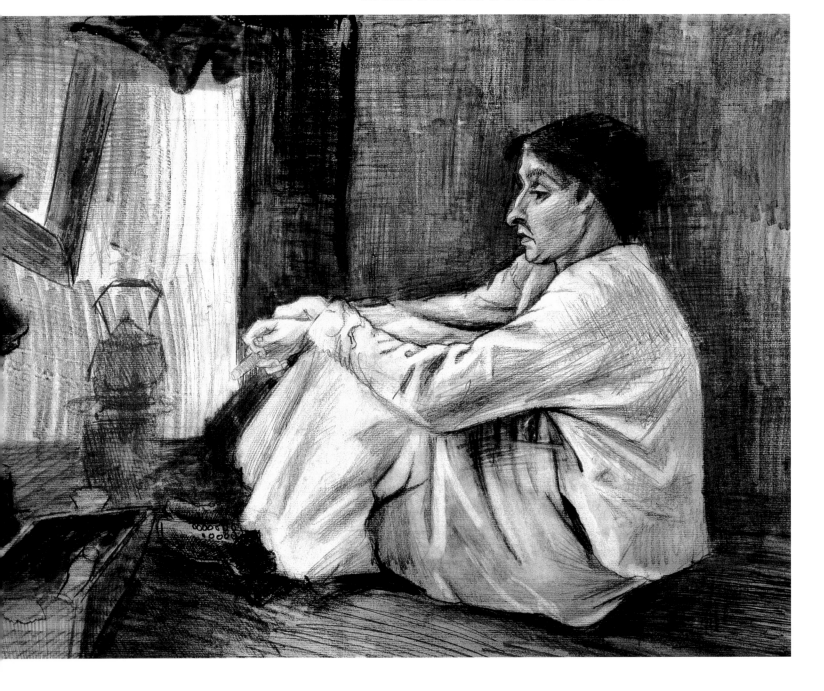

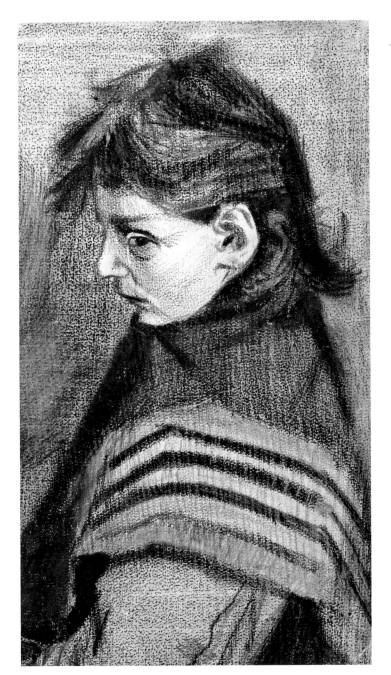

Van Gogh
Sien's Daughter with Shawl
1883
Black chalk, black pencil
Otterlo, Rijksmuseum Kröller-Müller

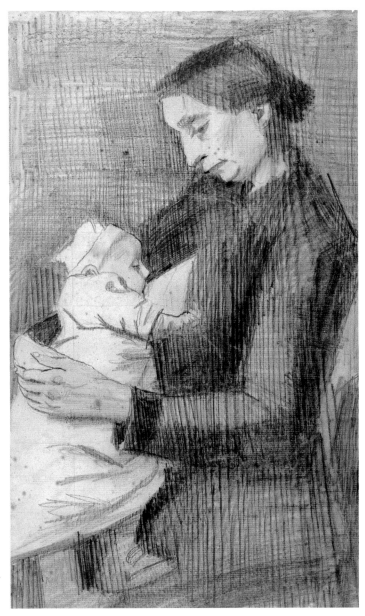

Van Gogh
Sien Nursing Baby
1882
Otterlo, Rijksmuseum Kröller-Müller

Van Gogh
The Potato Market
1882
Watercolor
44 x 55 cm
Private collection

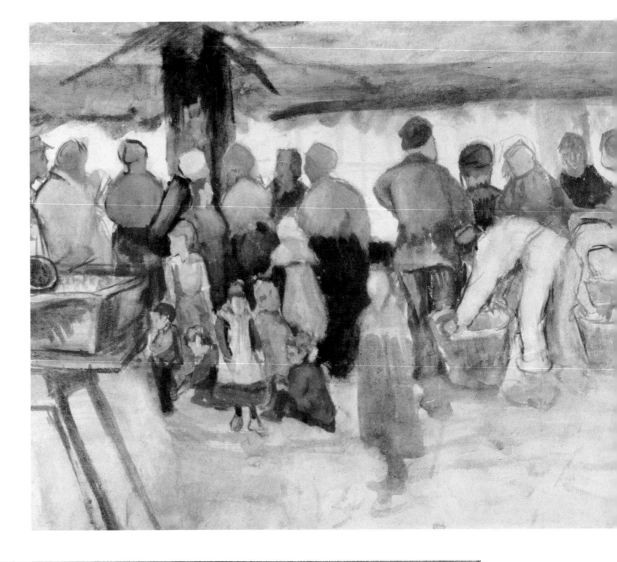

Van Gogh
The Beach at Scheveningen
1882
Oil on canvas
34.5 x 51 cm
Amsterdam, Rijksmuseum,
Vincent Van Gogh

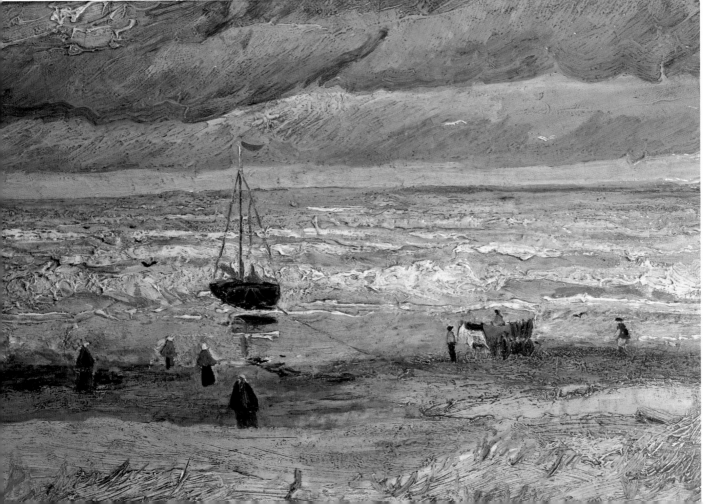

Digging deep into painting like a man plowing a field

Vincent was working hard. His landscapes of The Hague were increasingly sensitive and better structured; his figures – residents of the local old people's home, fishermen, Sien and the daughter she had had a few years earlier – still lacked suppleness, but his painter's eye was sharpening up. He mixed his media, as in the combination of charcoal, pencil, ink and watercolor in *Rooftops*, a view from his studio which for the first time shows him using light colors in a skillful study of perspective highlighted with white.

Dating from the summer of 1882, his first paintings show the beach at Scheveningen, little seascapes and views of forests interspersed with drawings. They are heavy-handed and outlined in black; Vincent had long been waiting to make the move to color and had told Theo of his doubts and fears, of his uncertainty about the use of black, about primary and composite colors, the choice of materials, canvas sizes and the purchase of a perspective frame. He also confided in Van Rappard, opening up to him about his artistic concerns and much else as well.

As he wrote, Sien and the newborn baby's cradle, which he was sketching, were at his side.

Among the paintings of the time were *A Wind-Beaten Tree*, a rough draft of *The Sower* and *Women Mending Nets in the Dunes*. Vincent was discovering light and shade, and the effects to be obtained from value and color contrast. *Potato Digging* was a sketch for a larger composition he never succeeded in finishing. He was digging into painting like a man plowing a field, furrow after furrow and with no outside advice, no master to guide him.

The little time left him by his "family", the little money he had and the little strength left him by his poor health all went into reading and drawing.

"Inside myself I feel a fire I must not let go out, a fire I have to fuel even though I have no idea of where all this is leading me."

And then Sien became pregnant again. Was Vincent the father? Feeling himself ridiculed and duped, he dared not even think about it as his companion, urged on by her mother, considered going to work in a brothel., Exhausted, Vincent resigned himself to leaving her: he had "truly felt pity for her", but could do no more to help her quit her degrading way of life. Plagued by feelings of cowardice, in September 1883 he left The Hague for Hoogeveen in the Drente: Van Rappard had already told him of "the austere atmosphere" of this region where as far as the cost of living went,"you won't find better anywhere."

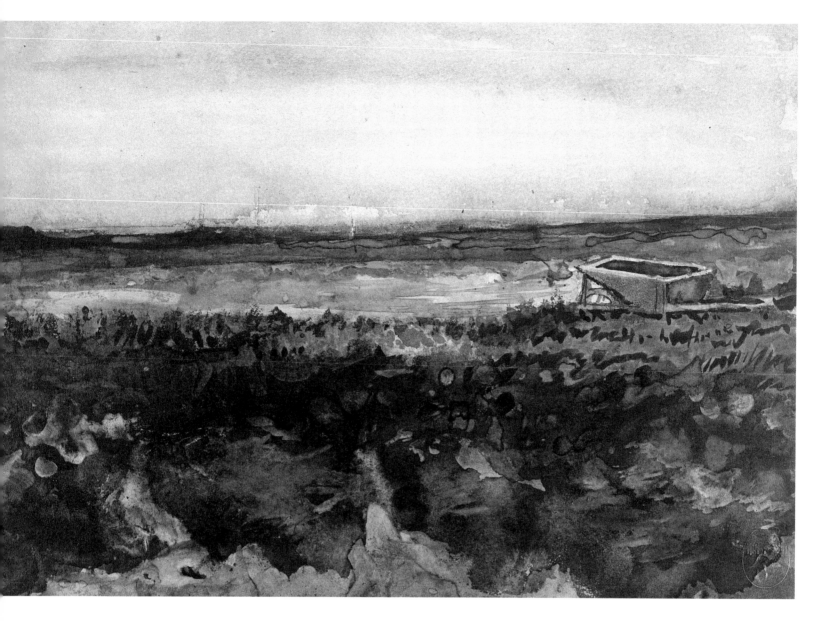

Van Gogh

The Heath with a Wheelbarrow

September 1883

Watercolor

24 x 35 cm

Cleveland, Museum of Art

The potato eaters

No region is more typical than the Drente of the "visionary country" of northeastern Holland celebrated by the poet Emile Verhaeren: much appreciated by painters like Max Liebermann, these wild moorlands and peat bogs under a lowering sky were home to a peasant population highly suspicious of "foreigners". Vincent moved into the Hartsviker Inn and his descriptions of the countryside he discovered on his long walks are movingly beautiful. But his many problems still dogged him, and the memory of Sien, whom he had forgiven, and her children never left him. In long, almost daily letters he urged Theo to join him; they would be a pair, he said, like the Van Eyck brothers.

He painted the moss-covered cottages, a peat boat, a peasant burning weeds; he drew landscapes and scenes of work in the fields, using powerfully saturated blacks and more subtle and harmonious grays.

With the coming of winter, the countryside was even more hostile than its inhabitants. Vincent's loneliness was unbearable: having run out of paint and brushes he succeeded in "defeating his pride" and returning to his parents' home. Reverend Van Gogh was now in the parish of

Van Gogh
Farmhouses
September 1883
Oil on canvas
35 x 55.5 cm

Amsterdam, Rijksmuseum,
Vincent Van Gogh

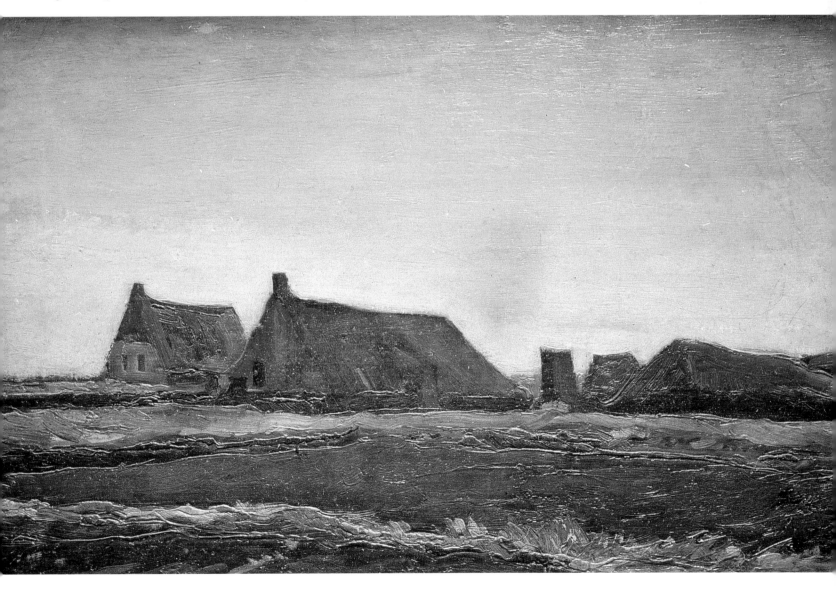

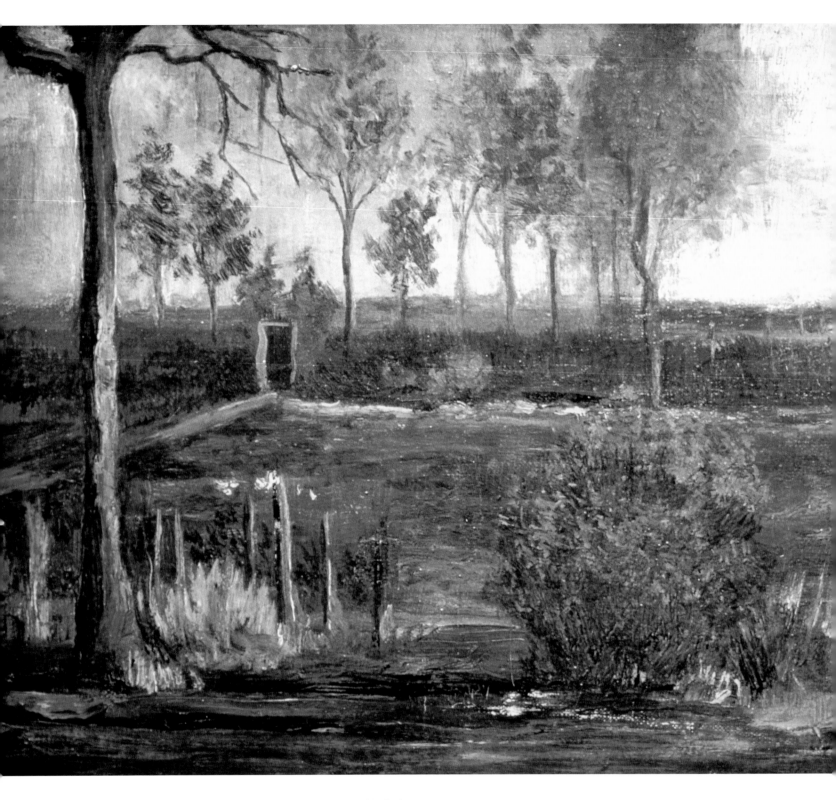

Van Gogh
The Parsonage Garden at Nuenen
May 1884
Oil on paper on panel
25 x 57 cm

Groningen, Groninger Museum

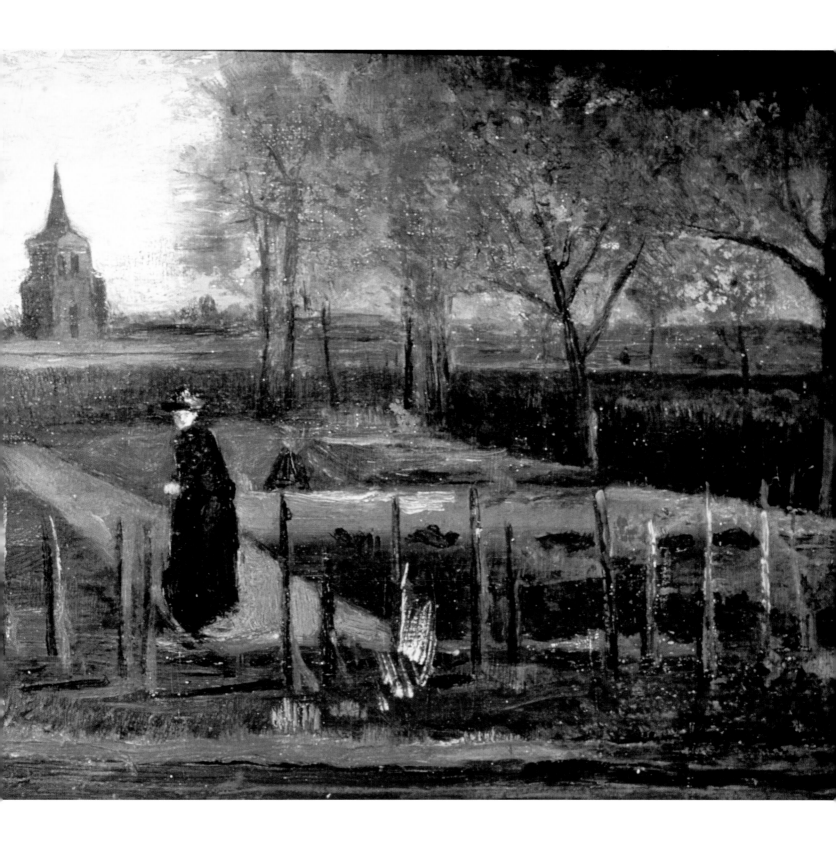

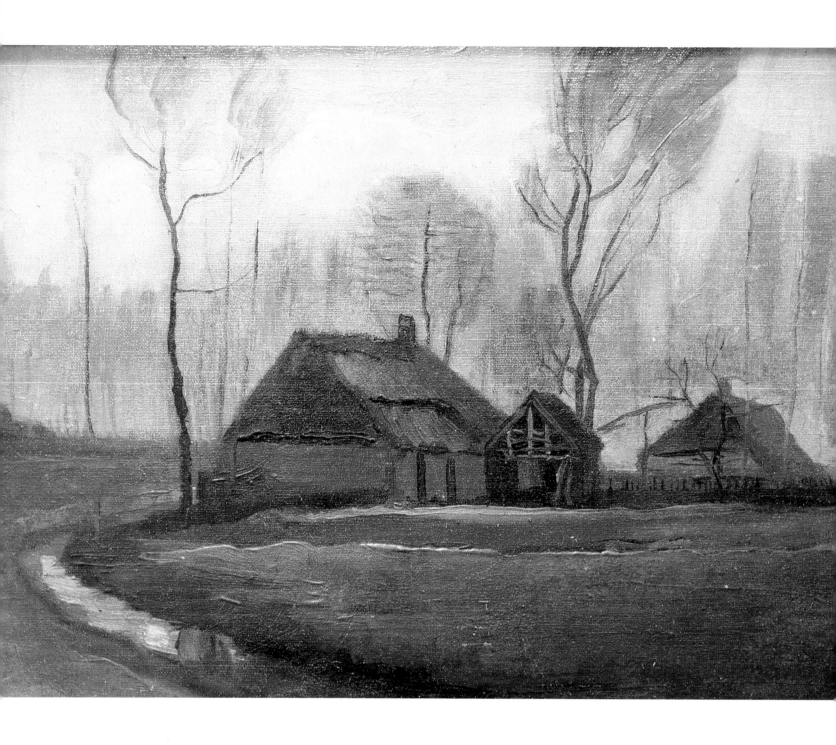

Van Gogh
Farmhouses among Trees
September 1883
Oil on canvas on panel
28.5 x 39.5 cm
Warsaw, Museum Kolekcji

Nuenen, still in the Brabant but in a Catholic area where Vincent was not well received. Nonetheless he continued to paint and draw his favorite subjects – landscapes and people, the congregation coming out of the church at Nuenen, the mill, the parsonage, the old tower – and in the workshop of Mr. Hermans, a former goldsmith and collector of antiques, he worked on decorative projects inspired by the work of Millet. He read voraciously, studied the Old Masters and was visited by Van Rappard. During their long walks together they discussed art, and Vincent railed against his father's ingratitude and the insensitiveness of Theo, whose attitude changed from one letter to the next.

Vincent declared himself more and more taken with the idea of light colors, but his work still stressed his subjects' "expressive force," as in the pen, pencil and watercolor studies for *Weaver* of January-April

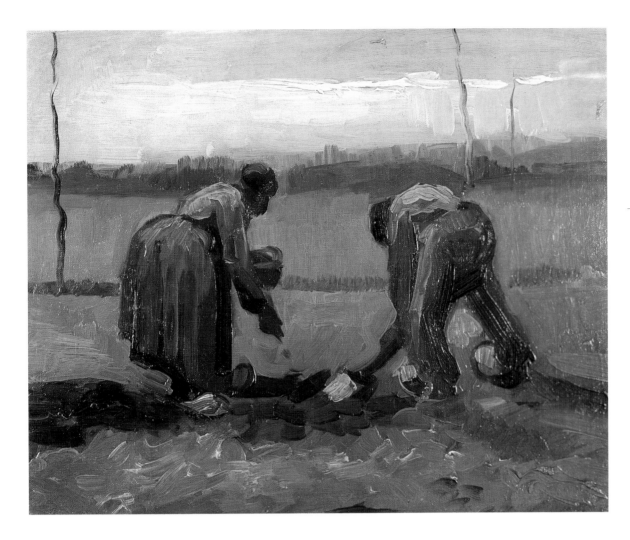

Van Gogh
Working in the Fields
1885
Oil on canvas
33 x 41 cm
Zurich Kunsthaus

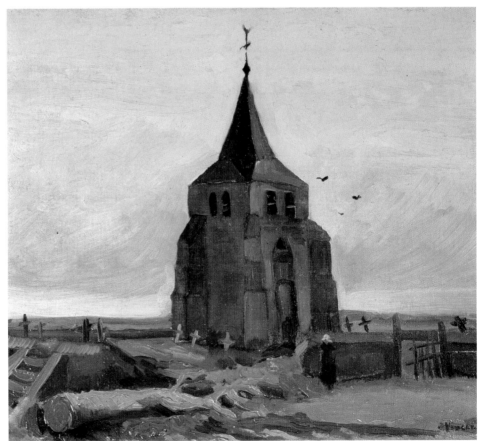

Van Gogh
The Old Church Tower at Nuenen
1884
Oil on canvas
47.5 x 55 cm
Zurich, E.G. Bührle Collection

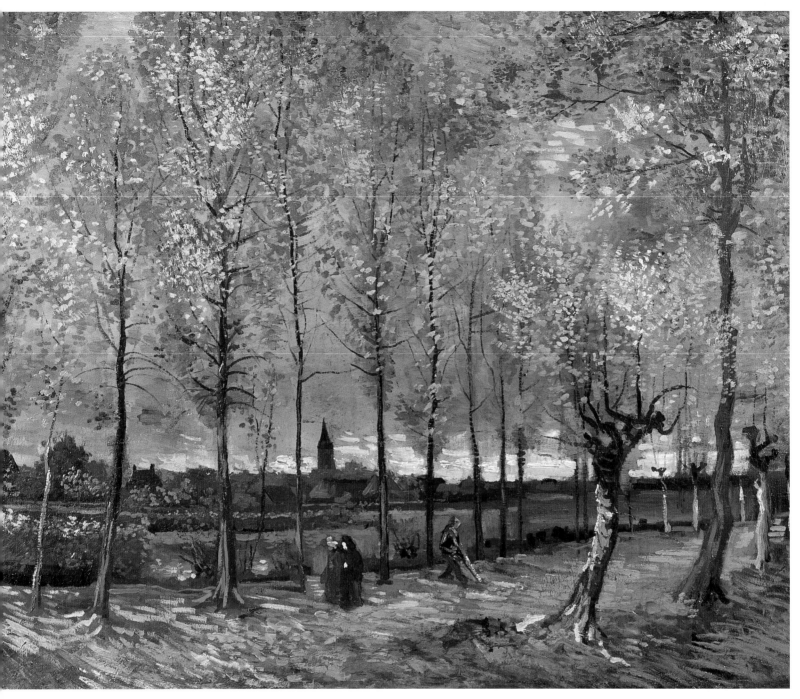

Van Gogh
Lane with Poplars
1884
Oil on canvas
78 x 97.5 cm

Rotterdam, Boymans van Beuningen Museum

1884 and his still lifes. We know of more than one hundred eighty paintings – most of them lost – and some two hundred forty drawings from the Nuenen period of 1884-85. His largest work, *The Potato Eaters* of April-May 1885, was preceded or accompanied by roughs and variants; "I lived and breathed this picture," he would say of it.

This is an authentic scene from the everyday life of its five characters: the De Groot family – whose daughter was said, wrongly it seems, to be pregnant by Vincent – is seen eating by lamplight after their day's work. The deliberate crudeness of the forms and the striking contrasts of light and shade fit perfectly with the ominousness of the earth colors and ochers; here each face, each posture is conveyed with impressive power.

The Nuenen period includes some forty still lifes, the result of the local Catholic priest's order to his parishioners not to pose for the "Protestant dauber". Vincent sought out humble domestic objects to paint: potatoes, fruit and the birds' nests he collected as symbols of birth and the natural order. And despite his fondness for dark hues and

Van Gogh
The Potato Eaters
April 1885
Oil on canvas on panel
72 x 93 cm
Otterlo, Kröller-Müller

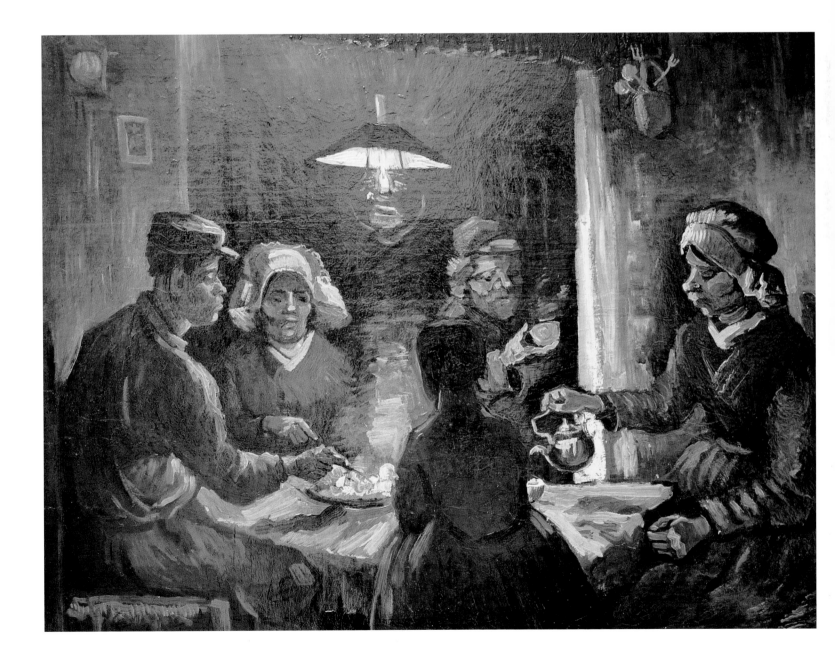

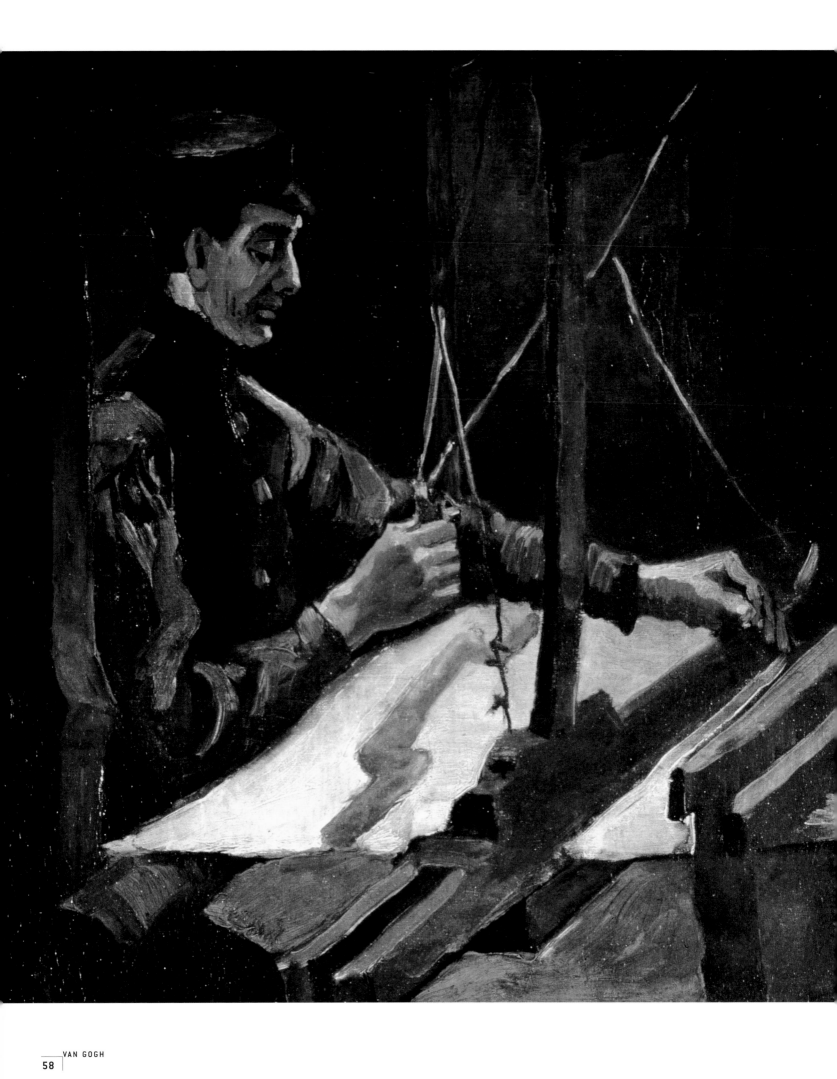

light and shade, he was using bright colors too. *Still Life with Bible* brings together the domestic and spiritual concerns of the end of his Dutch period.

The painting was also a tribute to his father, who had died suddenly in March 1885. The open Bible – "shot white", he wrote to Theo, "and leather-bound against a black background" – offers a spiritual and technical contrast with the brownish-yellow foreground and the touch of lemon yellow provided by Zola's novel *Joie de Vivre*. The same book reappears in an Arles still life, while the extinguished candle is a symbol of life cut short.

"I can even say that now I can paint an object of whatever color or shape fairly easily and without hesitating," Vincent added, for once satisfied with his work.

And so a painter was born out of these simple things and this hard country he was about to leave forever. He had known little peace there, and the hostility of the villagers had only been increased by his idyllic love affair with Margot Begeman, a neighbor aged thirty-nine. He was prepared to marry her, but when – too readily, it seemed – he gave in to the pressure from his family, Margot attempted suicide by poison. And what had really happened with Gordine de Groot? In spite of his readiness to speak at length of his love life in his letters, here he remained silent, his attention more taken up with his persecution by the parish priest.

Van Gogh
Weaver
1884
Oil on canvas
48 x 46 cm
Berne, H.R. Hahnloser collection

Van Gogh
Still Life with Yellow Straw Hat
September 1885
Oil on canvas
36.5 x 53.5 cm
Otterlo, Rijksmuseum Kröller-Müller

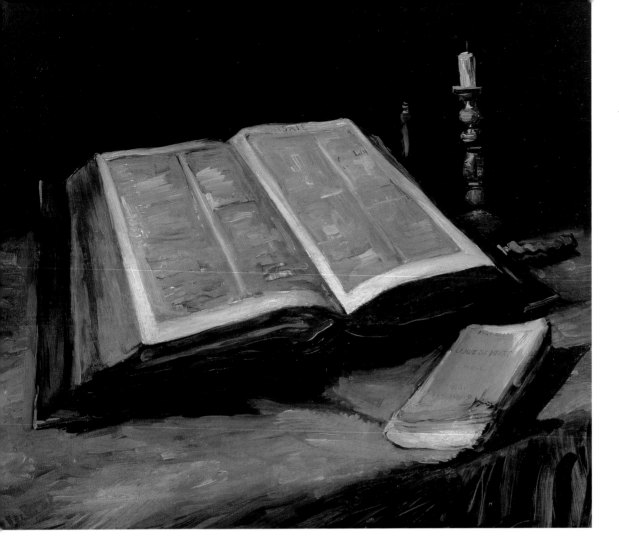

Van Gogh
Still Life with Bible
April 1885
Oil on canvas
65 x 78 cm

Amsterdam, Rijksmuseum, Vincent Van Gogh

Van Gogh
Autumn Landscape
November 1885
Oil on canvas
64 x 89 cm

Amsterdam, Rijksmuseum,
Vincent Van Gogh

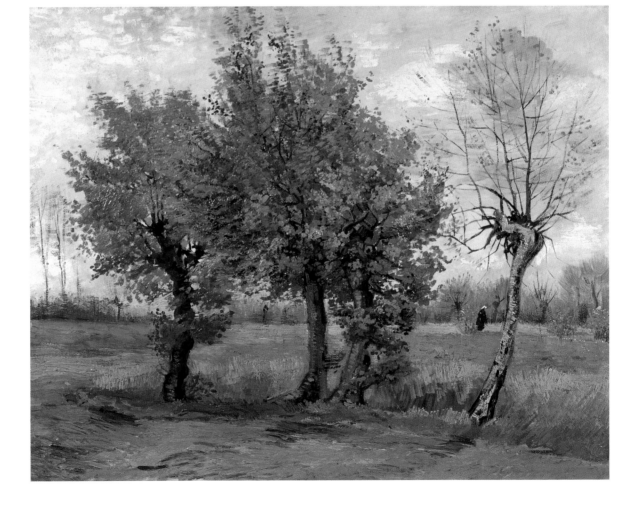

Clearly it was best to get out of this hateful village and set up in a city where he could sell his work; already, the Paris dealer Portier had found "real personality" in the paintings Theo had shown him.

The works he left with his mother were put into boxes and stored in the back room of a Breda delicatessen. Later they were acquired by a second-hand dealer, who sold them off for a very low price, mostly to a certain Mouwer, a tailor from Breda.

Nuenen, from December 1883 to November 1885, marked the end of Vincent's early period. The break with his old circle was now complete: with his father dead, there remained nothing for him at the parsonage, where the sucessor to the *dominie* sent him packing. There remained only Theo to offer help and understanding, for successive impulses had led him also to break with Van Rappard and Mauve. Summing up his situation in two undated letters to his brother in October-November 1885, Vincent wrote:

"Now my palette is beginning to loosen up and the sterility of my early days is finished. Sometimes I feel I'm banging my head against a brick wall when I start in on a subject, but the colors come spontaneously and when I take one as a starting point I see clearly in my mind what I can get from it and how to draw life out of it...Having worked alone all these years, it seems to me that even if I want to and can learn from others, and even borrow their techniques, I shall always use my own eyes for seeing and always work in a personal way...I painted without stopping so as to learn to paint and get a clear ideas of color and so on, until there was almost no room left in my brain for anything else...A painter's life is often hard."

Van Gogh
Peasant Woman Digging up Potatoes
1885
drawing
52 x 36 cm
Zurich, Hahnloser collection

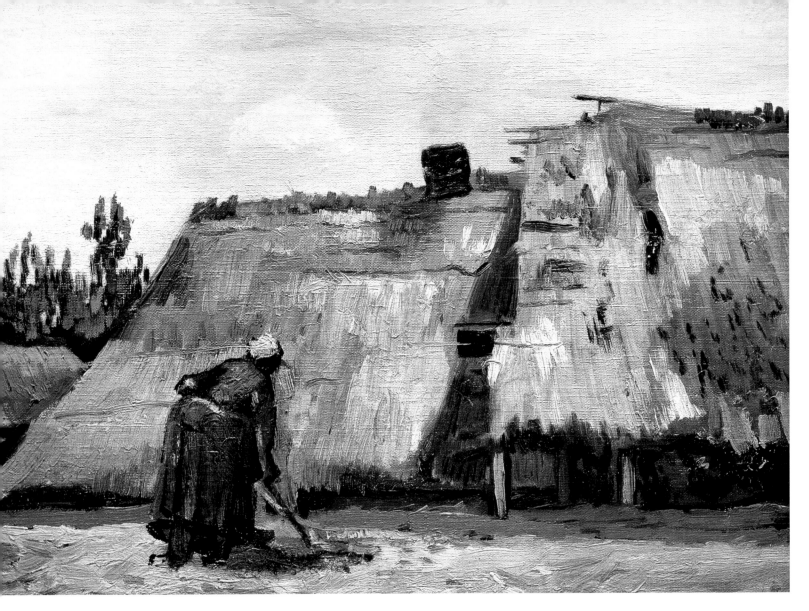

Van Gogh
Cottage with Woman Digging
June 1885
Oil on canvas
31 x 42 cm

Chicago, Art Institute

Van Gogh
Antwerp
December 1885
drawing

«I still have a lot of trouble hearing the colors»

Arriving in Antwerp on November 27 1885, Vincent rented a little room at 194 Beeldekenstraat (Street of the pictures) for twenty-five francs a month and spent his time visiting the museums. In the area around the port he bought colored Japanese prints that he pinned to the walls of his room, and at the same time he began to discover Rubens. These two influences were to transform his artistic vision: on the one hand were the frank contours and simple, direct areas of color of pictures created for bars where girls and sailors met in an atmosphere redolent with spices and alcohol; and on the other, the Baroque brio of Rubens, the eloquence of his sensual, vibrant colors and all the splendor – Vincent called it "divine" – of a palette rich in cobalt and emerald, in carmine as "warm and spiritual as wine". Vincent was fascinated by Rubens' technique, especially in the portraits, and by his unparalleled ability to express atmosphere, joy and drama by simple juxtaposition of colors. Speaking of Rubens to Theo, he mentioned *The Elevation of the Cross*, "with its white patch: this body set off by the light in such dramatic contrast to the rest, which remains in shadow." There was, also, *The Descent from the Cross*, in which, he wrote in January 1886, "the white recurs in the women's blond hair, and in their faces and necks, while those around them are so strikingly varied with all their dark shapes, and the reds, dark greens, blacks, grays and purples are given unity through tone."

He enrolled at Karel Verlat's academy of art and took evening classes with Frans Vinck, but was unimpressed by his teachers' conventionality. He painted views of the city, mainly its cathedral, did drawings of the cathedral tower, and wandered along the piers and docks, discovering their "splendidly Japanese character, so capricious, original and new".

"I still have a lot of trouble hearing the colors," he wrote to Theo. "Lacking routine, I spend too much time feeling my way and that means a lot of wasted effort." His poverty meant that most of his money went on paints and brushes; eating little, he suffered from spells of giddiness and fainting fits.

His trials and tribulations at the art academy ended up in demotion to the beginners' class, but Vincent was not discouraged: "Things will change as my work gets better and better, when I'm really able to do something, when I really know something."

He now hoped to return to Paris and live there with Theo, who was not overly impressed with the idea of settling for "a room with an alcove and a mansard roof, or a bit of an attic." But suddenly Vincent's mind was made up and he left Antwerp at the end of February 1886. The dozen or so canvases painted there include *Quayside with Ships in Antwerp*, two self-portraits, the *Head of a Woman with Her Hair Loose* with its rich, powerful brushstrokes, and the extraordinary *Skull with Burning Cigarette*, a macabre, somewhat blasphemously cynical work – doubtless inspired by those nights of hunger, of thoughts of death and of imagining himself beyond the grave – that sarcastically mocks the harshness of life.

Van Gogh
**Head of a Woman with
Her Hair Loose**
December 1885
Oil on canvas
35 x 24 cm
Amsterdam, Rijksmuseum,
Vincent Van Gogh

Van Gogh
**Skull with Burning
Cigarette**
1885-1886
Oil on canvas
32 x 24.5 cm
Amsterdam, Rijksmuseum,
Vincent Van Gogh

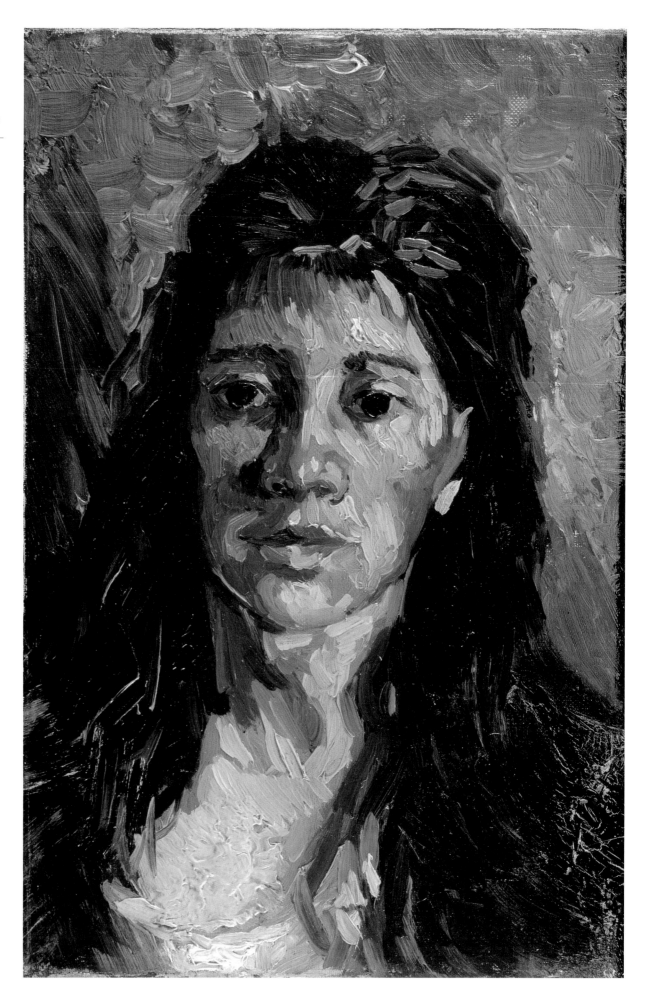

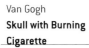

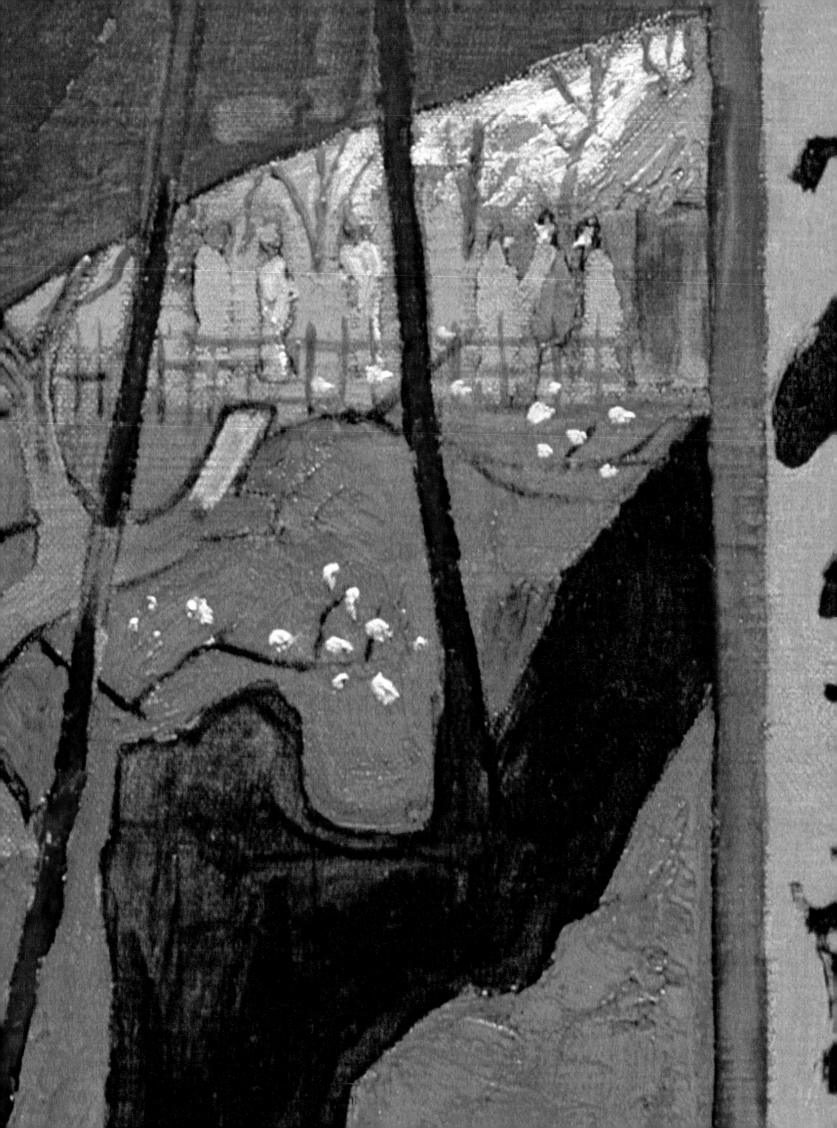

3

The Light of Île de France

Contacts and influences in Paris

Reaching Paris on February 28 Vincent sent a note to Theo suggesting they meet in the Salon Carré at the Louvre. His idea was that they share his brother's apartment on the Rue de Laval (now the Rue Victor-Massé), but space was short there and it was hardly the place for the life Vincent hoped for and Theo dreaded. He would have to live elsewhere, then, but his first concern was to enroll at the Paris Art School, in the atelier of one of the most mediocre, narrow-minded and academic pundits of the time, Fernand Cormon. Cormon had quite a reputation and was a pillar of the Salon.

The "master" was more than a little shocked to see this weird Dutchman attack the business of drawing so ardently and with no preliminaries. The other students accepted the rules of the studio unquestioningly and sniggered as Cormon, who had his doubts about the newcomer's mental state, glanced dismissively at the work and moved on.

However, art was thriving in the spring of 1886. On May 15 opened the eighth, and last, Impressionist exhibition. Differences within the group meant that Renoir, Monet and Sisley were absent, but Degas was there, along with Berthe Morisot, Signac, Odilon Redon, Armand Guillaumin and, among others, a beginner named Paul Gauguin, armed with no fewer than nineteen canvases vibrant with unresolved potential. Pissarro, whom Vincent had met through Theo, had adopted the Divisionist technique devised by Seurat, whose *La Grande Jatte* created a sensation.

In June Renoir and Monet took part in the fifth international exhibition in the splendid setting of the gallery run by Georges Petit, the rival of Durand-Ruel who had discovered the Impressionists. Two months later the Salon des Indépendants saw the Divisionists turn out in force; the focal point was once again *La Grande Jatte.*

Gauche and dazzled, Vincent toured the exhibitions with Theo and got to know the young painters who were beginning to make a name for themselves in avant-garde circles. Impressionism was the word on everybody's lips, and now that tempers had cooled a little, it was finding more and more admirers. Vincent, however, his eye trained by the landscape painters of Barbizon and The Hague, and by the Franz Hals and Rubens seen in museums, was a disciple of Eugène Delacroix – he was a great admirer of *Le Journal* – and was not spontaneously drawn to the new movement. Yet at the same time, the light of the Île de France region, the subtle clarity of the Paris skies, and a freer, more joyous atmosphere than he had breathed up until then, all combined to inspire him. Did this new painting style suit his temperament? Perhaps, he thought, Paris would calm him, bring him peace, ease his tattered nerves. But yet again, disillusion was lurking in the wings. He spent two years in Paris and, after leaving in February 1888, he wrote to Theo during the following summer: "You know, whatever the virtues of the sacred cow Impressionism, what I want for myself is to do things the preceding generation – Delacroix, Millet, Rousseau, Diaz, Monticelli – could understand." A few

days later he remarked that, "The thing is, what I learned in Paris is *leaving me* and I'm returning to the ideas I had in the country, before I knew the Impressionists…It's true that color is going ahead and we have the Impressionists to thank for that, even when they're off the target; but Delacroix was more wide-ranging than they are."

The letters of this time sum up several months of self-questioning and doubt. Vincent had met many of Theo's painter friends, seen their work and listened to them – especially Pissarro, who introduced him to Divisionism. But as often as possible he was at the Louvre, looking at Delacroix, whose theories on color gripped his imagination and helped him overcome his persistent misgivings about modern paintings – even if he admired Monet and could see what Seurat was getting at.

There were, too, other influences that his habit of divergent thinking mixed together: he had discovered the work of the recently deceased Monticelli, with his generous use of paint and the sumptuous bursts of color against variegated backgrounds that appear in Vincent's own flower paintings. The art dealer Portier, the brothers' neighbor at their new apartment at 54 Rue Lepic, introduced him to Guillaumin, an Impressionist.

Van Gogh
Montmartre near the Upper Mill
Autumn 1886
Oil on canvas
44 x 33.5 cm

Chicago, Art Institute

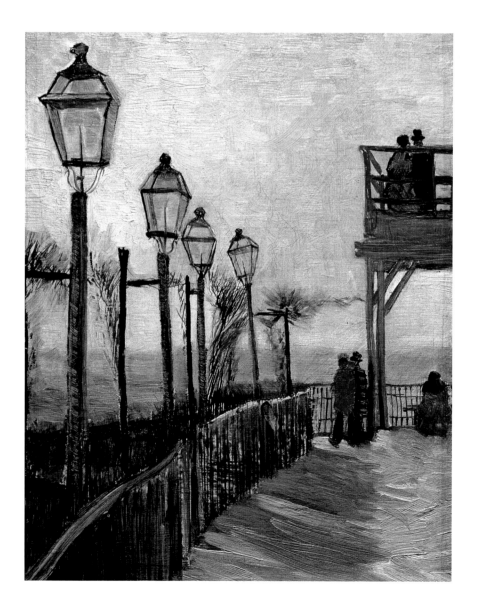

Still attending classes with Cormon – who ignored him – Vincent got to know Henri de Toulouse-Lautrec, a dwarf who liked the good things in life, and his southerner friend François Gauzi, who spoke of seeing Van Gogh working with "feverish haste". He also met Émile Bernard, expelled by Cormon for "thinking for himself"; Anquetin, whose succinct simplifications showed the influence of Japanese prints; and the Australian John Peter Russell, who did his portrait. In September 1889 he wrote to Theo: "Make sure you keep Russell's portrait of me, I'm very attached to it."

The haphazard artistic life style with its visits to studios, galleries and cafes, meant meeting lots of people: one of them was Paul Gauguin, who had given up his family and a career as a stockbroker for a bohemian existence as a painter. Vincent was fascinated by the assurance and prestige of this man, who would later play such an important part in his life. He ran into Seurat again – he had first met him in a workers' restaurant – in the art supplies store belonging to Père Tanguy, an old revolutionary who dealt in pictures on the side. The store on the Rue Clauzel, down from Montmartre, was also frequented by Vincent's pointillist friend Signac.

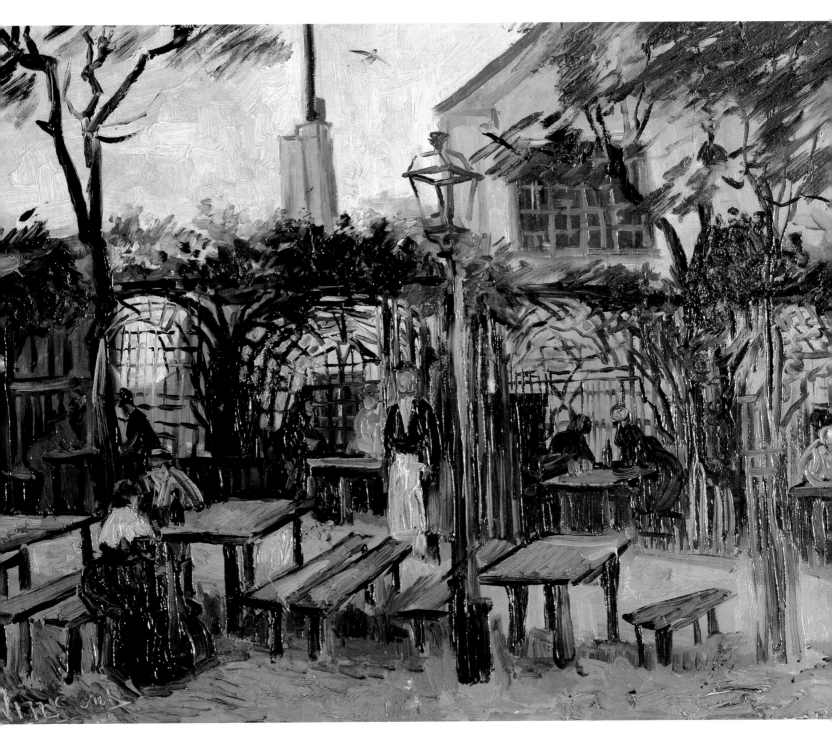

Van Gogh
Terrace of a Café on Montmartre (La Guinguette)
October 1886
Oil on canvas
49 x 64 cm

Paris, Musée d'Orsay

following page>
Van Gogh
**View of Paris from
Montmartre**
Summer 1886
Oil on canvas
38.5 x 61.5 cm

Basel, Kunstmuseum

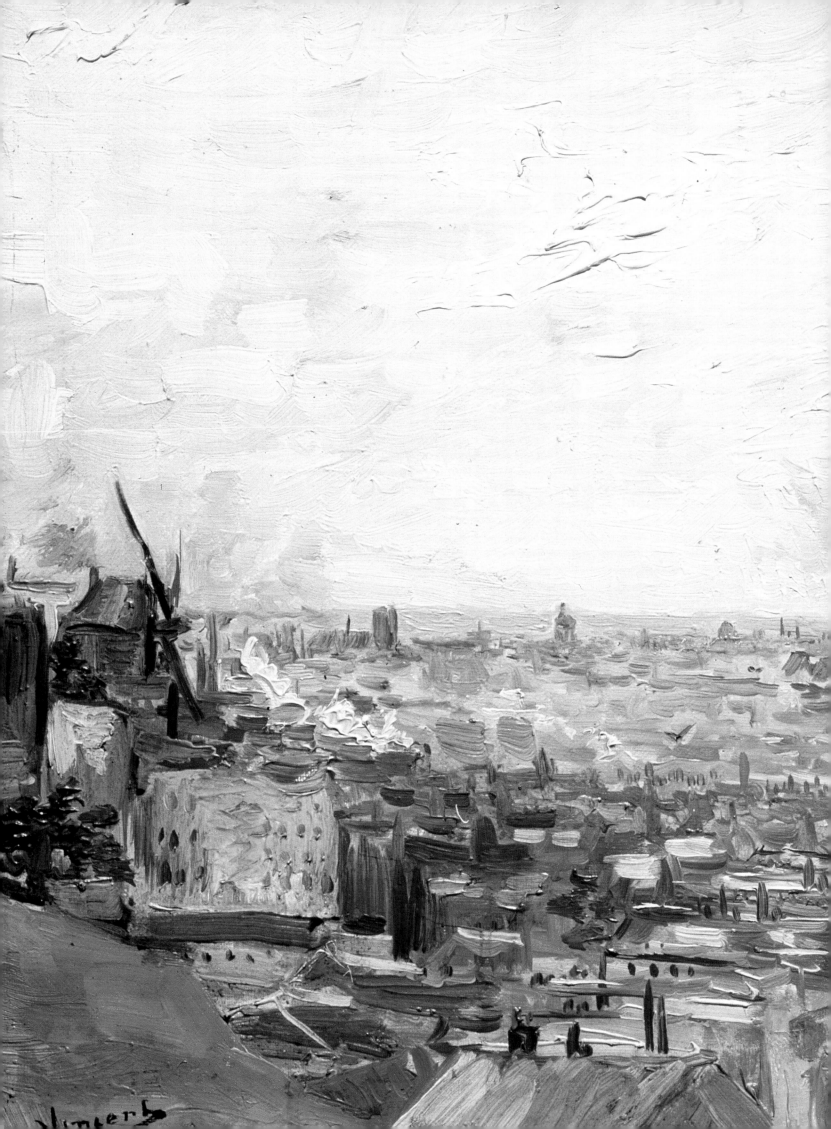

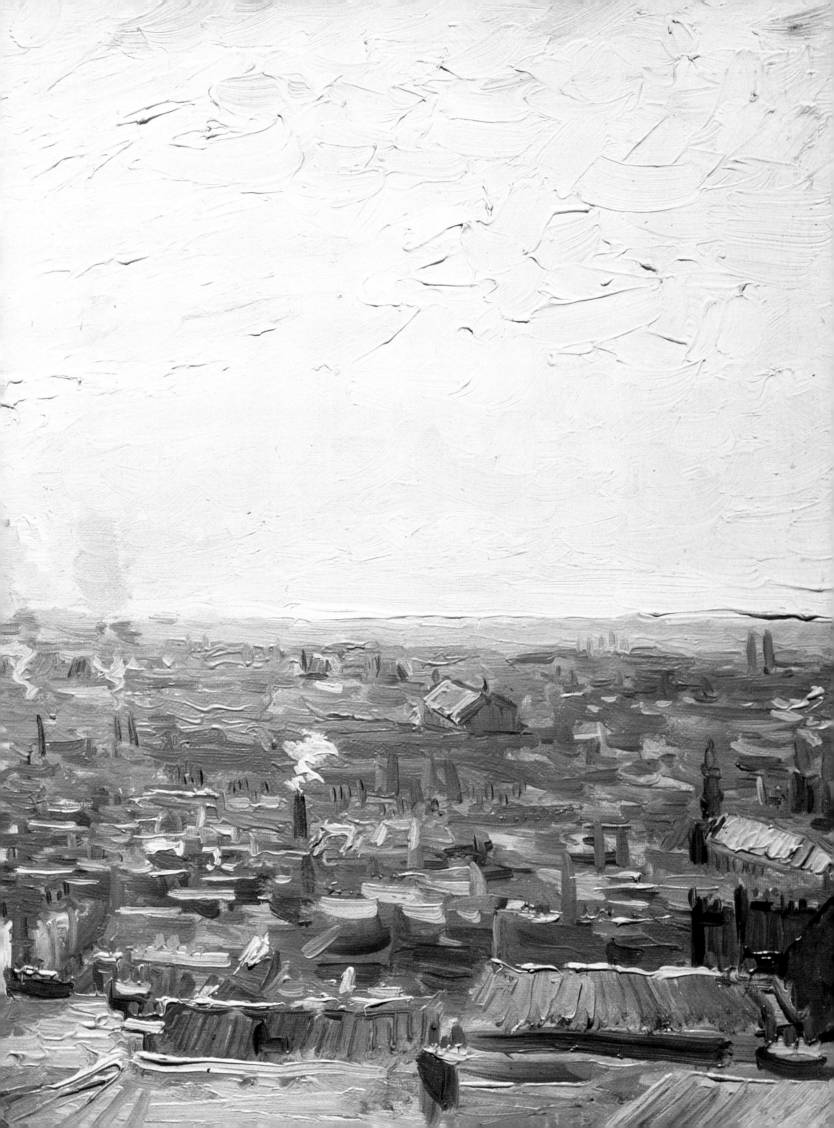

The future critic Gustave Coquiot described the Dutchman as "clad in a workingman's overall and talking vehemently" at the Tambourin cabaret, where discussions were vigorous and there were heated clashes amid the pipe smoke and the noise of glasses; as round succeeded round Vincent's head would start swimming. His relationship with Theo began to suffer, for after a hard day's work, his brother had little patience with his bouts of euphoria and endless diatribes. Things were not helped when the Cormon studio closed briefly and Vincent set up his easel in their small home.

Vincent began with Paris as seen from the apartment, using delicate, light-colored strokes to create the blue-gray sky of the *View of the Roofs of Paris*. He often walked the cobbled streets of the Butte Montmartre and his brush recaptured the browns, dark ochers and bleached out reds of an earlier time in *Le Moulin de la Galette.*

Van Gogh
Le Moulin de la Galette
Autumn 1886
Oil on canvas
38 x 46.5 cm
Berlin, Nationalgalerie

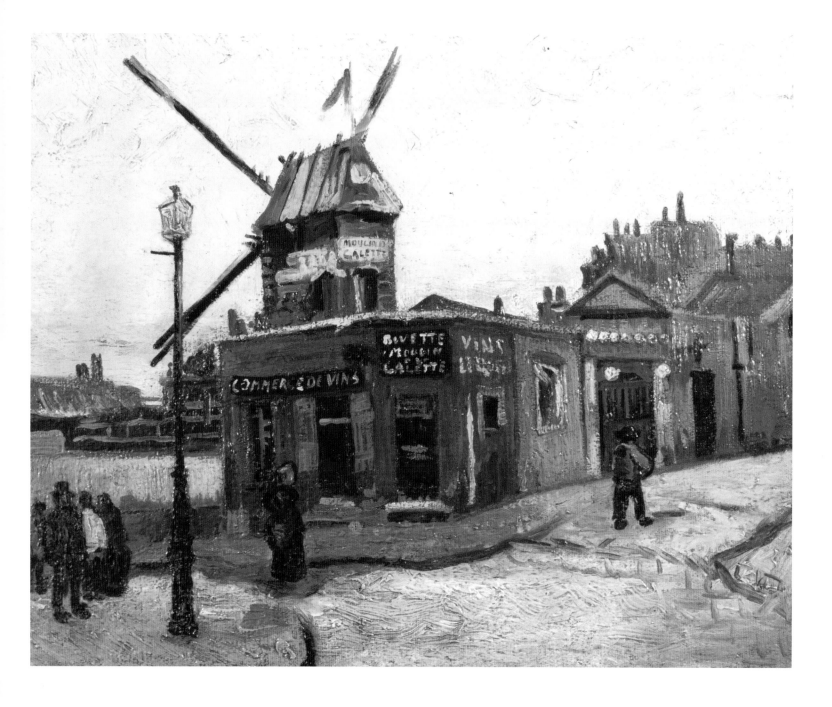

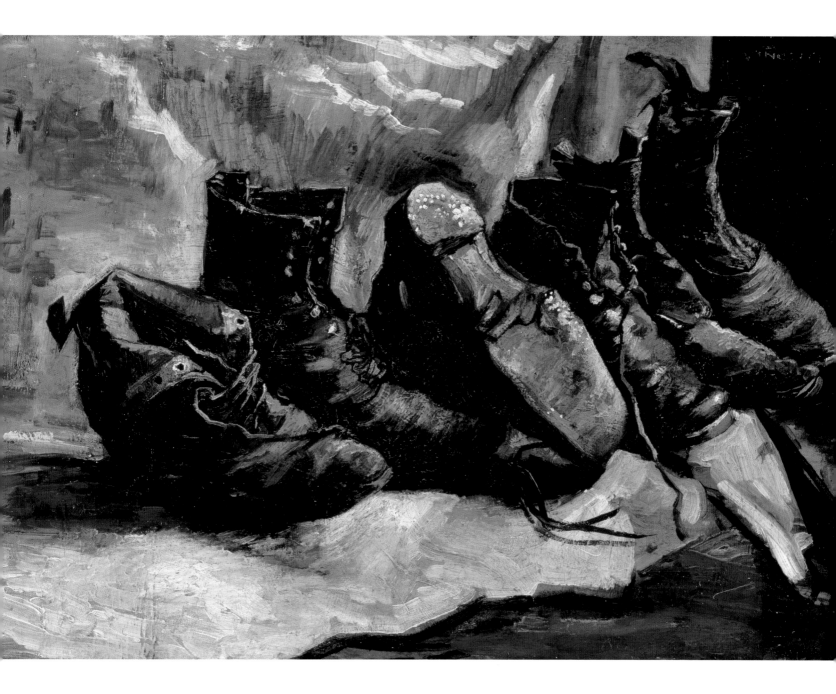

A Pair of Shoes shows his boots worn down, dented and battered by endless walking, and uses an eloquent range of earth colors that takes us back to the earlier wanderings in the Drente. *Montmartre*, with its terrace and its row of gas lamps under a mournful sky, its subtle grays, its reddish-browns and greenish-grays, conveys an overwhelming impression of solitude. On a melancholy winter's night, a solitary wanderer contemplates the life of the city before him.

Working away in his room, Vincent tried moving toward the fluidity of the Impressionists: *Still Life with French Novels and a Rose* and *Still Life with Plaster Statuette, a Rose and Two Novels* testify to his technical and stylistic experiments, while in his flower studies – there are fifty or so dating from this period in Paris – he sought, as he explained to his sister Wil (Wilhelmina), to "get used to using something other than gray: pink, light or pure green, light blue, purple, yellow, orange, a nice red…" Drawing on Renoir, Fantin-Latour and above all Monticelli, he made his

Van Gogh
Three Pairs of Shoes
December 1886
Oil on canvas
49 x 72 cm
Cambridge, Fogg Art Museum

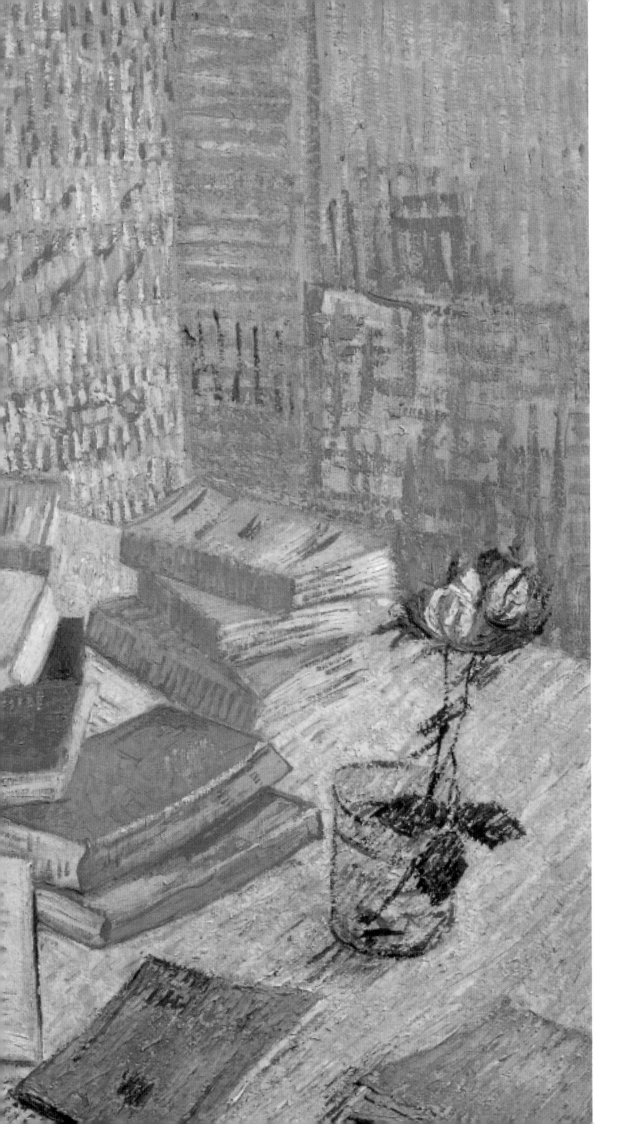

Van Gogh
**Still Life with French Novels
and a Rose**

Autumn 1887
Oil on canvas
73 x 93 cm

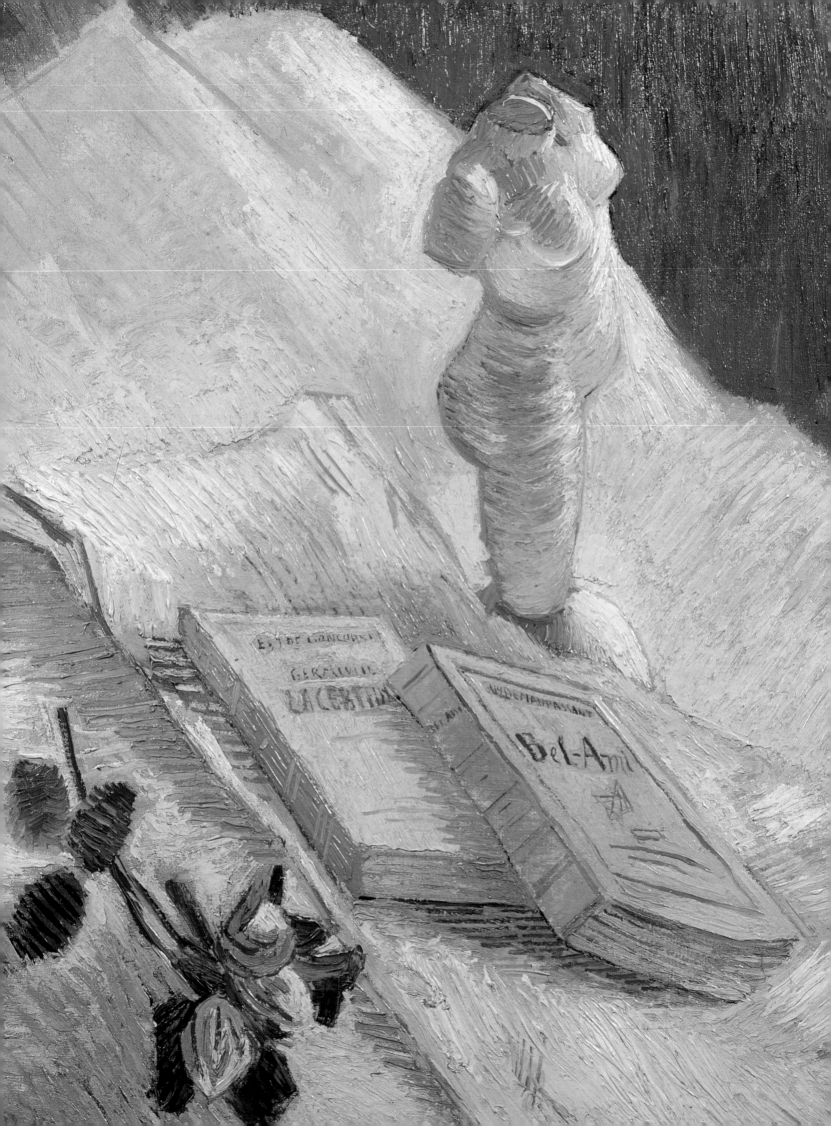

tones sing, playing with their light-colored variations; but as he confided to Theo in the summer of 1888, "Sometimes I regret not having simply stayed with the gray Dutch palette."

Hoping to establish a community based on work and friendship, Vincent several times tried to bring artists he knew together to exhibit in the lobby of the Théâtre Libre or at the Tambourin. It was said Agostina Segatori, the beautiful owner of the Tambourin, was attracted to Vincent, but the artist handled the situation clumsily and nothing permanent came of it.

Vincent had met Gauguin in November 1886 and was bowled over by his self-confidence, skill with people and ability to succeed: Durand-Roel, the Impressionists' dealer, had bought paintings from him that were clearly influenced by the movement. Gauguin had taken part in several Impressionist exhibitions (admittedly without great success), knew Pissarro, had experimented with ceramics, and from July to mid-October had worked at Pont-Aven in Brittany, where he met Laval and Bernard. Finally, having run out of money, he moved to Paris.

That Vincent was impressed by his effrontery, his smooth talk and his pose as an "accursed painter" living a wild life is certain. In 1887, Gauguin took a ship for Panama with Laval, and returning after serious attacks of dysentery and malaria, he sought Vincent out and exchanged paintings with him. Theo put his work on show at the Boussod and Valadon gallery, and a little later, bought three works from him at his lodgings at Schuffenecker the painter's. Vincent was probably with him. The two painters were to see each other again after another stay at Pont-Aven by Gauguin in the spring of 1888.

Vincent also painted one of his few nudes, a heavy-bodied, unattractive woman who seemed crushed by the weight of the sheets around her. At this time, Theo wrote to their sister Lios that "He is making giant strides and beginning to succeed. He's in a better frame of mind than he used to be, too, and people like him…If we can hold on, I think his difficult time will become a thing of the past and things will go well for him."

Van Gogh
Still Life with Plaster Statuette, a Rose and Two Novels
1887
Oil on canvas
55 x 46.5 cm
Otterlo, Rijksmuseum Kröller-Müller

Van Gogh
Italian Woman (Agostina Segatori)
December 1887
Oil on canvas
81 x 60 cm
Paris, Musée d'Orsay

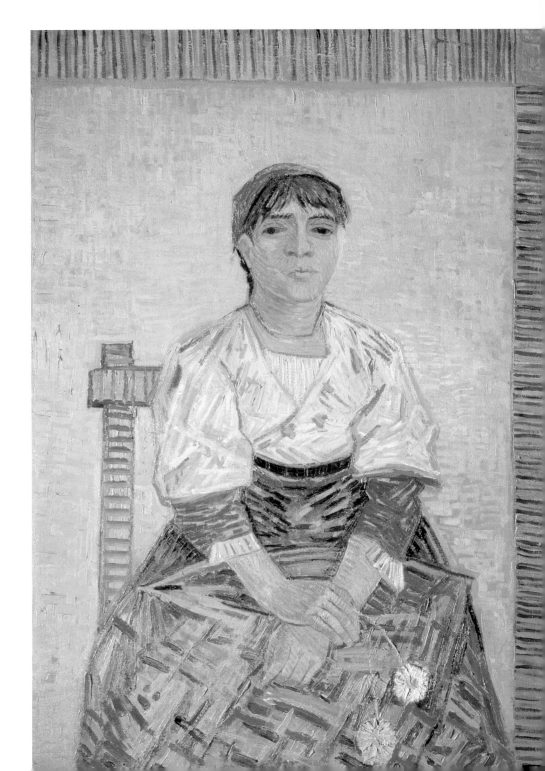

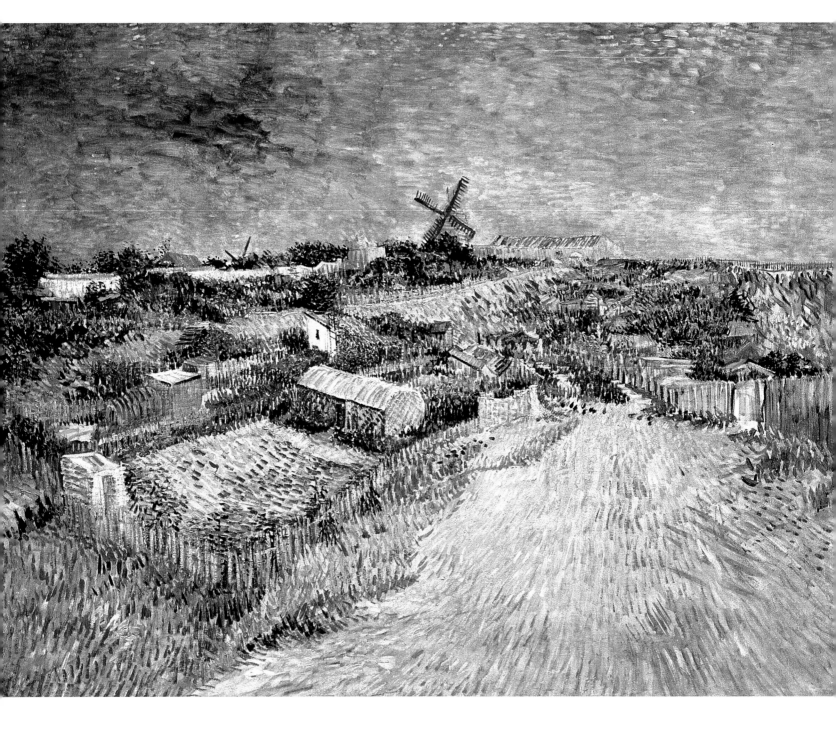

Van Gogh

Vegetable Gardens in Montmartre:

La Butte Montmartre

June-July 1887

Oil on canvas

96 x 120 cm

Amsterdam, Stedelijk Museum

However the success he spoke of was strictly relative. The dealers Tanguy and Portier were showing his paintings and that was all; occasionally a customer would glance at them, shrug and move on. One day a gloomy, difficult-looking man in his forties with a strong southern accent came into Tanguy's store: he too sometimes left canvases that Tanguy stood on the floor with the others. Vincent arrived while he was there. The two looked at each other, at first without speaking, then the visitor introduced himself as Paul Cézanne. "You really paint like a madman!" he said. The madness of painting haunted them both.

Van Gogh
Nude Woman on a Bed
Early 1887
Oil on canvas
59.5 x 73 cm

Merion, The Barnes Foundation

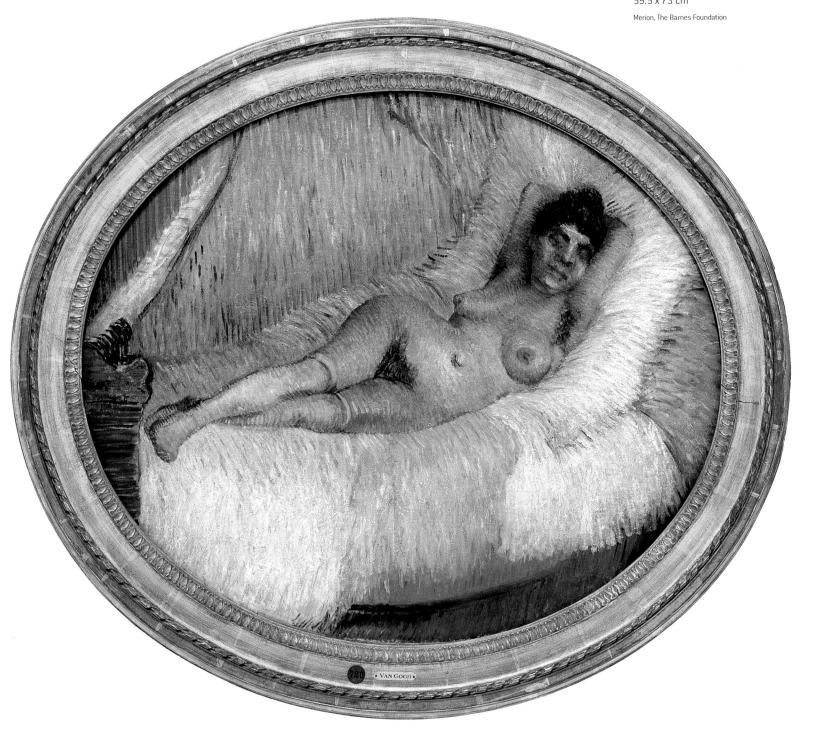

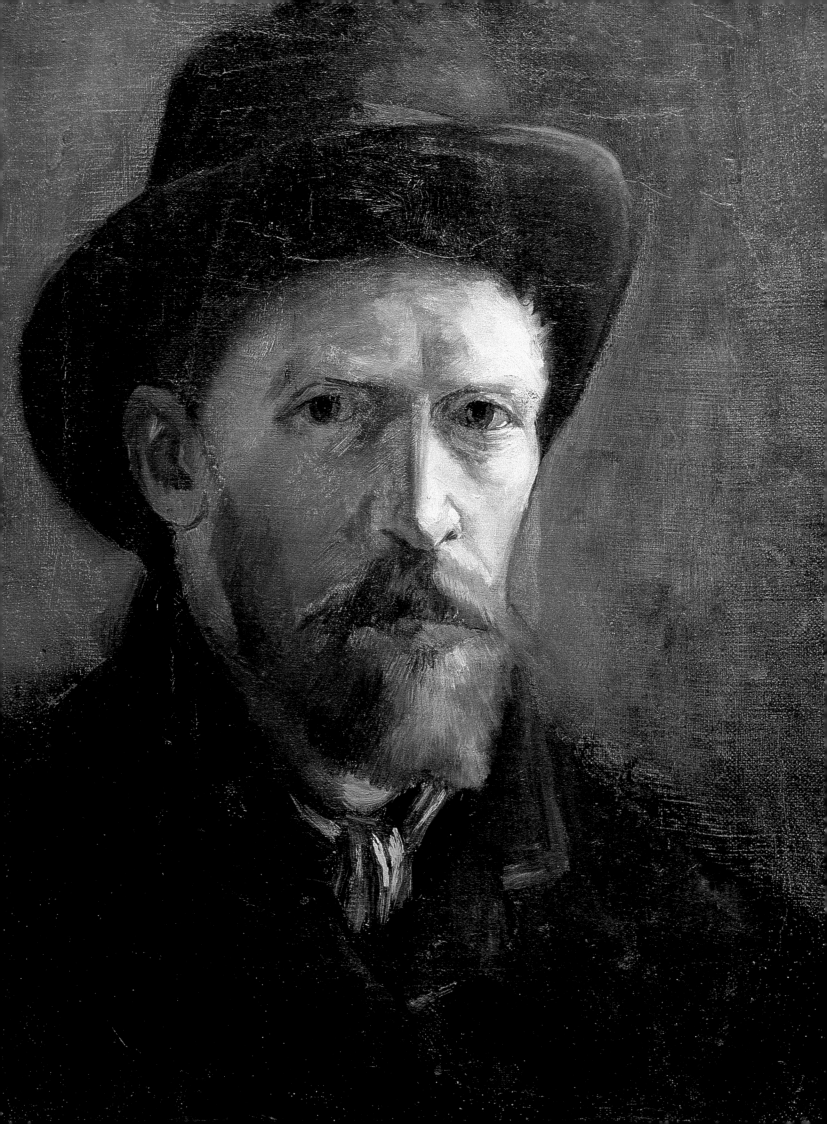

Looking into his own face

With the passing of winter the city became bright and clear again, as if renewed. Signac, who briefly influenced Vincent's work, led him to try his "pointillist" technique in the rural outlying suburbs. "Pressed up against me," Seurat's associate recounts, "he shouted and gesticulated, brandishing his large canvas[1] and spattering paint on himself and the passers-by." On the north slope of the Butte Montmartre, with its hedges, vegetable gardens, huts and mills, Vincent, moved by a rural charm that made him think in mind of Holland, painted *View from the Butte Montmartre*, covering the entire canvas. The visual rhythm is established by the parallel fences of the vegetable gardens, and the colors – blues, greens and yellows – are fresh and spirited.

In the spring of 1887, he went to paint with Émile Bernard, who had set up a studio in a hut at Asnières. Cormon, also working there, relates that Vincent set up his canvas and "divided it into squares according to his subjects; in the evening he would come back with it full, like a little traveling museum with all the emotions of the day inside it."

1 72x92 cm

Van Gogh
Self-Portrait with Dark Felt Hat
Spring 1886
Oil on canvas
41.5 x 32.5 cm

Amsterdam,
Rijksmuseum , Vincent Van Gogh

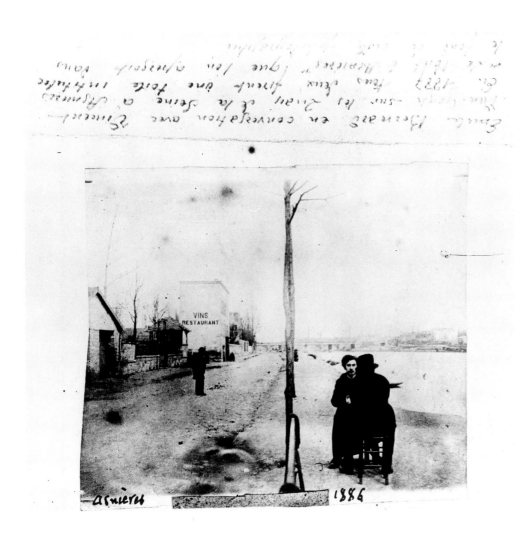

Photograph of Vincent Van Gogh
and Émile Bernard by the Seine
at Asnières, 1886

Amsterdam, Rijksmuseum
Vincent Van Gogh

Van Gogh
Restaurant de la Sirène at Asnières
Summer 1887
Oil on canvas
54.5 x 65.5 cm

Paris, musée d'Orsay

Vincent painted the famously popular *Restaurant de la Sirène at Asnières* in a brightly Impressionist style, while applying the Divisionist technique to *Interior of a Restaurant*, speckled with reds, greens, yellows and mauves. When he saw *Wheat Field with a Lark* years later, Antonin Artaud, who might be described as Vincent's literary double, exclaimed,"An area of wheat in the sunlight, leaning over, and above it a single bird suspended like a comma. What painter other than someone who was a painter and nothing else, would have dared, like Van Gogh, to take on such a disarmingly simple subject!"[1]

1 A. Artaud: *Van Gogh. Le suicidé de la société* (1947), Gallimard, Paris, 1974

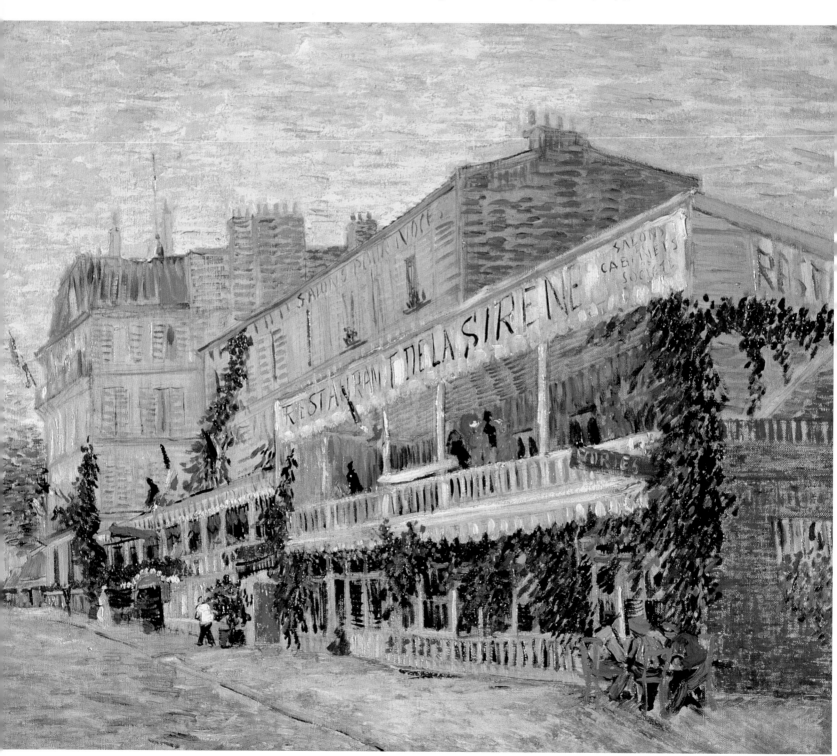

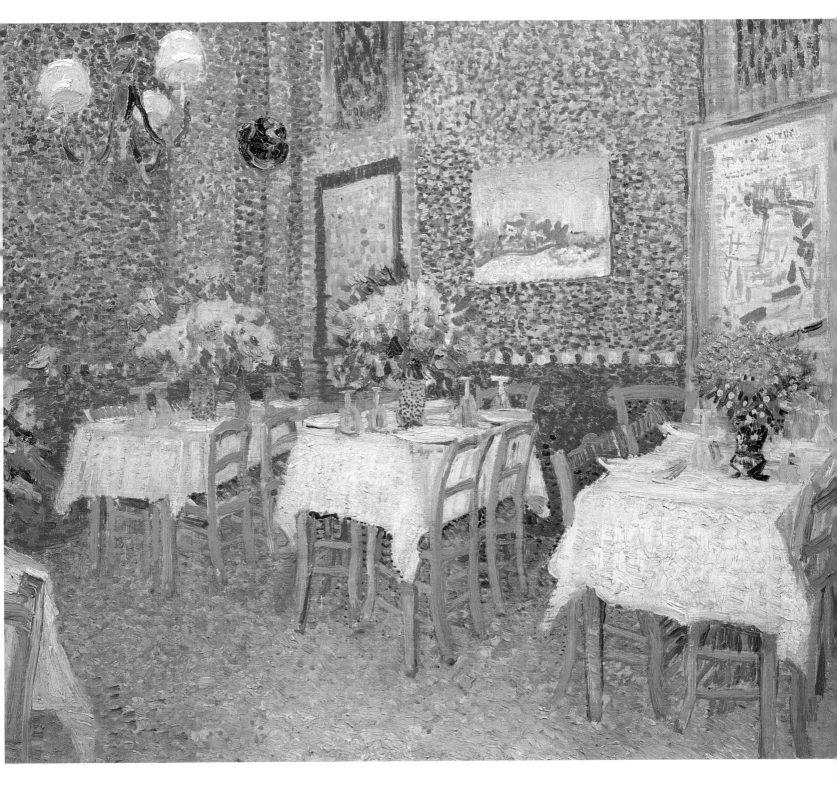

Van Gogh
Interior of a Restaurant
Summer 1887
Oil on canvas
45.5 x 56.5 cm
Otterlo, Rijksmuseum Kröller-Müller

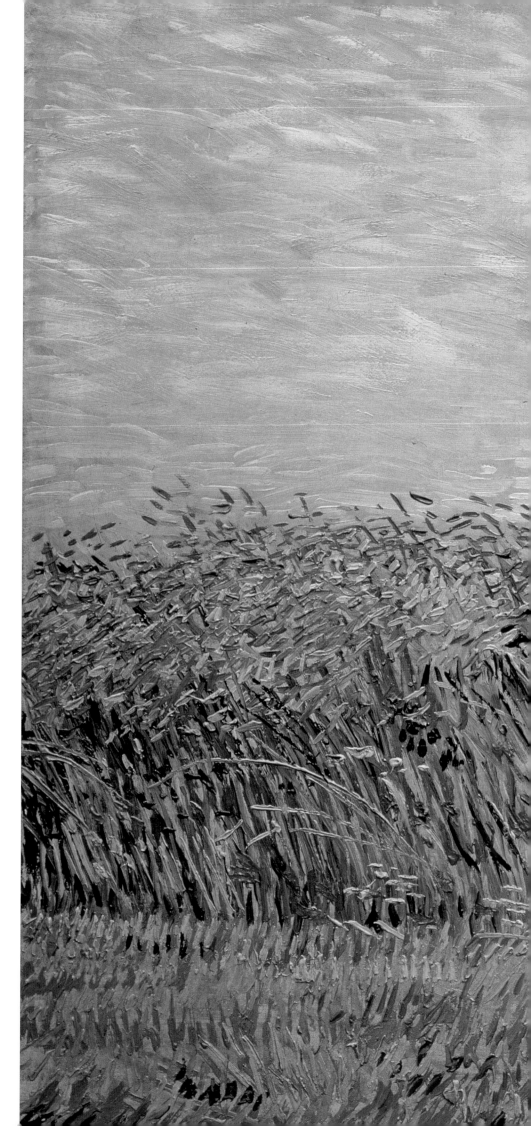

Van Gogh
Wheatfield with a Lark
Summer 1887
Oil on canvas
54 x 65.5 cm

Amsterdam, Rijksmuseum,
Vincent Van Gogh

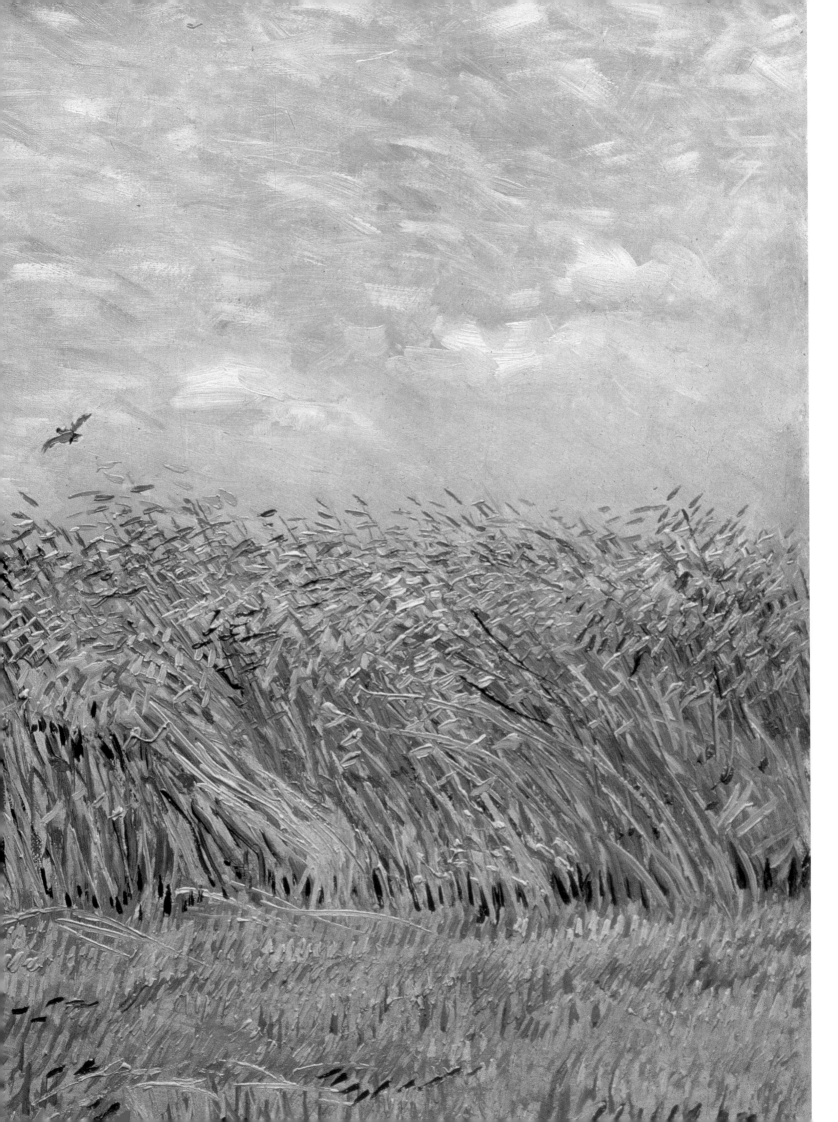

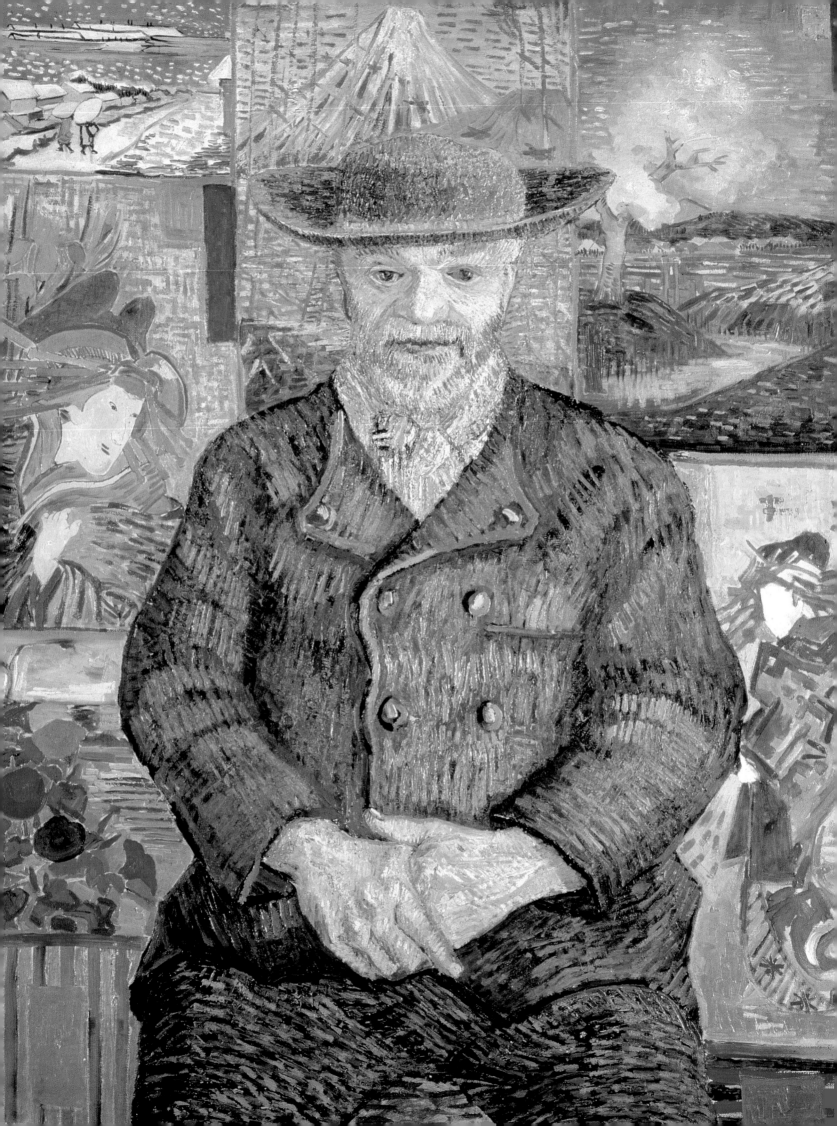

Each canvas, in fact, was an exercise in which Vincent attempted to understand the painting of his time. Divisionism is a constraint in terms of pictorial construction, but once the rhythms were established, he wasted no time in getting the colors moving freely. The influence of Japanese woodcuts was more direct: Vincent made frequent visits to Bing, the Eastern art dealer on the Rue Chauchat and asked to see what was new. When he could afford it, he bought works by Hiroshige, Hokusai and Utamaro, loving their off-center layout, their oblique, high angle points of view, the clearly defined areas of solid color. Jean Leymarie is perfectly right in remarking that Vincent "had drawn from Japanese art…his own "Orient," an example of a technique underpinned by a spiritual and social message.[1] The "true religion"[1] he would preach in Provence was the equivalent of Japan[1].

He chose a background of Japanese woodcuts for his picture of Père Tanguy[2], sitting with joined hands like a benign divinity in a broad-brimmed hat. He made copies in oils of Hiroshige's *Tree* and *Bridge in the Rain*, surrounding both with a frame bearing Japanese characters.

As he could rarely afford a model, portraits were few, apart from those of the young English painter Alexander Reid, a fellow-student at

1 J. Leymarie: *Van Gogh*, Geneva 1989
2 Musée Rodin. Paris. Another version is held in an American collection and a third, a half-figure portrait without the background woodcuts, is in the Copenhagen Glyptothek.

Van Gogh
Père Tanguy
Autumn 1887
Oil on canvas
92 x 75 cm

Paris, musée Rodin

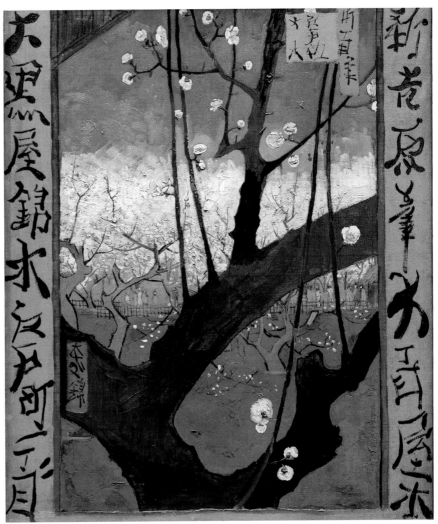

Van Gogh
Flowering Plum Tree
September/October 1887
Oil on canvas
55 x 46 cm
Amsterdam, Rijksmuseum
Vincent Van Gogh

Cormon's studio, of Père Tanguy and those thought to be of La Segatori. However the period yielded more than twenty painted or drawn self-portraits, for Vincent had begun a series of studies of his own face: its varying expressions according to his feelings, in frontal or three-quarter view, and with or without a hat. His gaze is keen if sometimes equivocal, and disturbingly direct; each of these masks is simultaneously a psychological document, an experiment in technique and a search for a style in which Vincent sums up his pictorial concerns of the moment.

The most moving of them is *Self-Portrait at the Easel*, dating from January 1888. Perhaps drawing on a similar work by Cézanne, Vincent uses a pale background to set off the powerful colors of the head with its reddish hair and green eyes, the blue tunic and the yellow easel. He makes use here of the Divisionist technique, distributing the light in a way that stresses the dual character of the face: restfully light on one side, dramatically shaded on the other.

Curiously, there are no portraits of Theo. Was it in fact this other self that he was seeking in his own features? At this time Theo was trying to put an end to a love affair and Vincent pushed his sense of identification to the point of offering to take his place: to become the lover of the mysterious "S" or marry her. Theo was touched, but could hardly accept such a crazy proposition. Sometimes this brother, irritable, hypersensitive and too concerned with his needs, frightened him; but they were tied by an unspoken pact, a disturbing symbiosis.

At the same time, in spite of the mounting difficulty of their life together and the disparity between their personalities, Theo had faith in Vincent, confiding to his sister Wil on April 25, 1887, that "I think things can be better between us. I'll certainly do my part…"

Yet whether he wished it or not, he was "on the other side of the barricades".

In his painting Vincent was seeking to make himself understood, to explain – if not justify – the painful sequence of his bouts of serenity, exaltation and doubt. The canvas was not just a mirror, it was a tool for self-analysis as well: with each self-interrogation he put his experience of life to the test.

Photograph
of Theo Van Gogh in 1888

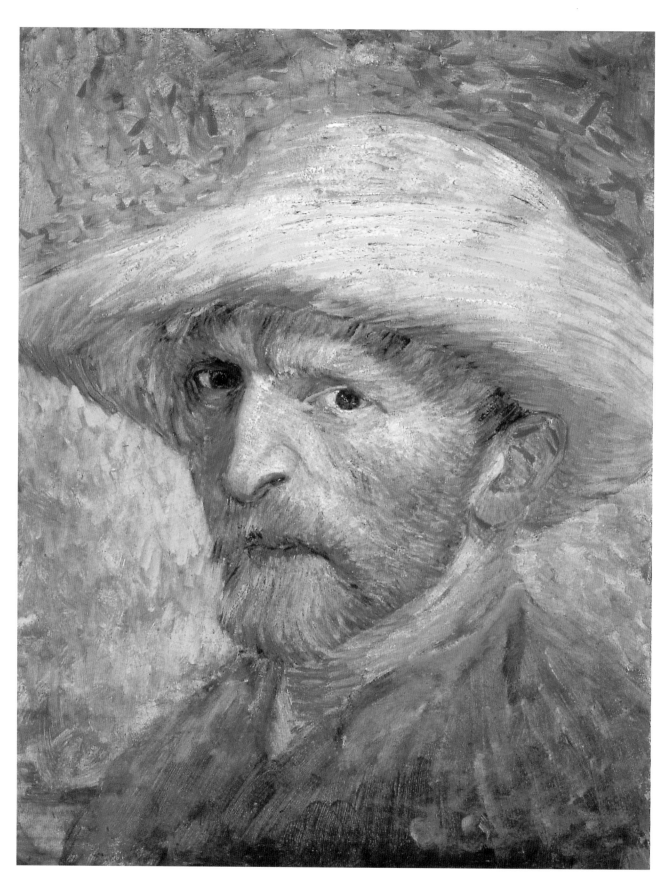

Van Gogh
Self-Portrait with Straw Hat
Summer 1887
Oil on panel
35.5 x 27 cm

Detroit, The Institute of Arts

Van Gogh
Self-Portrait
Autumn 1887
Oil on canvas
47 x 35 cm
Paris, Musée d'Orsay

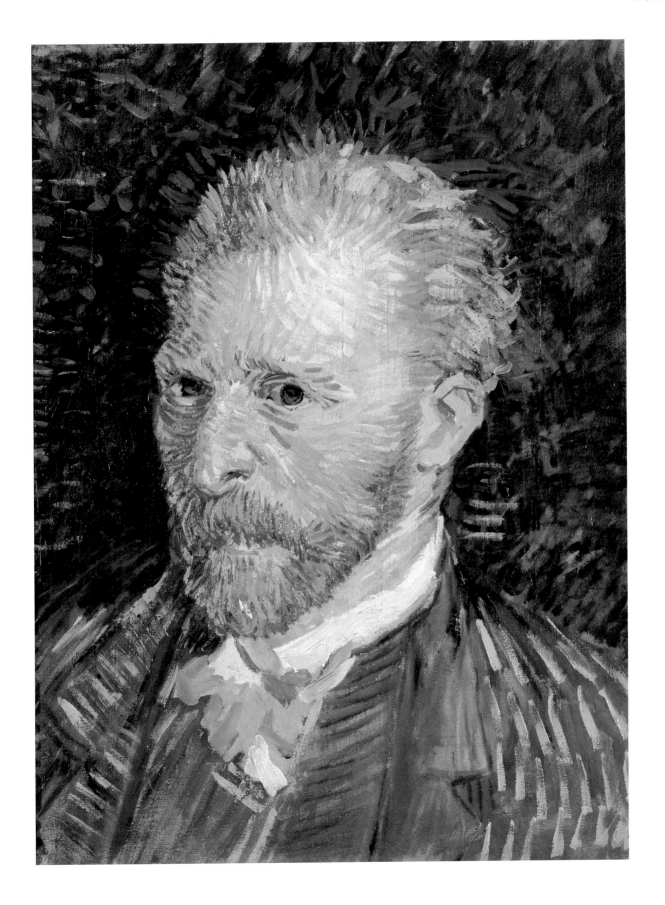

Van Gogh

Self-Portrait at the Easel

Early 1888

Oil on canvas

65.5 x 50.5 cm

Amsterdam Rijksmuseum
Vincent Van Gogh

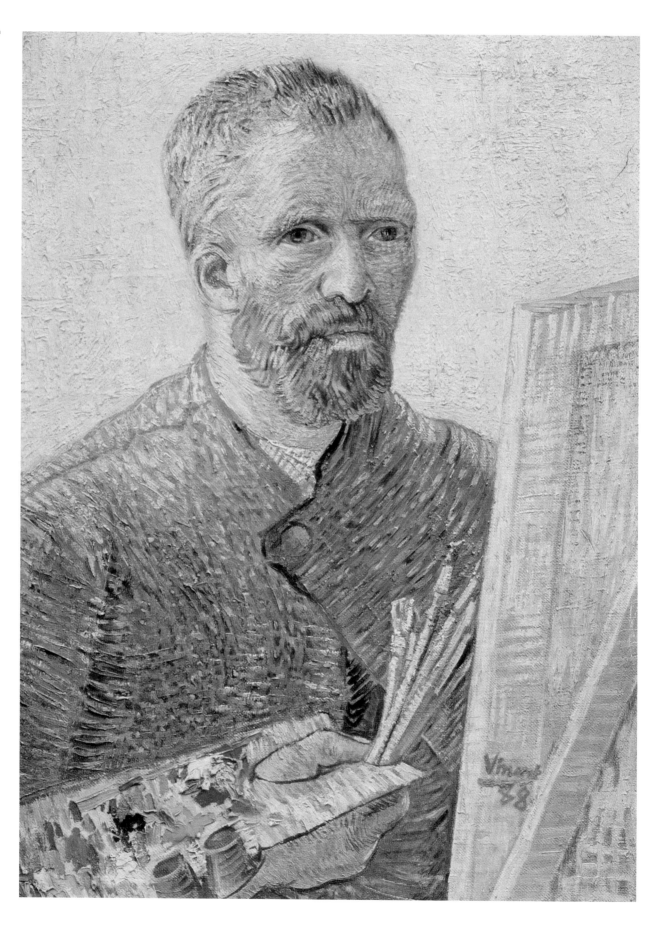

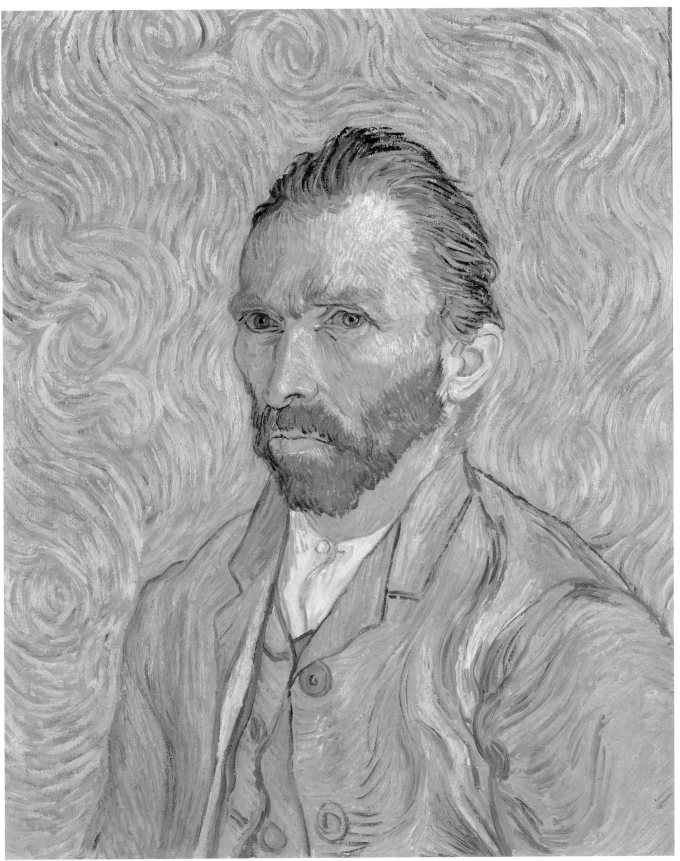

Van Gogh
Self-Portrait
September 1889
Oil on canvas
65 x 54 cm

Paris, Musée d'Orsay

Van Gogh
Fritillaries in a Copper Vase
April-May 1887
Oil on canvas
73.5 x 60.5 cm
Paris, musée d'Orsay

Van Gogh
Still Life with Pears
Autumn 1887
Oil on canvas
46 x 59.5 cm
Dresden, Staaliche Germälde Galerie

It must have been so agreeable when things were going well, when the weather was fine and the air clear, to go out to the suburbs with his equipment on his back and set up on the banks of the Seine, alone or with a friend. And then returning in the evening with the other workers, and stopping off at a bar or two.

The places and figures he painted were those favored by Pissarro, Guillaumin, Angrand, Seurat and Maximilien Luce: the banks of the Seine, the bridge at Asnières, the fishermen from Paris, the factories, and on the horizon the fields or vacant land dotted with shacks. The things he chose to paint – fruit and flowers – came from Cézanne and Renoir. The Dutch influences were done with, for Vincent had joined the new family of modern Paris painters; like them he was much taken with the Impressionist attachment to the open air, and like them he worked at color and light with separate brushstrokes, catching tone with arabesques in the manner of Lautrec and Anquetin.

His Paris period, then, was one of "episodes", of borrowings, experiments, glancing contacts he hardly exploited or stored away. But

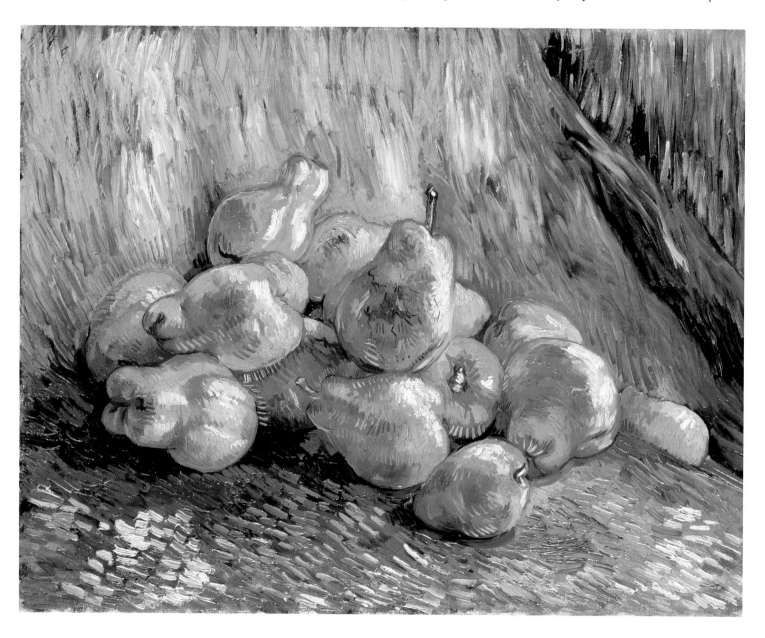

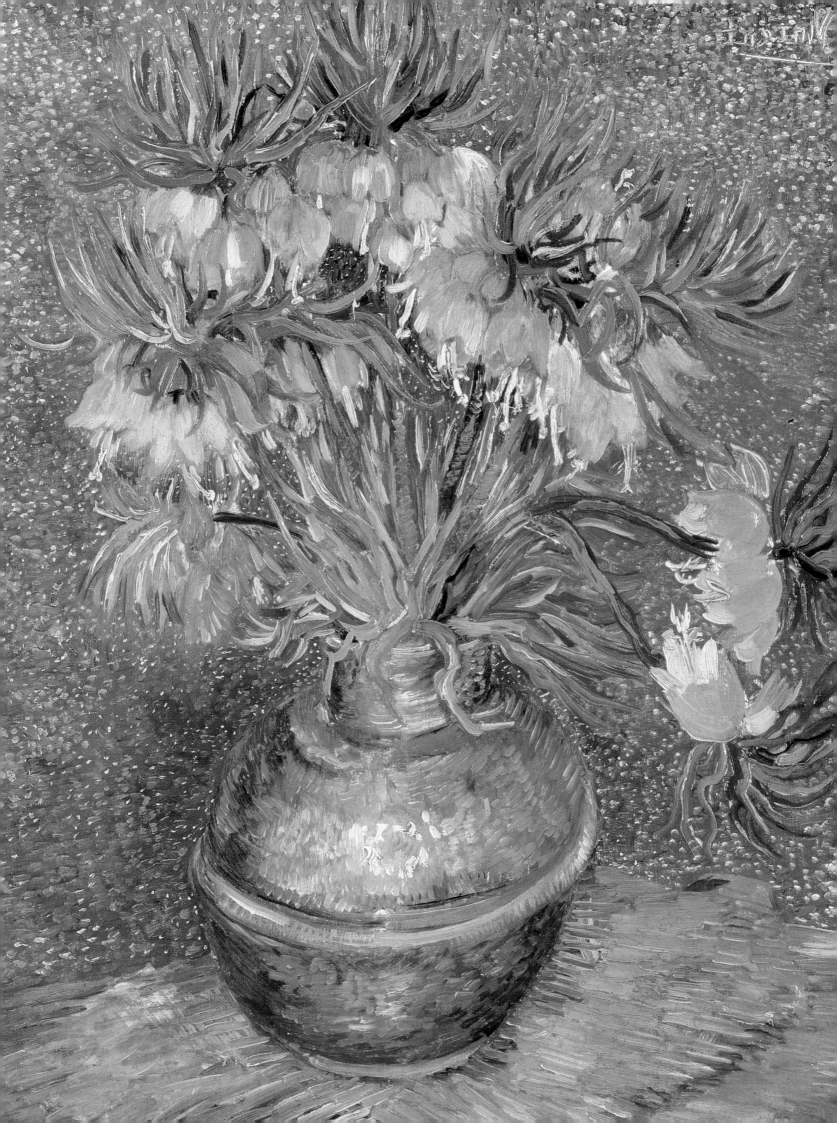

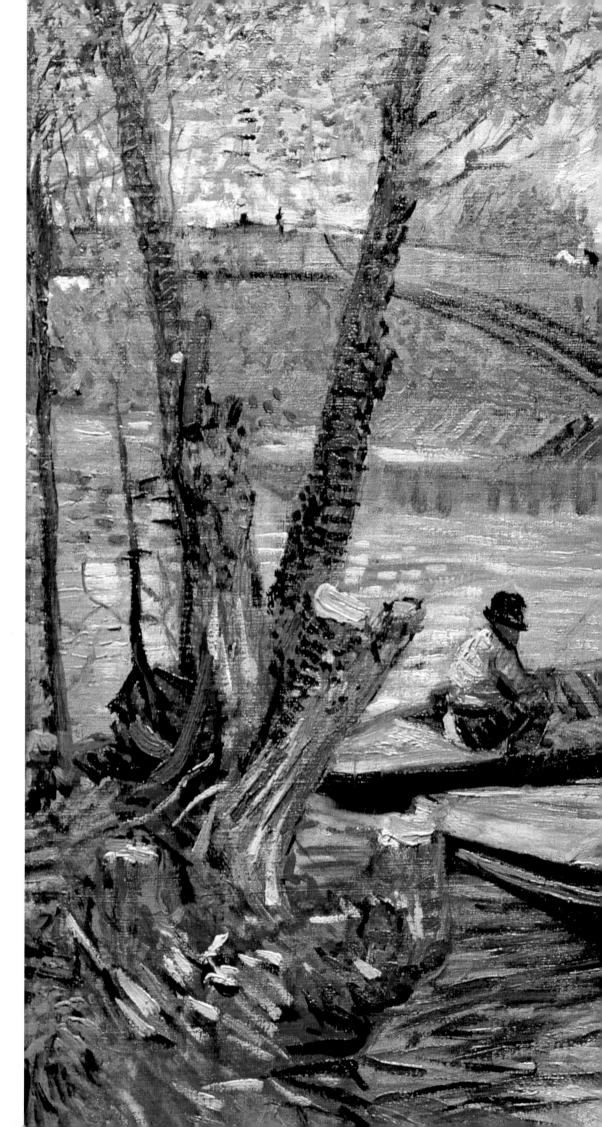

Van Gogh
Fishing in Spring,
The Pont de Clichy
(Asnières)
Spring 1887
Oil on canvas
49 x 58 cm
Chicago, The Art Institute

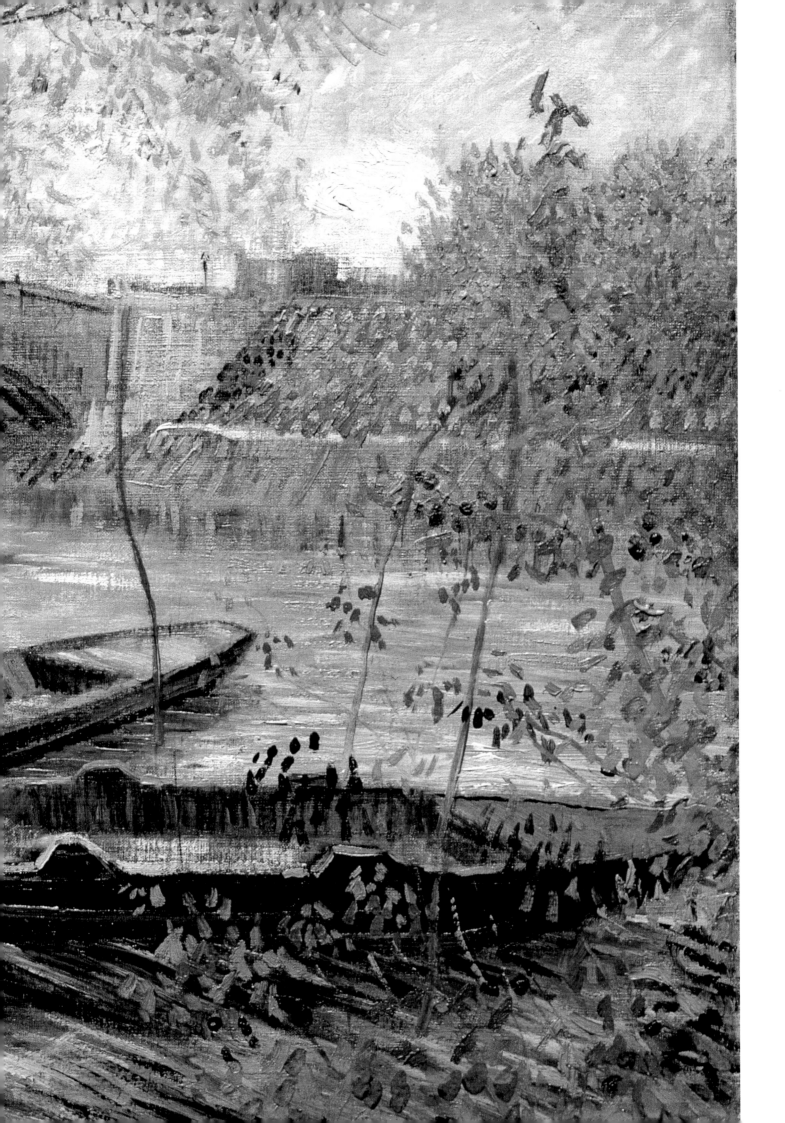

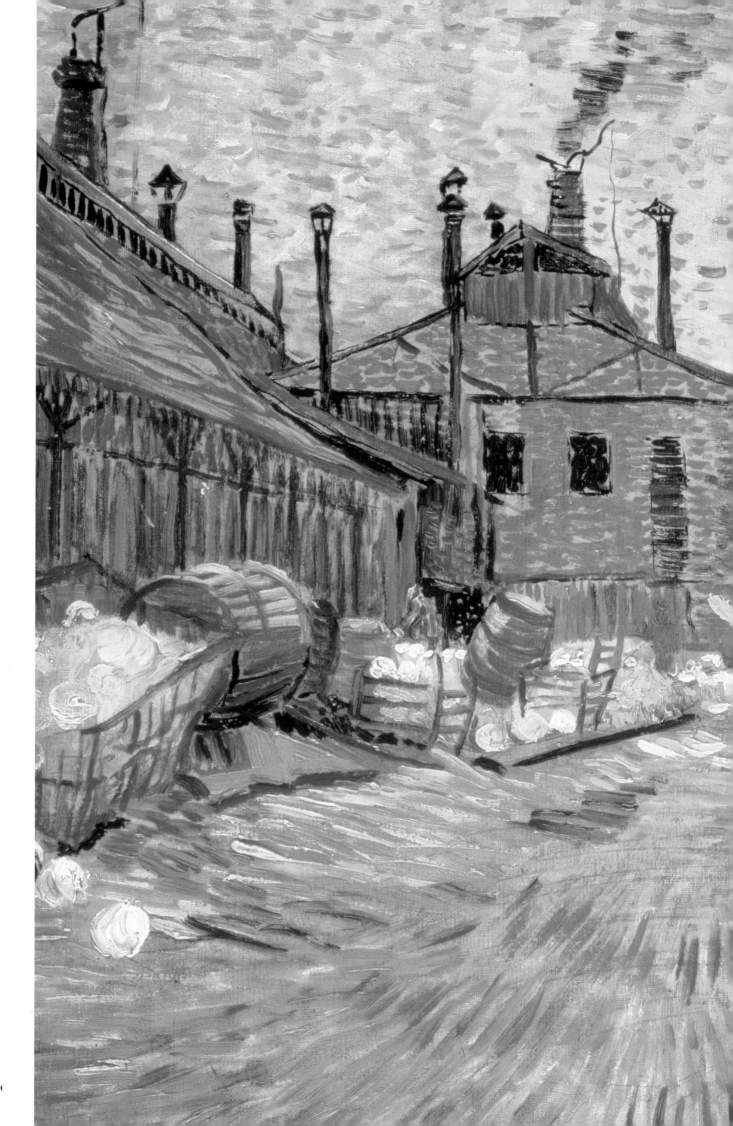

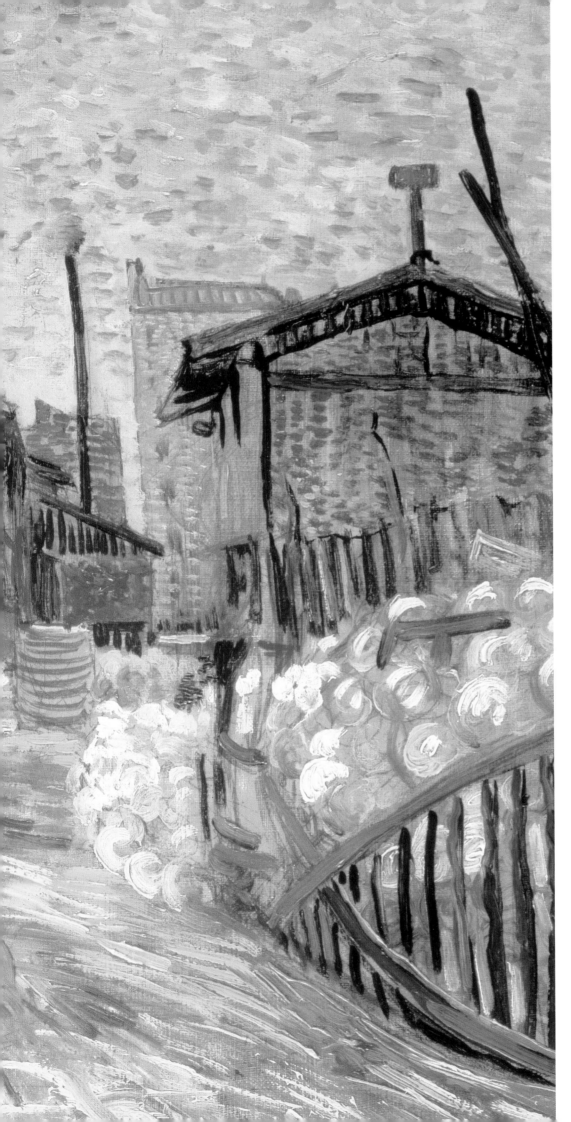

Van Gogh
The Factory at Asnières
Summer 1887
Oil on canvas
46.5 x 54 cm

Merion, The Barnes Foundation

Van Gogh
The Fourteenth of July Celebration in Paris
Summer 1886
Oil on canvas
44 x 39 cm
Winterthur, Sammlung Villa Flora

the period to come would be much less tranquil and relaxed, much less marked by such transitory pleasures: looking at the self-portraits we see a gaze full of the anguish and doubt of the future, the exasperation and violence, the mental problems, isolation, confrontations with others, poverty – and the "betrayal" by Theo.

The explosion came on the French national holiday, July 14, 1887, with its noisy crowds, children startling strollers with firecrackers, girls squealing, shouts and laughter. More violently than ever before, his brush swept the canvas with blood red, with blues and whites thrown onto the surface then crushed, impasted, kneaded in a kind of orgy of colors erupting directly from the tube in anticipation of the Fauves. *The Fourteenth of July Celebration in Paris* reveals a Vincent delirious, raging, at the end of his tether; but the next day the lanterns have gone out, the flags have disappeared, the crowd, once again mournful and resigned, is back at work – and he has returned to his solitude.

He was still taken with the idea of getting his painter friends together for a group exhibition. To counter the Impressionists, who had shown in the galleries on the "grand boulevards" – among them the one where Theo worked – or not far away, he got together with Bernard, Anquetin, Lautrec, Seurat, and Signac to form the "Petit-Boulevard Painters" Group, named after the working-class Boulevard de Clichy. But the message from the restaurants and cafés he approached was unequivocal: none of that rubbish on our walls!

La Segatori, though, said yes. True, the Tambourin, where her generous hips and multicolored finery had taken Vincent's eye, was something of a dive, but the Italian lady – herself a former artist's model – had chutzpah and imagination: she let her lover cover the walls with Japanese woodcuts and the works of the Montmartre artists and poets who were his friends. Vincent held forth triumphantly, deliberately annoying the customers: one evening Gustave Coquiot left rather than watch one of the ensuing confrontations, with "Vincent literally assaulting the other with his opinions".

It hardly needs to be said that the exhibition was a flop. As Vincent relapsed into weariness and dejection, his friends abandoned him. Suzanne Valadon, a former acrobat turned artist's model, recounts that "In he came with a heavy canvas under his arm, put it down in a corner where it would catch the light and waited for someone to take notice. No one did. He would sit down for a moment and follow people's gazes without saying much. Then pick up his latest work and leave."

As a gallery manager and art dealer himself, Theo had not really appreciated Vincent's putting on a show at the Tambourin; and it may have been at this time that he was suffering the first symptoms of the paralysis that was to kill him shortly after his brother's death. Vincent and his group put together another exhibition at the Bouillon du Chalet, a workers' restaurant at 43 Boulevard de Clichy, but it fared no better than the first.

What Vincent could not understand was why Theo was showing and selling canvases by Gauguin – he had paid nine hundred francs for

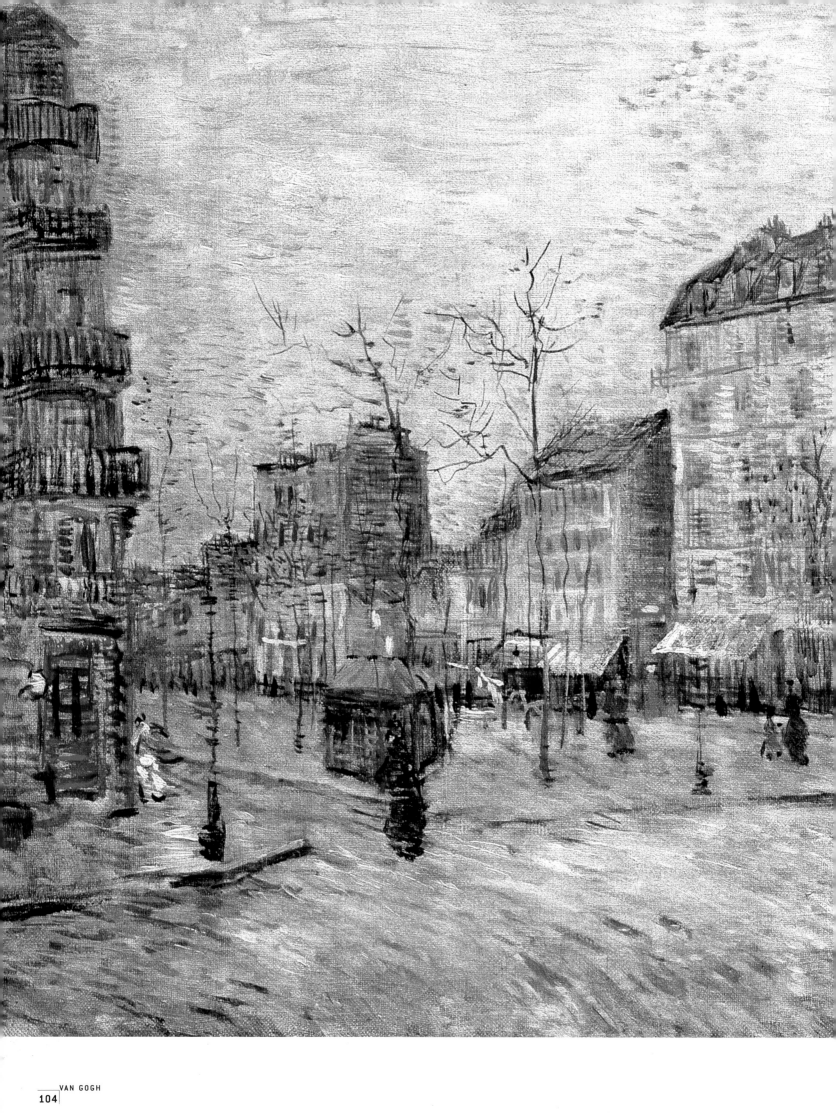

the three works bought from Schuffenecker, and soon afterward put another, *Two Bathers*, on show – while doing nothing for his brother. The relationship became increasingly stormy, but almost despite themselves, a near-pathological attachment remained. Each, however, finally came round to the idea that putting some distance between them would avoid a complete break.

For some time, Vincent, acutely sensitive to the gray cold of Paris, had been thinking of leaving for the Midi – the south of France –"a country full of blues and joyful colors." During the fall of 1887, he wrote to his sister Wilhelmina that "Without Theo I could not get what I want just by working…My plan is, as soon as I can, to go spend some time in the south, where there are more colors, and more sun."

One evening in February 1888, he told Émile Bernard, "I'm leaving tomorrow; we'll organize things at the studio so my brother will think I'm still here." He tacked Japanese prints on the walls of the little apartment on the Rue Lepic, set canvases on the easels and entrusted to his friend a bundle of Chinese paintings picked up from a secondhand dealer. Bernard was worried by this hasty departure; the Australian painter John Peter Russell had spoken to Vincent of Arles, where a friend of his lived, and Vincent liked the idea: the little town was close to Marseille, home of the Monticelli he so much admired. Bernard and Vincent walked down the Avenue de Clichy together, full of the sadness of Paris in winter.

On the morning of February 21, Vincent, who had taken the train the previous evening, arrived to find Arles under snow. He wrote to his brother, "I have seen splendid red vineyards set against mountains of the purest lilac. And the snowy landscapes, with the white peaks rising before a sky as luminous as the snow itself, were just like those winter landscapes made by the Japanese."

Van Gogh
Boulevard de Clichy
February-March 1887
Oil on canvas
45.5 x 55 cm

Amsterdam, Rijksmuseum,
Vincent Van Gogh

4 Dazzled by Provence

Discovering the Midi

Vincent took a room in the Hotel-Restaurant Carrel, 30 Rue de la Cavalerie. He was fatigued; his features were drawn, his back bent, and people watched curiously as the "foreigner" with the fixed gaze strode by with his painting gear on his shoulder. He had over-indulged in absinthe too – he described himself as a "near-alcoholic" – and had suffered too much from the indifference and scorn of others. And he missed Theo.

As time went by, the sky cleared, the almond trees blossomed; but from the very first day in this unknown town –"no bigger than Mons or Breda," with its Roman ruins and the medieval doorway of the church of St. Trophimus that he found "as monstrous as a Chinese nightmare" – he had been tramping across its countryside.

His dream was to set up a workshop there, a sort of community of painters like himself, as lonely and ill-treated as the "poor carriage horses in Paris". He wrote to Theo that he wanted a"shared life" with Laval, Bernard and Gauguin, to whom he had suggested forming a kind of association to sell their works. Theo would be, he went on, "one of the first dealer-apostles" – hardly, one imagines, a pleasing prospect for a well-paid painting salesman with the full confidence of his employers. And then Gauguin was in no hurry to get involved, either.

In April, Vincent painted *Orchard in Blossom,* a hymn to light and spring renewal and *Pink Peach Tree in Bloom (Reminiscence of Mauve),* for he had just learned of Mauve's death. "Something I can't describe grabbed me and choked me with emotion," he wrote at once to Theo. He was doing lots of drawings, using short, serried, stick-like strokes and included some of his sketches with the letters. At the same time he had a dozen canvases in progress, as his technique gradually moved away from Impressionism towards "the kind of colors you find in stained glass windows and a firm drawing style". And still his dream lived on: "Artists in love with sun and color could really do themselves a favor by moving to the Midi."

It was at this time that his work took a dramatically personal turn and shed its derivative aspects. "You have

Van Gogh
Orchard in Blossom with View of Arles
April 1889
Oil on canvas
72 x 92 cm
Munich Neue Pinakothek

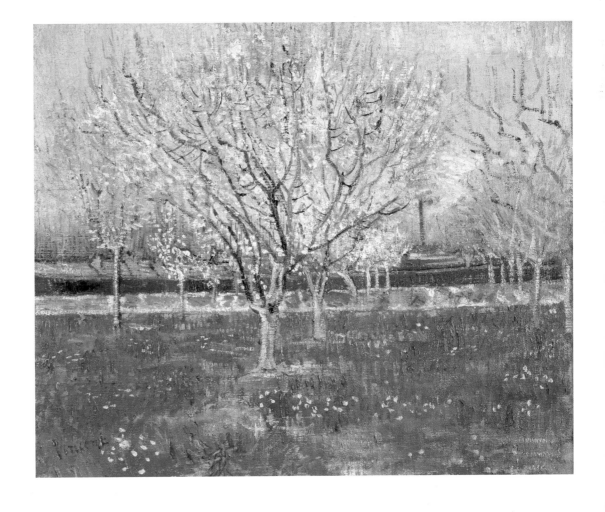

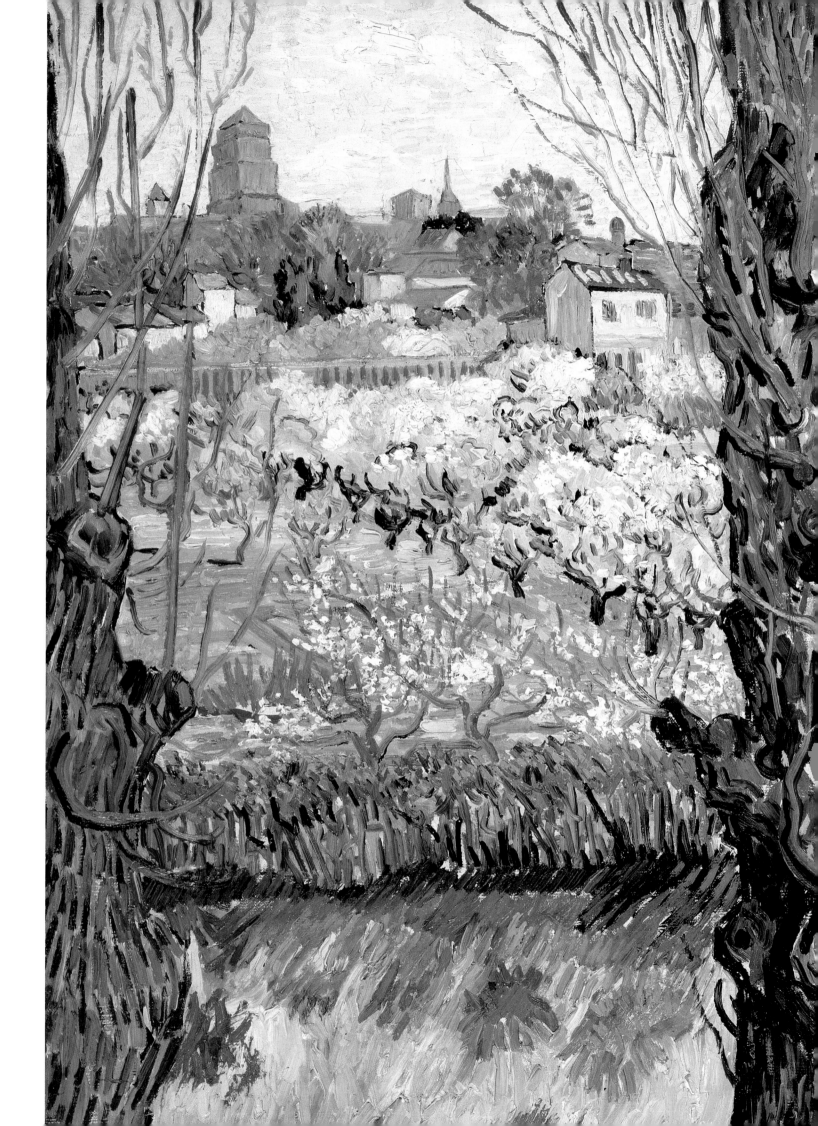

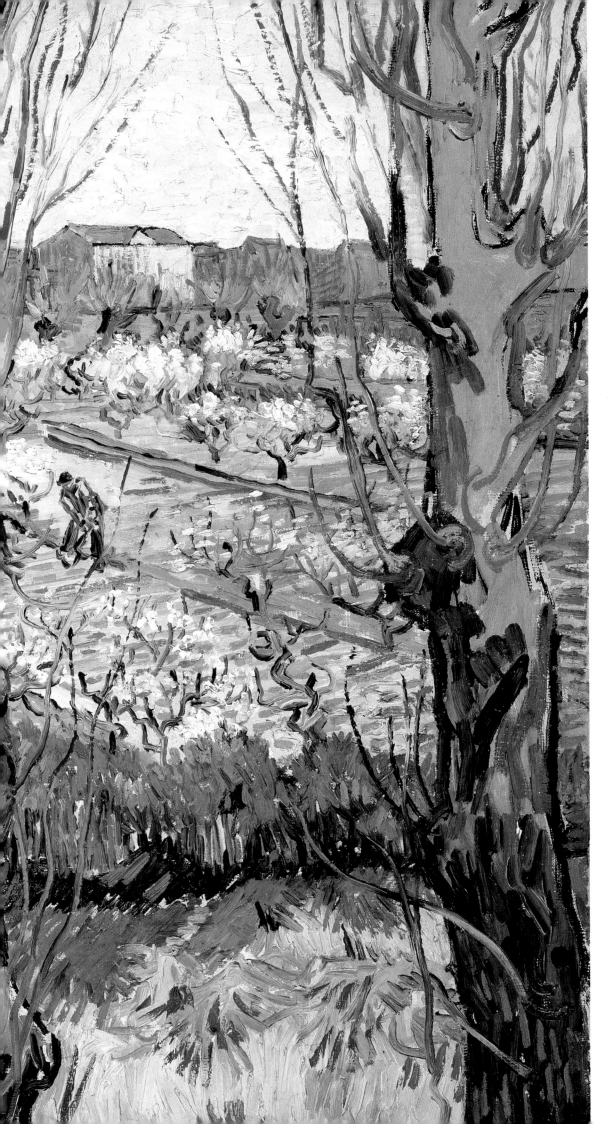

Van Gogh
Orchard in Blossom (Plum Trees)
April 1888
Oil on canvas
55 x 65 cm

Edinburgh, National Gallery of Scotland

to understand," he wrote to Wilhelmina, "that you can't get nature in this southern countryside right by using, for example, the palette of someone like Mauve, from the north. My palette now is absolute color: sky blue, light green, clear wine-red, violet…"

He drew and painted *The Langlois Bridge*, a curious sort of drawbridge over the Arles Canal at Bouc; the *Avenue of Plane Trees Near Arles Station*, in which the trunks of the enormous, still leafless trees stand out against the railway viaduct; and the *View of Arles with Irises in the Foreground*, whose flowers announce the imminence of summer. Working from the same spot with reed pen and India ink, he produced a drawing of Arles as a silhouette dominated by its steeples and towers and standing against the sky behind a partial screen of trees. "The town," he wrote to Émile Bernard, "is surrounded by immense meadows covered with thousands of buttercups, a veritable sea of yellow. The meadows are broken in the foreground by a ditch full of purple irises – what a subject! A yellow

Van Gogh
Blossoming Pear Tree
April 1888
Oil on canvas
73 x 46 cm

Amsterdam, Rijksmuseum,
Vincent Van Gogh

Van Gogh
The Harvest
1888/1889
drawing
51.5 x 24 cm

Van Gogh
**The Langlois Bridge
at Arles with
Women Washing**
March 1888
Oil on canvas
54 x 65 cm
Otterlo, Rijksmuseum Kröller-Müller

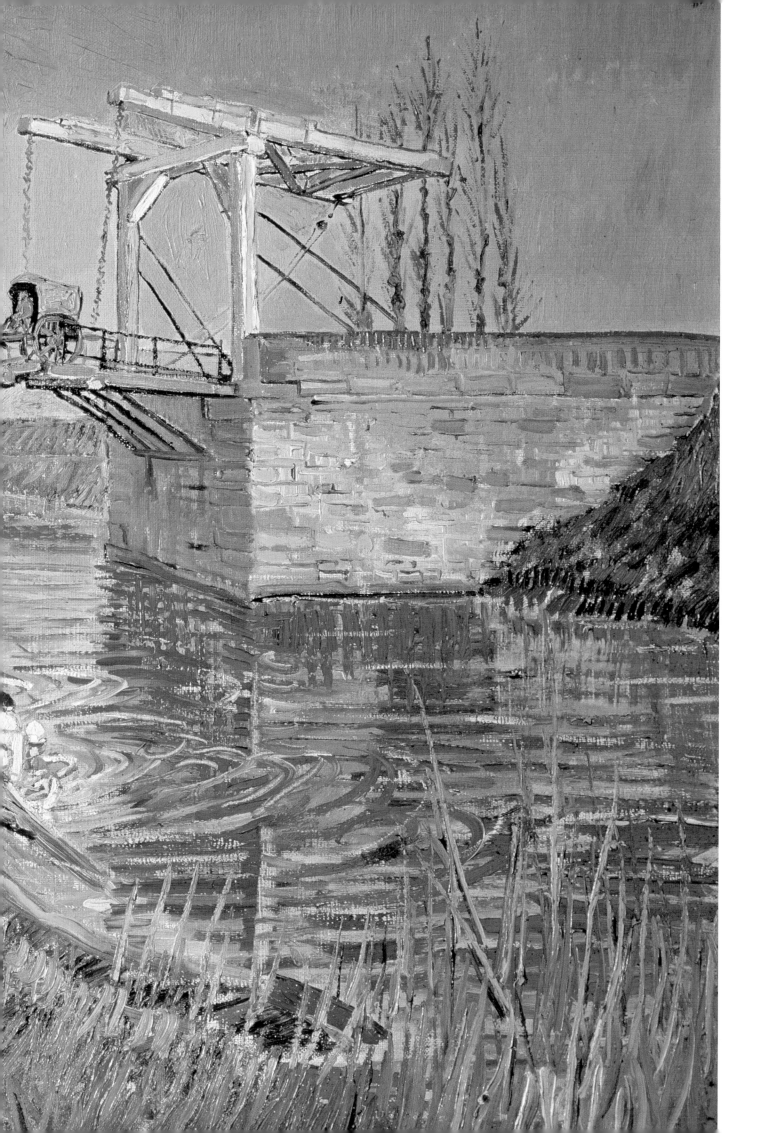

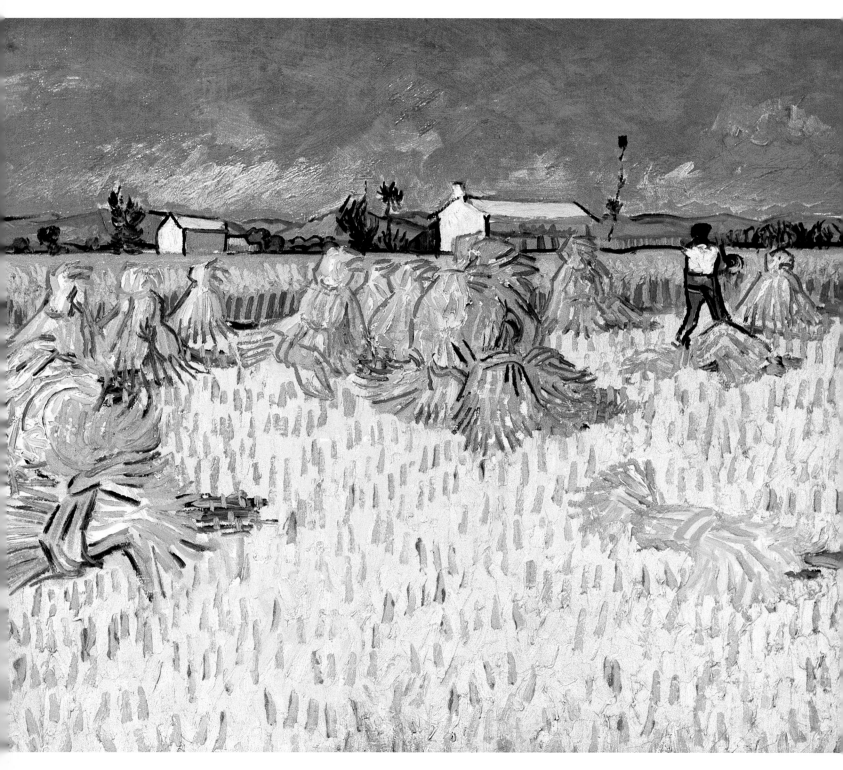

Van Gogh
Harvest in Provence
June 1888
Oil on canvas
50 x 60 cm

Jerusalem, The Israel Museum

sea with a strip of purple irises and in the background the trim little village with all its pretty women."

Early in May he rented for fifteen francs a month the small, empty Yellow House, as he called it, on the Place Lamartine, between the ramparts and the Tarascon road: "The studio is too exposed for any woman to be tempted into it and you could hardly bring any skirtlifting to a successful conclusion." But Vincent was already a regular visitor to the ladies who kept open house along the banks of the Rhône.

The summer moved on apace: "Everywhere you look there's old gold, bronze and copper." This was the gold that fires *Haystacks in Provence* and the splendid panorama of *Market Gardens at La Crau*, which Vincent also called *Harvest at La Crau*. He spent the period from June 10-20 at Saintes-Maries-de-la-Mer, convinced that he was "outraging color

Van Gogh
Wheat Field
June 1888
Oil on canvas
50 x 61 cm

Amsterdam, Rijksmuseum,
Foundation P.N. de Boer

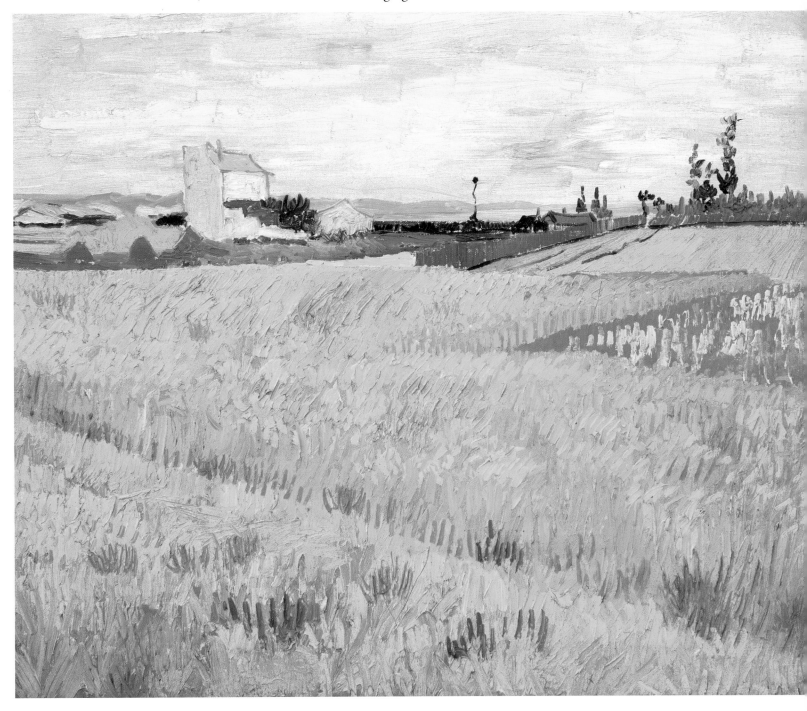

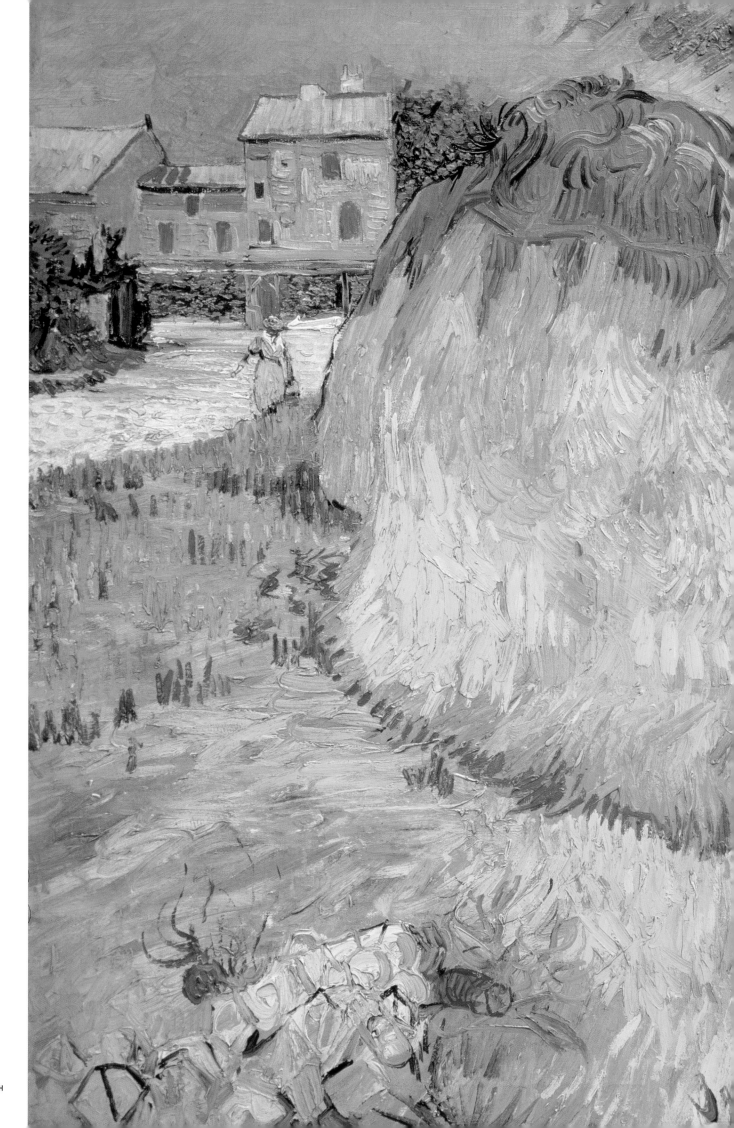

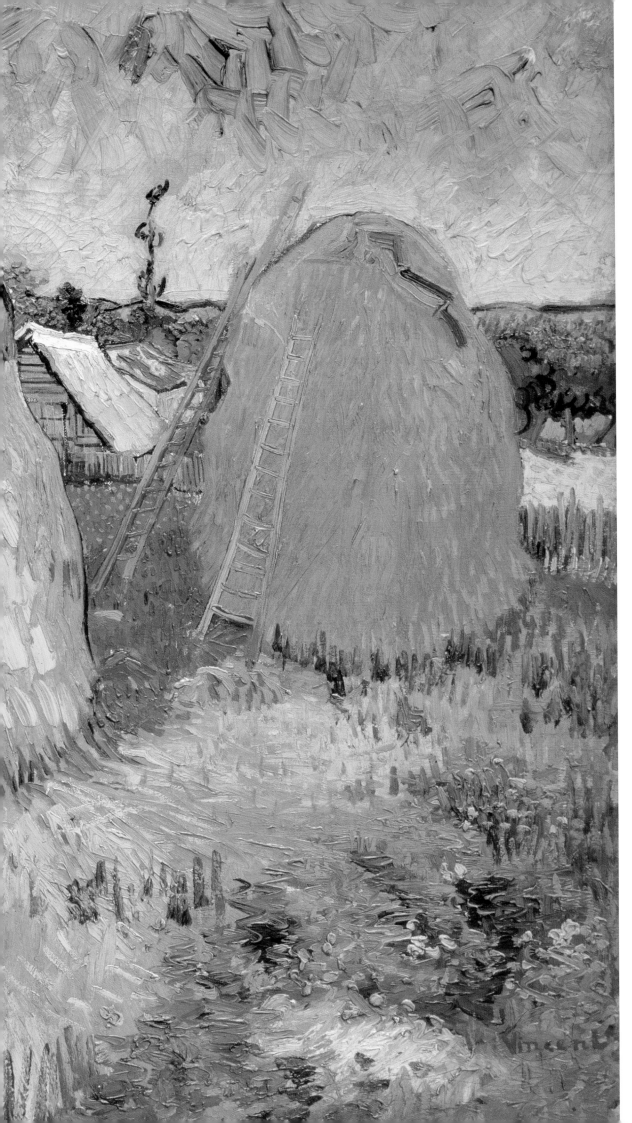

Van Gogh
Haystacks in Provence
June 1888
Oil on canvas
73 x 92.5 cm

Otterlo, Rijksmuseum Kröller-Müller

Van Gogh
Avenue of Plane Trees near Arles Station
1888
Oil on canvas
46 x 49.5 cm

Paris, Musée Rodin

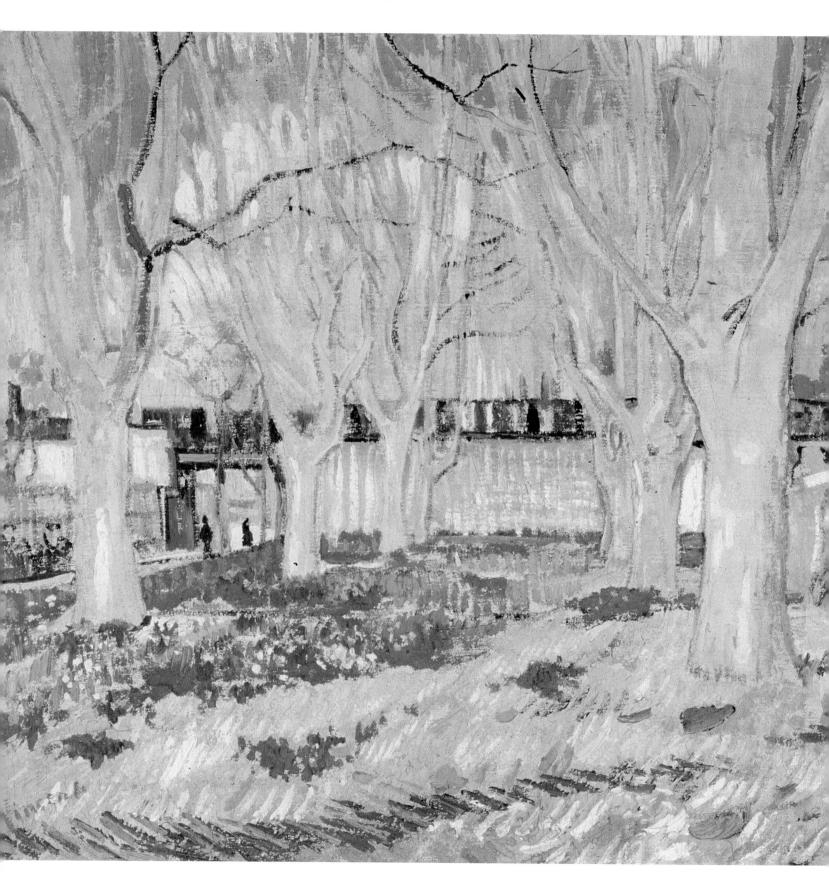

Van Gogh
Late Summer, Arles
1888
drawing
24.5 x 32.1 cm

Winterthur, Kunstmuseum

Van Gogh
View of Saintes-Maries de la Mer
June 1888
drawing
43 x 60 cm

Winterthur, Kunstmuseum

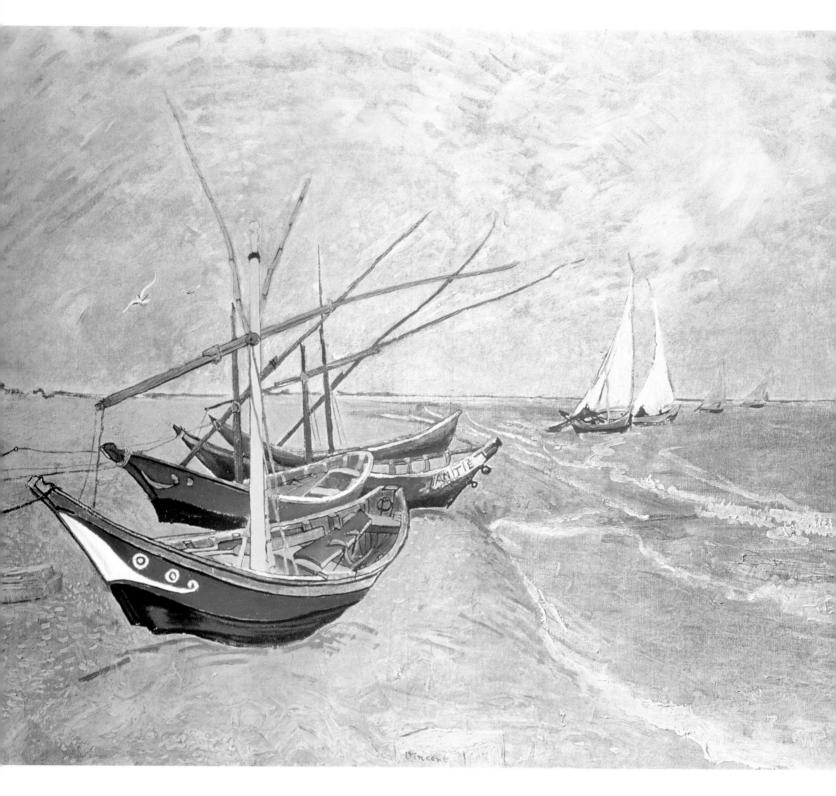

Van Gogh

Fishing Boats on the Beach at Saintes-Maries

June 1888

Oil on canvas

64.5 x 71 cm

Amsterdam, Rijksmuseum,
Vincent Van Gogh

even more". He painted and drew on the beach – the Mediterranean has never been as tortured as under his reed pen – in the narrow streets of the village and in its striking fortress-church: *Fishing Boats at Saintes-Maries*, *View of Saintes-Maries* and *Seascape at Saintes-Maries* are all from this period, as are several watercolors of red and blue fishing boats at rest on the yellow sand and drawings of whitewashed herdsmen's huts with their thatched roofs.

Vincent was as delicate a landscape artist in his letters as in his painting. In a letter to Theo from Saintes-Maries on June 16, 1888, "The deep blue of the sky was scattered with clouds of a blue more intense than the most saturated cobalt, and with others that were lighter – the blue whiteness of the Milky Way. Against the blue backdrop sparkled the stars: clear, greenish, yellow, white, light pink, much more like precious stones here than at home, and even in Paris; you can rightfully speak of opals, emeralds, lapis lazuli, rubies, sapphires…The sea a deep ultramarine, the beach purplish-red and, it seemed to me, with bushes on the dunes – bushes of Prussian blue."

Van Gogh
**Fishing Boats on the Beach
at Saintes-Maries**
June 1888
Reed pen
39.5 x 53.5 cm
Private collection

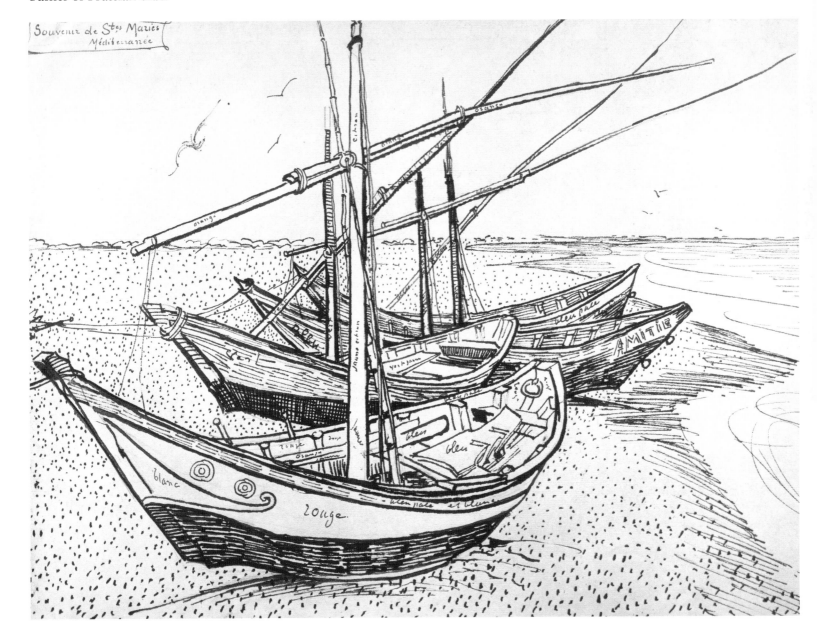

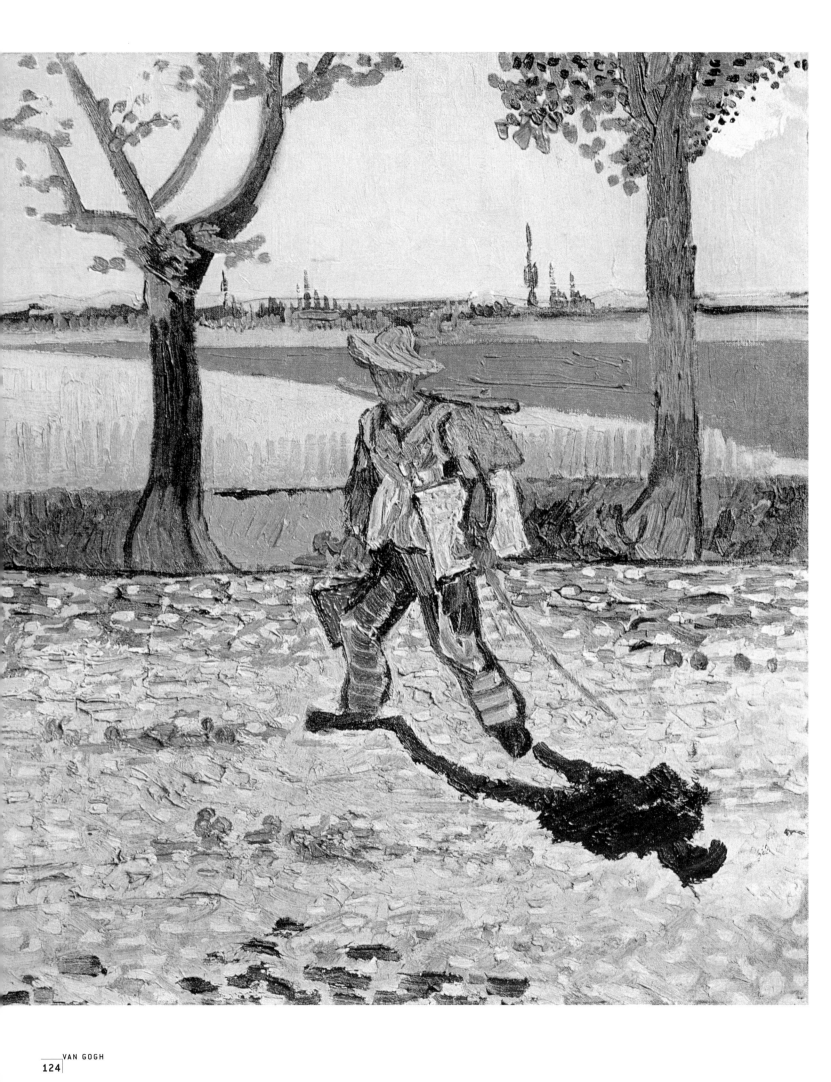

The Arles portraits

Vincent worked like one possessed, writing to Émile Bernard and Theo that "I've spent a week of relentless work in the fields, under the blazing sun." His only distractions were the odd drink in a bar and reading: Daudet's *Tartarin de Tarascon*, Loti's *Madame Chrysanthème*, *L'Année terrible*, Balzac and the Bible. Not to mention "the little ladies" of the cheap bordellos along the river. "But all things considered," he wrote, "I feel it my duty to subordinate my life to painting."

Once seized by a subject he became oblivious of everything, a kind of sleepwalker transcribing an emotional impact that guided even as it haunted him. Vincent returned from his painting sessions exhausted, "utterly abstracted and incapable of even the most ordinary things."

And then there was the sun, whose sheer violence he had never experienced before.

In *The Painter on His Way to Work*, destroyed by fire during the bombing of Germany in 1945, he portrays himself with a canvas under his arm, his painting gear on his back and a broad-brimmed straw hat on his head: a touching image of a long, hard walk under the broiling sun, with his shadow reaching out across the cobbled road. The "ghost of the road," said Francis Bacon, who took inspiration from the painter; Vincent was like a robot coming out of nowhere and bound for somewhere else.

And still he was haunted by the idea of an artists' brotherhood, by the visit from Gauguin he constantly demanded in his letters to Theo. At last his brother, alarmed by Vincent's distressed state, offered to Gauguin, who had just returned from another stay at Pont-Aven, a monthly payment of fifty francs if he would go to live in Arles and send back a canvas every month. And when Gauguin accepted, there began an endless series of letters from Vincent to Theo, with endless complications: Theo was beginning to have some success in selling Monet and even the still penniless Gauguin, but remained very prudent where his brother was concerned – although he did send three of his canvases to the Salon des Indépendants in 1888.

In September, Vincent suggested to Bernard and Gauguin that they exchange self-portraits, and sent his to Gauguin. This would be, he thought, a first step toward getting Gauguin to Arles. During the same period, he painted *The Yellow House*, "under a sulfurous sun, under a sky of pure cobalt…The ground is yellow too…and the house on the left is pink with green shutters."

He had embarked on a series of portraits – in Arles alone there were forty-six, including six of himself: "People are at the root of everything," he explained. "The human figure is the subject that allows me to work at what is best and most serious in me." He also returned twice to the theme of *The Sower*. In one version the man and an enormous tree trunk stand out in chiaroscuro against a landscape dominated by an enormous yellow sun.

Van Gogh
The Painter on the Route to Tarascon
July 1888
Oil on canvas
48 x 44 cm
This painting was burned during the war, in May 1945.

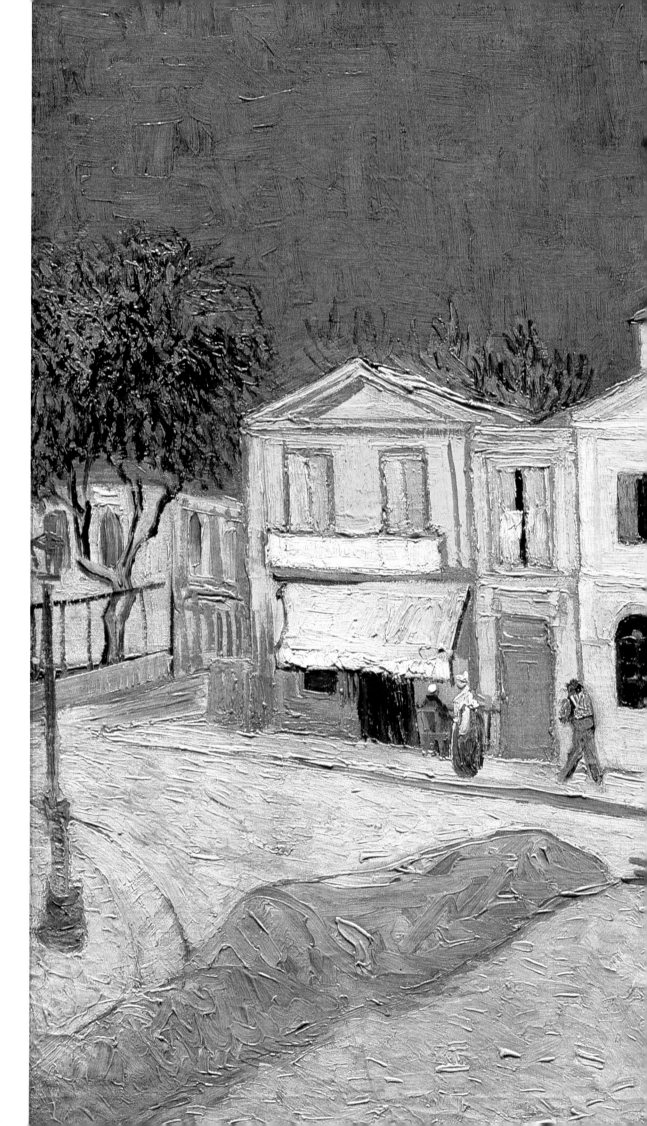

Van Gogh
Vincent's House in Arles
(The Yellow House)
September 1888
Oil on canvas
76 x 94 cm

Amsterdam, Rijksmuseum,
Vincent Van Gogh

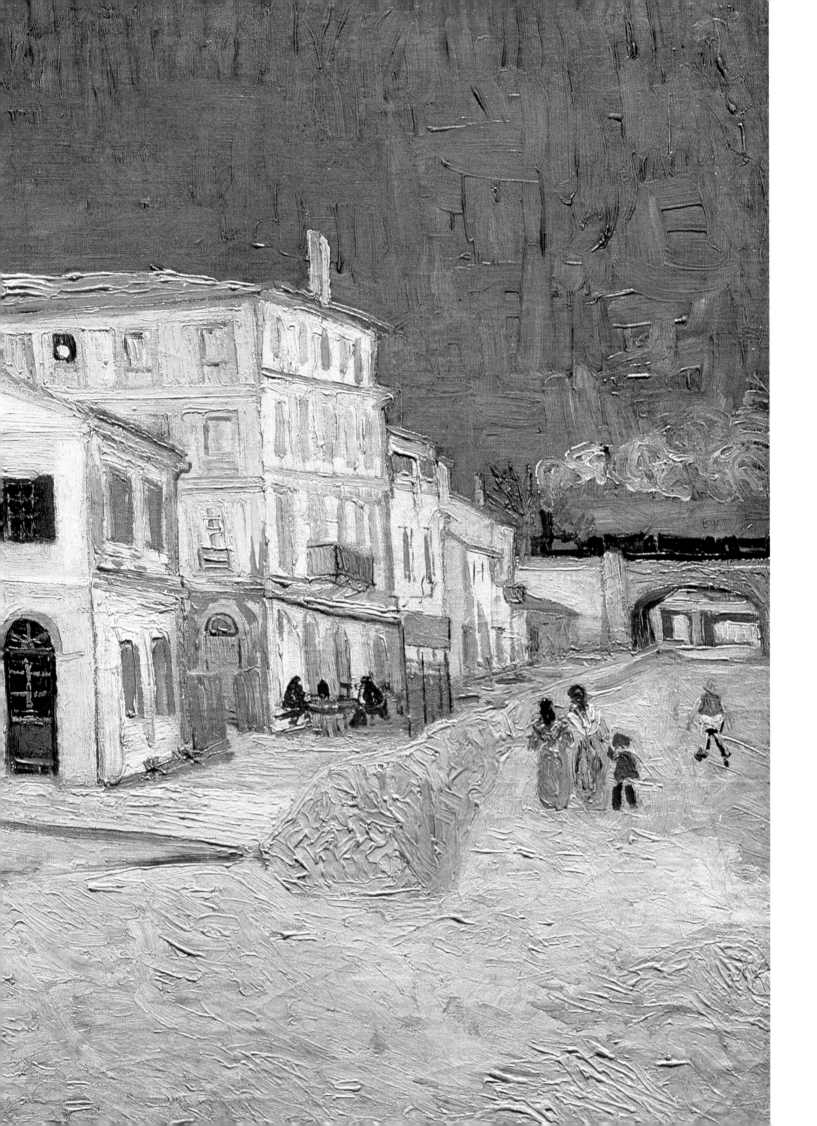

Van Gogh
The Sower
November 1888
Oil on canvas
73.5 x 93 cm
Zurich, Bührle collection

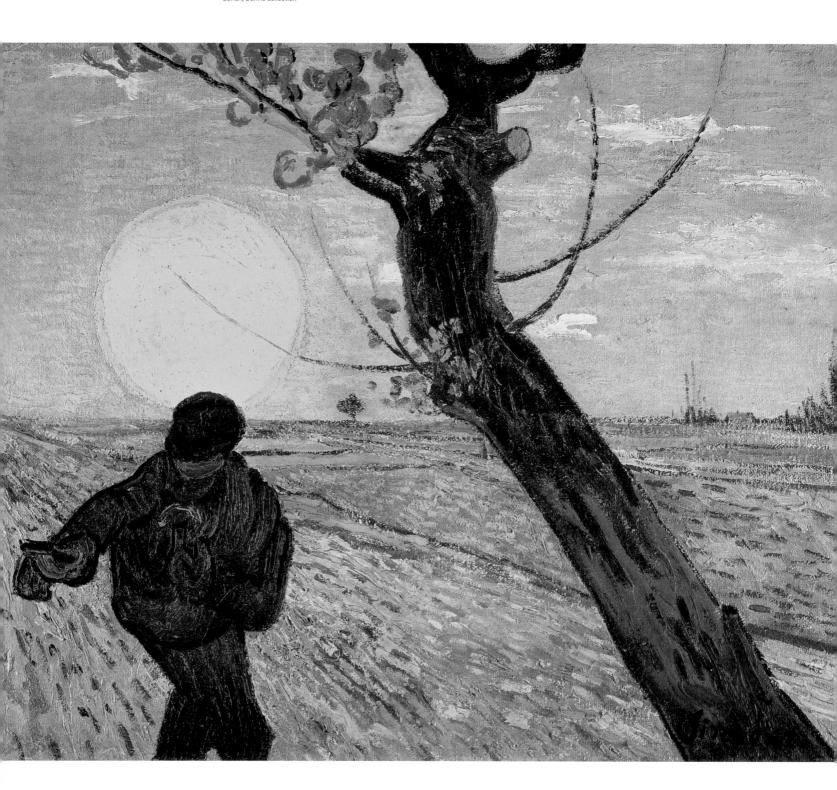

Vincent drew and painted the local people – when they were ready to pose for this peculiar Dutchman. Some of them were friends, appearing in works like *Joseph Roulin the Postman*, drawn in pencil and reed pen with his enormous beard and his uniform, and then painted; *Portrait of Milliet, Second Lieutenant of the Zouaves*, divided up into enormous, vibrant areas of solid blue and red; *La Mousmé* and *L'Arlésienne (Madame Ginoux)*, in local dress; *La Berceuse (Augustine Roulin)*, against a backdrop of Japanese flowers and acanthus leaves, and her children.

Van Gogh
Portrait of the Postman Joseph Roulin
April 1889
Oil on canvas
64 x 54.5 cm
New York, MOMA

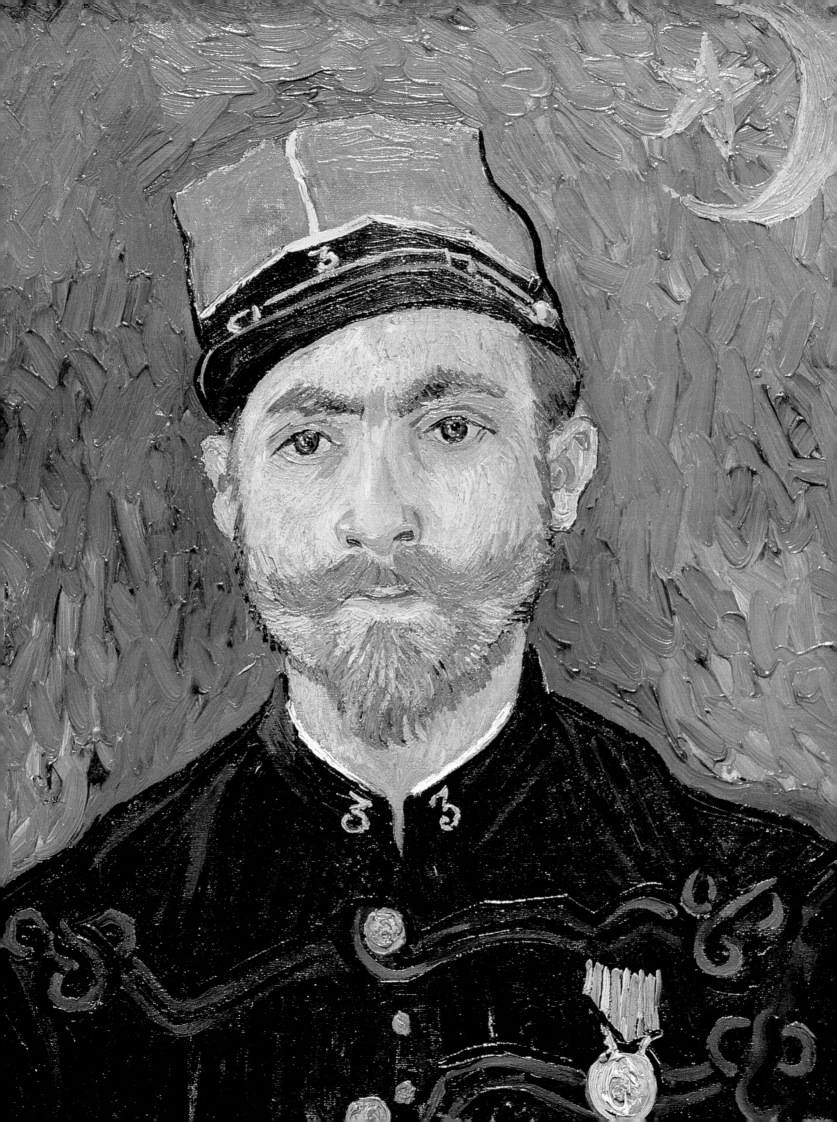

Van Gogh
Portrait of Milliet, Second Lieutenant of the Zouaves
September 1888
Oil on canvas
60 x 49 cm
Otterlo, Rijksmuseum Kröller-Müller

Van Gogh
La Mousmé, Sitting
July 1888
Oil on canvas
74 x 60 cm
Washington, National Gallery of Art

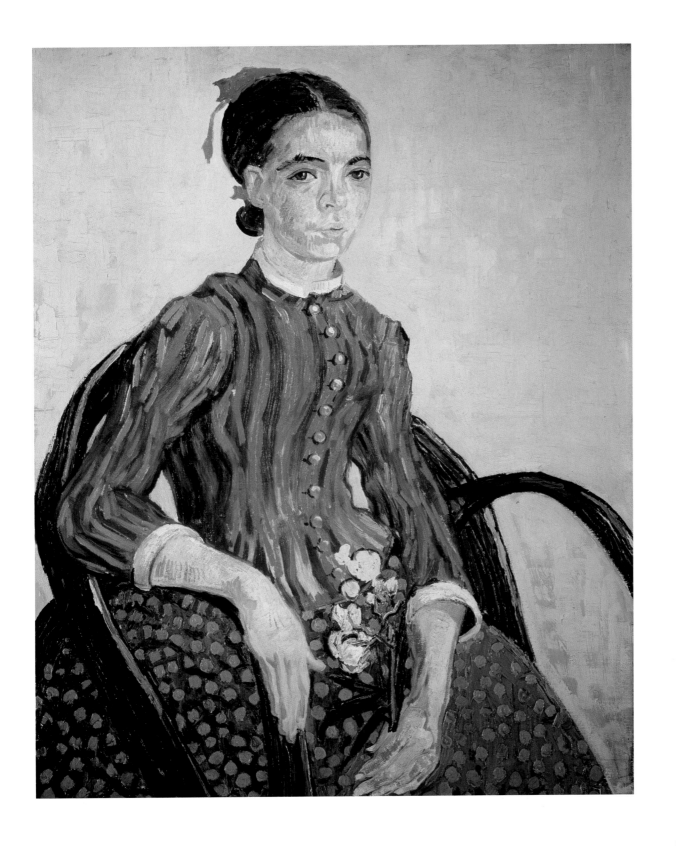

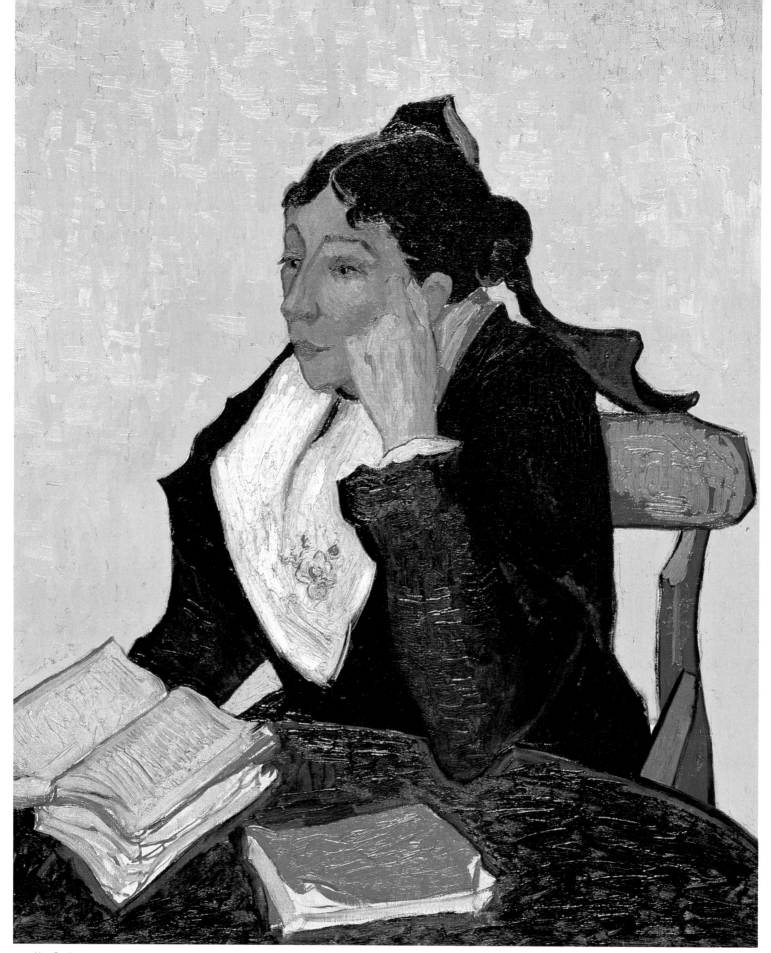

Van Gogh
L'Arlésienne (Madame Ginoux)
December 1888
Oil on canvas
91.4 x 73.7 cm
New York, MOMA

Van Gogh
Portrait of a Man (Joseph Michel Ginoux)
December 1888
Oil on canvas
65 x 54.5 cm

Otterlo, Rijksmuseum Kröller-Müller

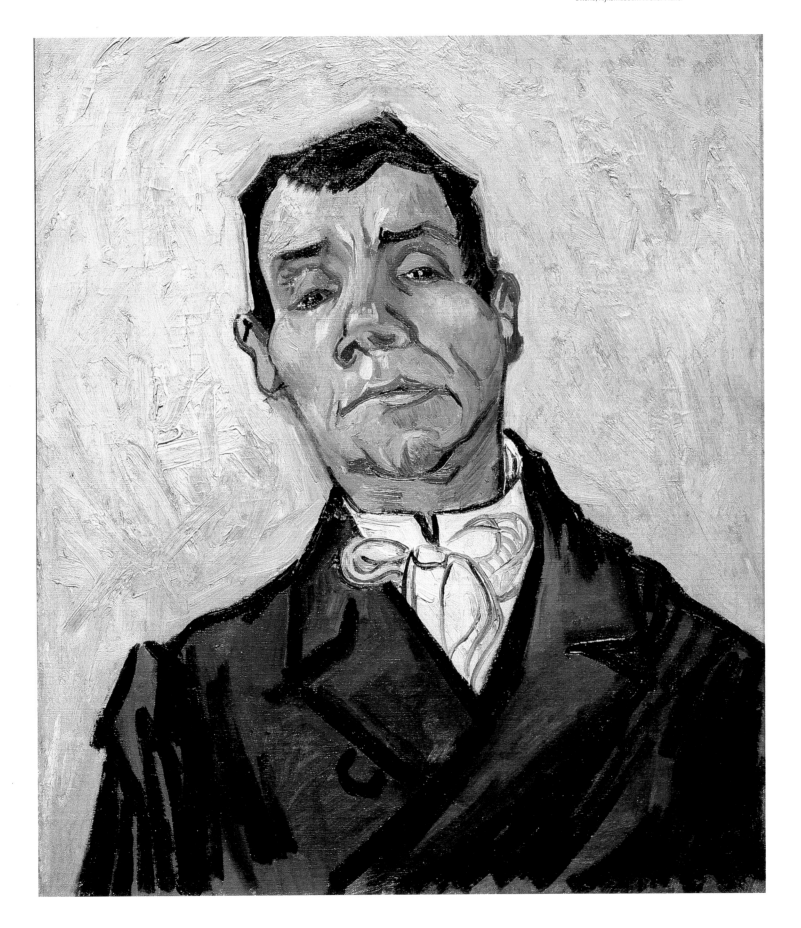

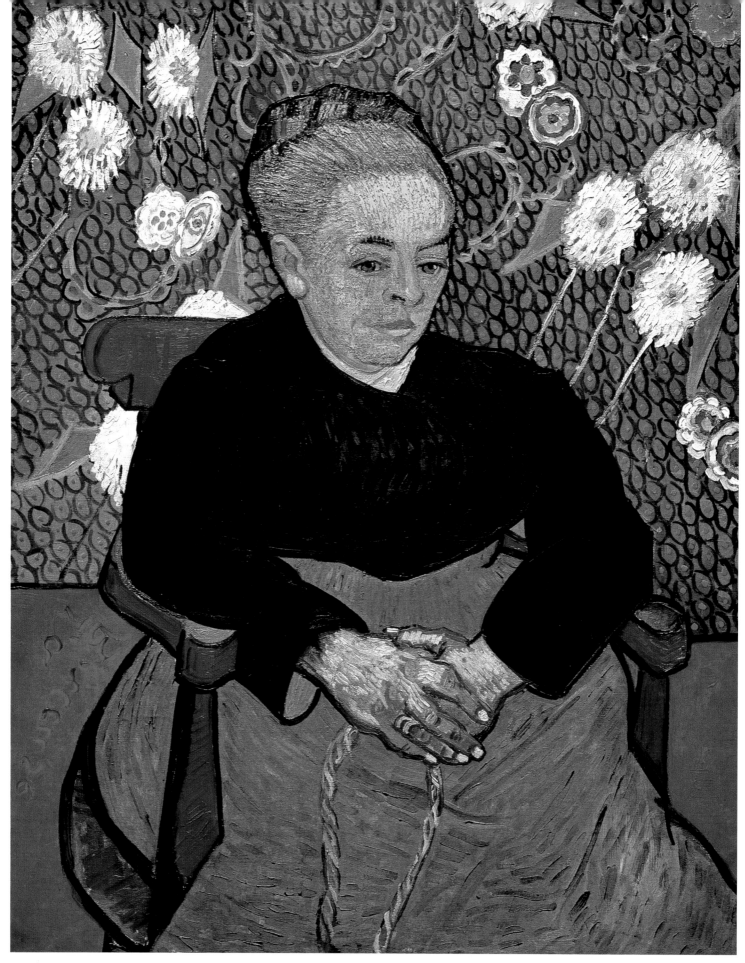

Van Gogh
La Berceuse (Augustine Roulin)
February 1889
Oil on canvas
92.7 x 72.8 cm

Boston, Museum of Fine Arts

Van Gogh
Portrait of Eugène Boch
September 1888
Oil on canvas
60 x 45 cm
Paris, Musée d'Orsay

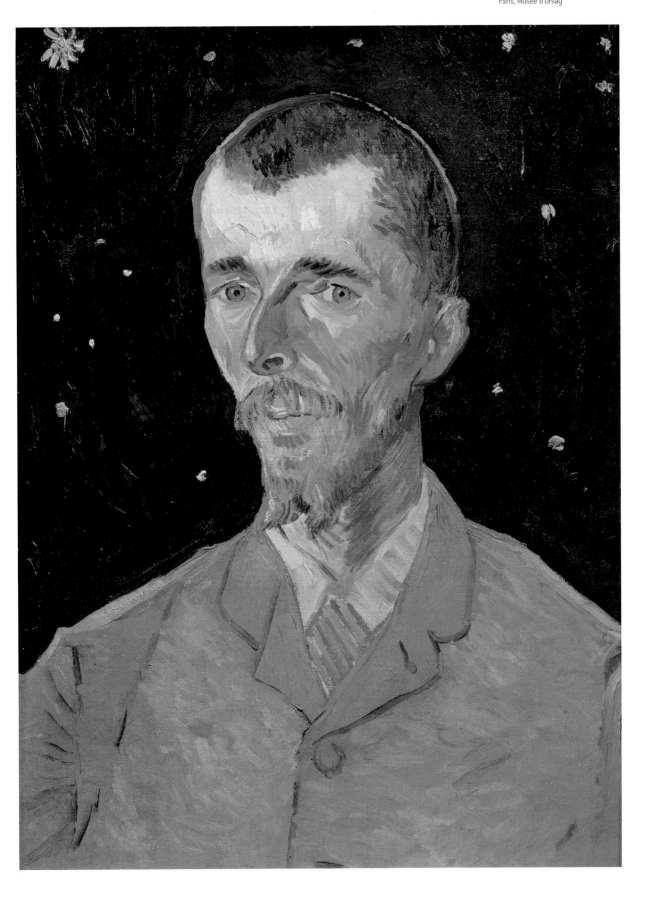

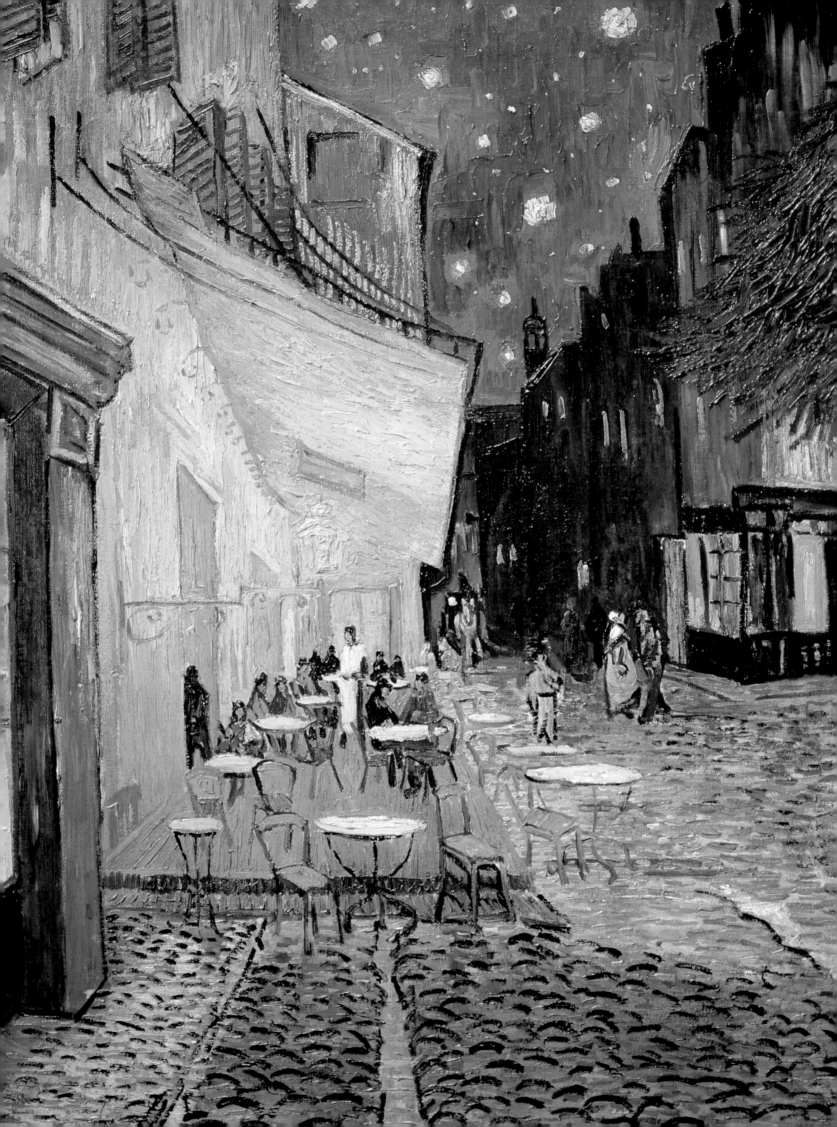

In the *Portrait of Eugène Boch*, the Belgian writer, with his emaciated features, wears a vivid yellow jacket set off by an ultramarine background dotted with white stars: "Behind his head…I paint the infinite, using a simple blue, the richest and most intense blue…and the blond head catching the light against the blue background creates all the mystery of a star in the depths of the sky."

With their extraordinary boldness of color, these portraits are contemporaneous with the ascetic *Self-Portrait (Dedicated to Paul Gauguin)*, with the ashen face and slightly slanted eyes of someone from another world; this ghostly figure, this wan Lazarus, was exchanged against Gauguin's self-portrait. It was painted the same week as *The Café Terrace on the Place du Forum, Arles, at Night*, showing the Café de la Gare run by the Ginoux family, "the terrace lit by a great gas lamp in the blue night, with a patch of starry blue sky."

In *The Night Café in Arles*, Vincent captures the haven of boredom and provincial solitude he sought out after an exhausting day's work: "The café is a place where you can destroy yourself, go mad, commit crimes," he wrote to Theo in September 1888. "To get my effect, I

Van Gogh
**The Café Terrace
on the Place du Forum, Arles, at Night**
September 1888
Oil on canvas
81 x 65.5 cm
Otterlo, Rijksmuseum Kröller-Müller

Van Gogh
The Night Café in Arles
September 1888
Watercolor
44.4 x 63.2 cm
Bern, H. R. Hahnloser collection

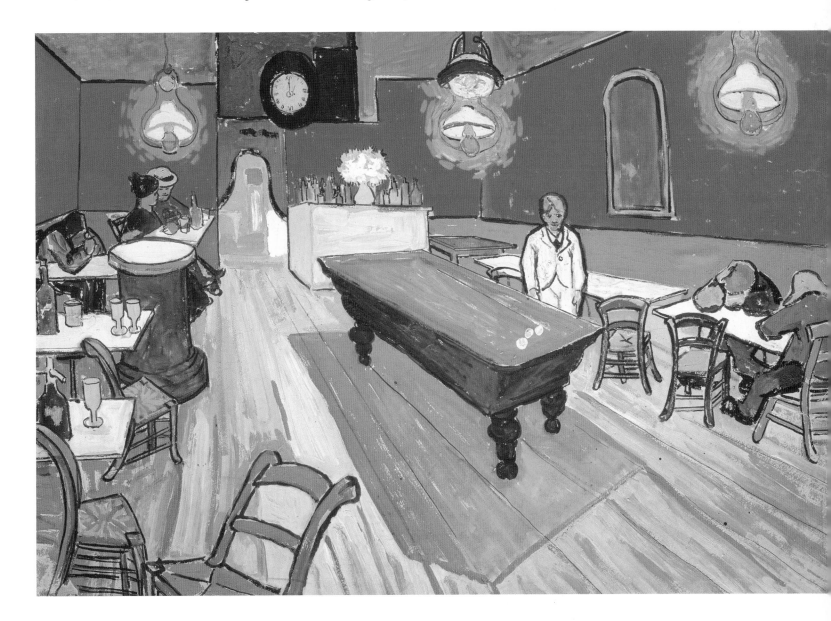

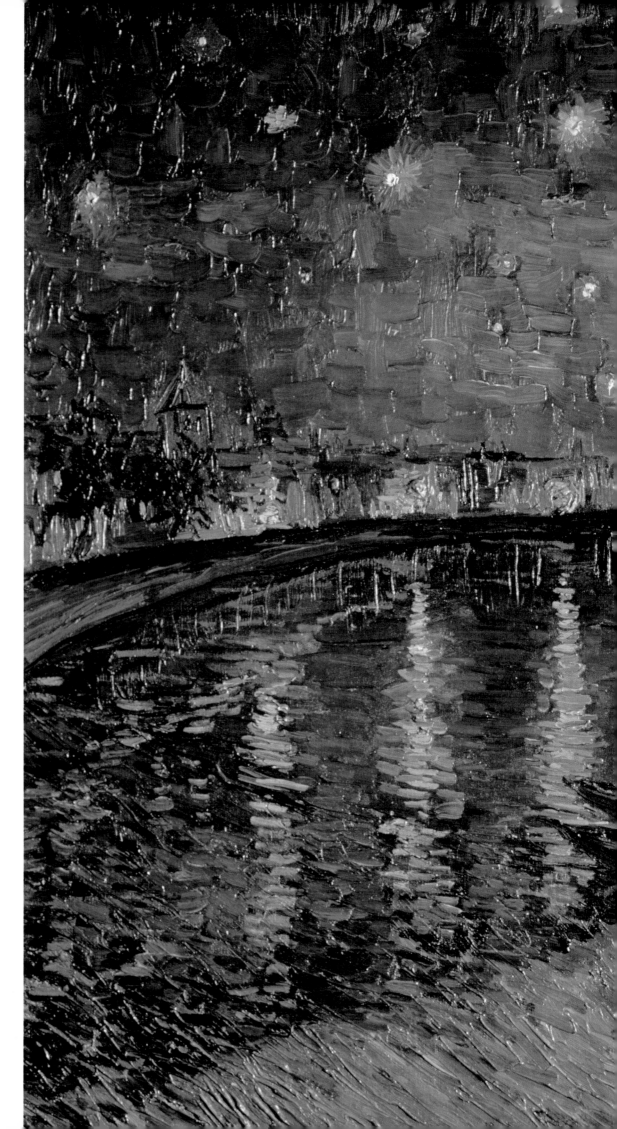

Van Gogh
Starry Night, Arles
September 1888
Oil on canvas
72.5 x 92 cm

Paris, Musée d'Orsay

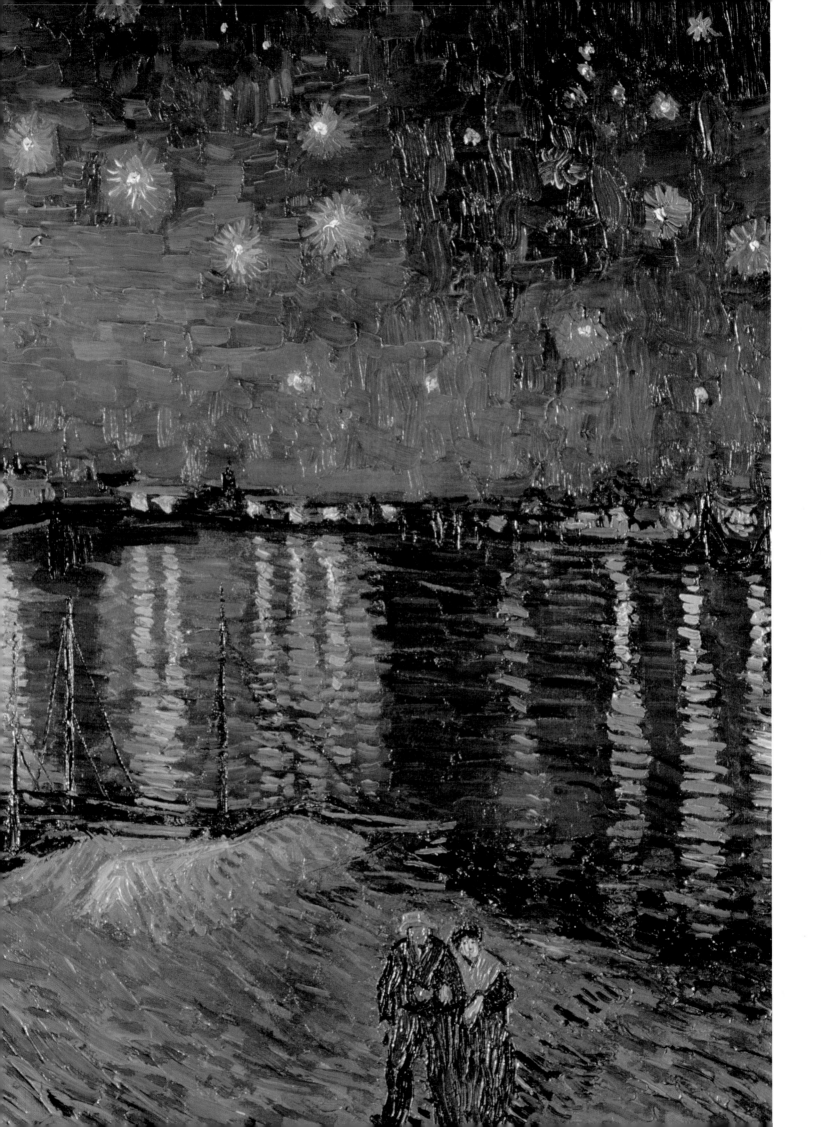

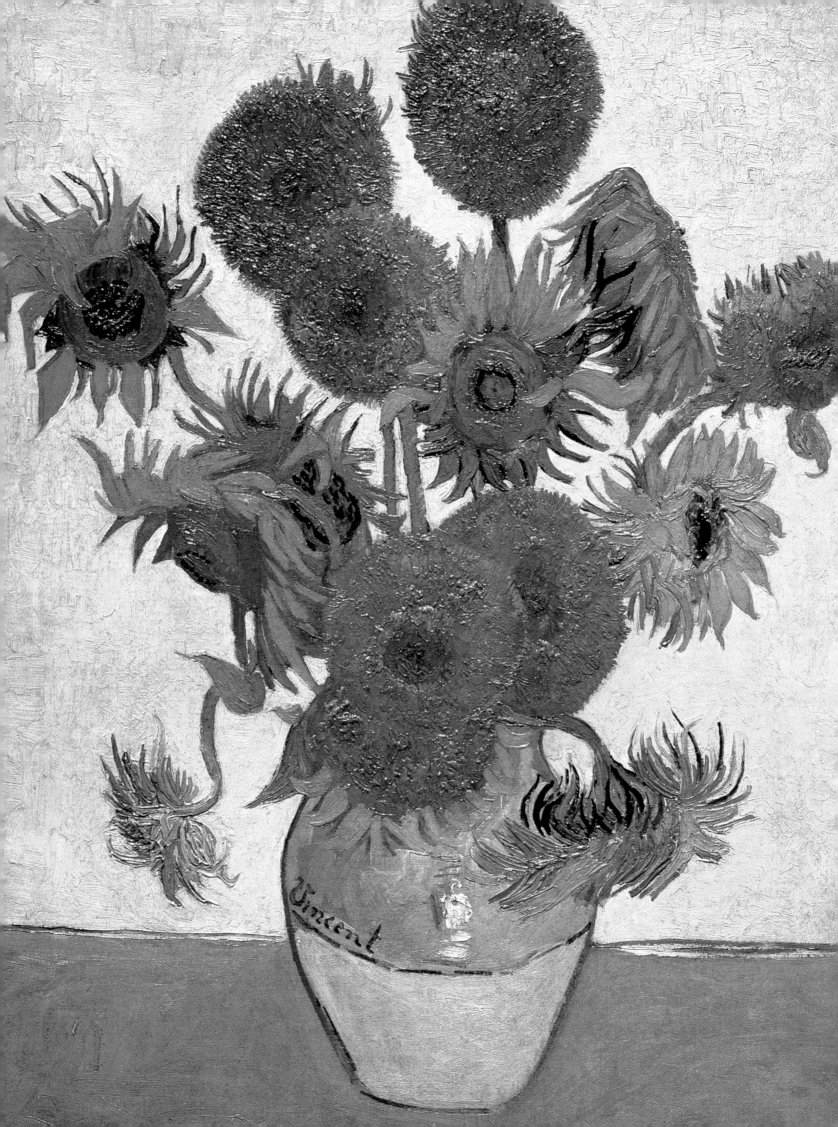

contrast soft pink, blood red, wine red, and gentle greens – Louis XV and Veronese – with hard yellowish and blueish greens, in the atmosphere of some hellish furnace…But all the time keeping up the illusion of Japanese joyousness and Provençal bonhomie."

While the little town slept, Vincent set up on the riverbank and painted *Starry Night over the Rhône*. The painter's visionary eye plunged into the depths of this extraordinary spectacle, with flickering lights reflected in the deep blue of the river while the pale-haloed stars dot the sky "like suns wheeling or frozen in time."

To Theo in August 1888: "I'm painting like a Marseillais eating bouillabaisse; nothing surprising about this, as I'm working on big sunflowers."

The year before, he had made studies of cut sunflowers set on the ground: one using yellow on a blue backdrop, now in the Metropolitan Museum in New York, and the other with a range of yellows, oranges and browns, in the Bern Kunstmuseum. Between August 21 and 26, he painted three vivid yellow sunflowers in a vase on a green background; a second version has been lost. Shortly afterward came the dazzling *Still Life: Vase with Fourteen Sunflowers*, using a yellow pottery vase and blue-green background and a second version with the same vase, but this time

Van Gogh
Still Life: Vase with Fourteen Sunflowers
August 1888
Oil on canvas
93 x 73 cm
London, National Gallery

Van Gogh
Two Cut Sunflowers
August-September 1887
Oil on canvas
43.2 x 61 cm
New York, MOMA

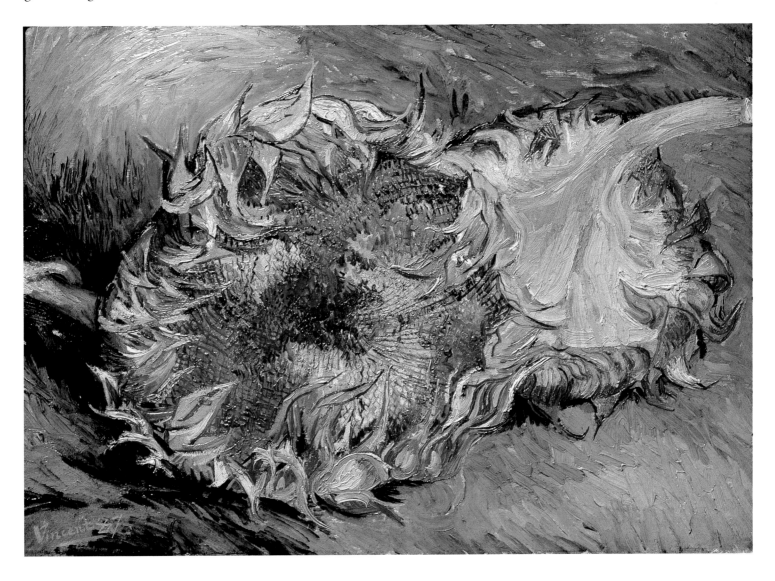

"all in yellow", including the background. For Vincent these full-blown sunflowers symbolize his art, his surrender to the sun and his predilection for yellow. To welcome Gauguin he planned to decorate the house with "nothing but sunflowers", whose luminous quality he compared to that of Gothic rose windows.

In his letters to Gauguin and Theo, Vincent would add little sketches of his room and in mid-October he painted *Vincent's Bedroom in Arles*, "using flat, thick, crudely brushed colors," he told Gauguin in a letter. "The walls are pale lilac, the floor a broken, faded red, the chairs and bed chrome yellow, the pillows and sheet very pale lime green, the bedcover blood red, the bedside table orange, the washbasin blue, the window green."
On the rustic bed lie two pillows, side by side.

Van Gogh
Encampment of Gypsies, with Caravans
August 1888
Oil on canvas
45 x 51 cm
Paris, Musée d'Orsay

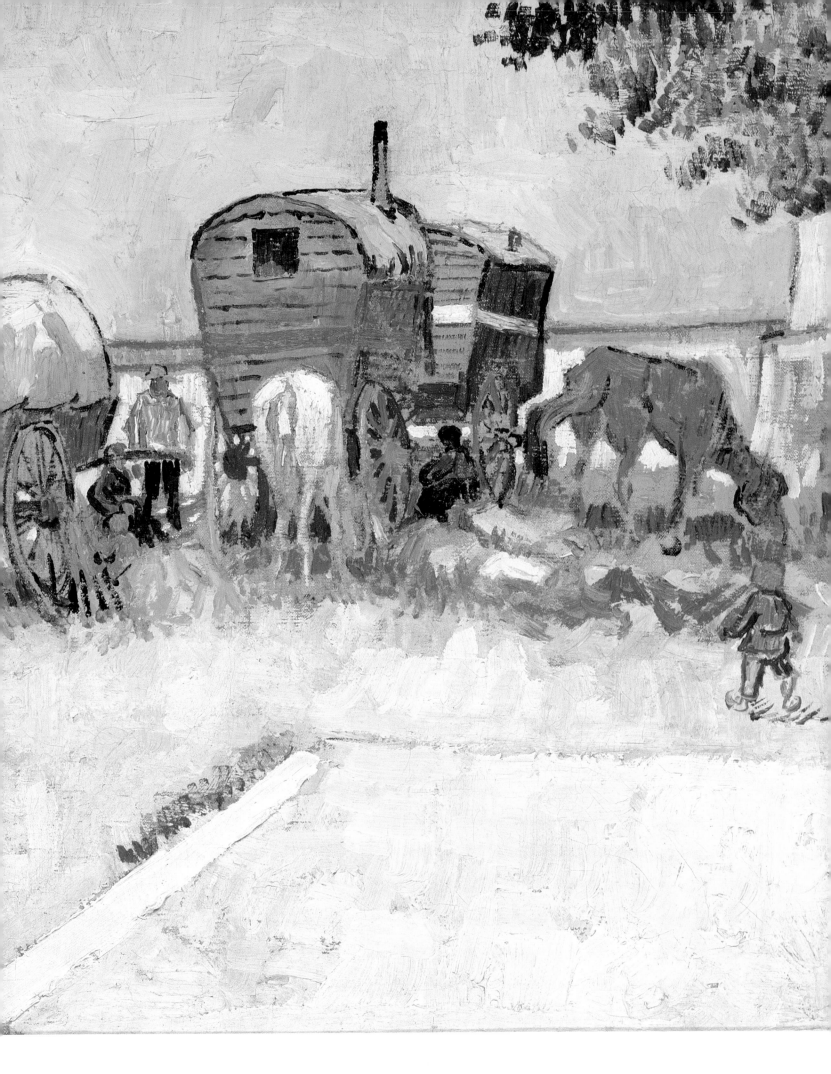

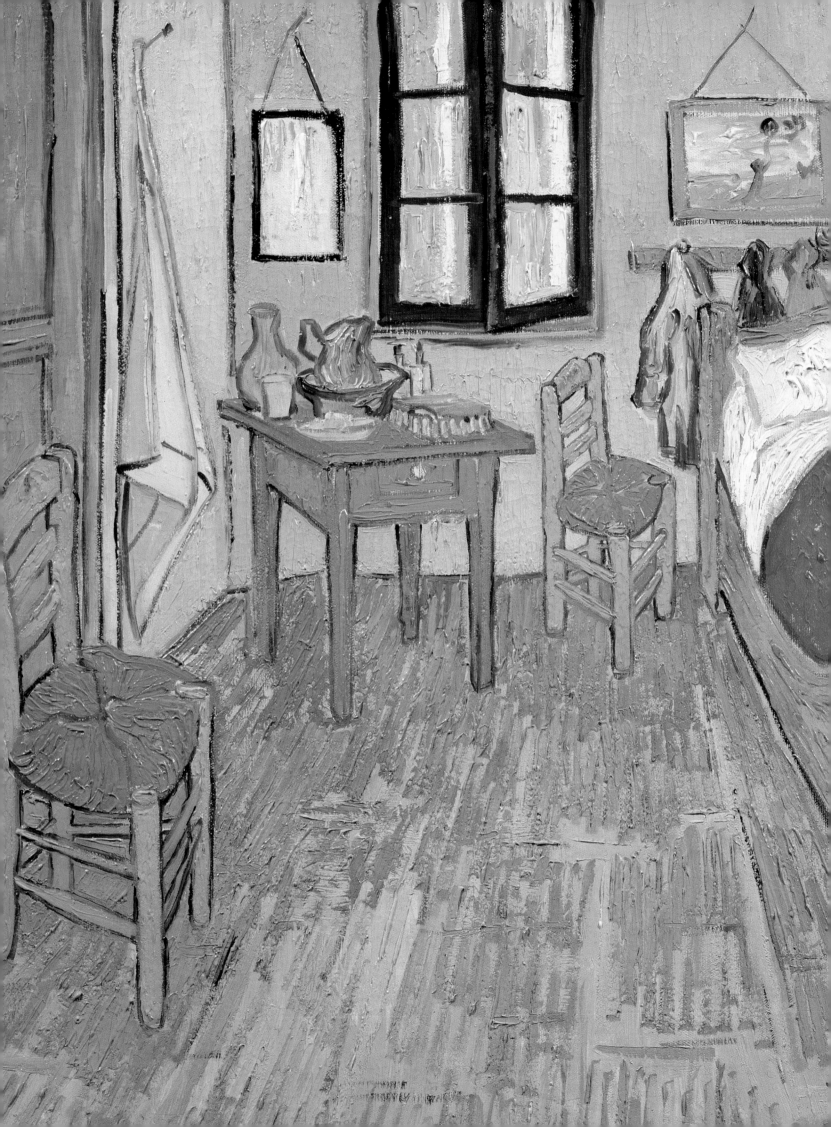

Van Gogh
Vincent's Bedroom in Arles
September 1889
Oil on canvas
56.5 x 74 cm

Paris, Musée d'Orsay

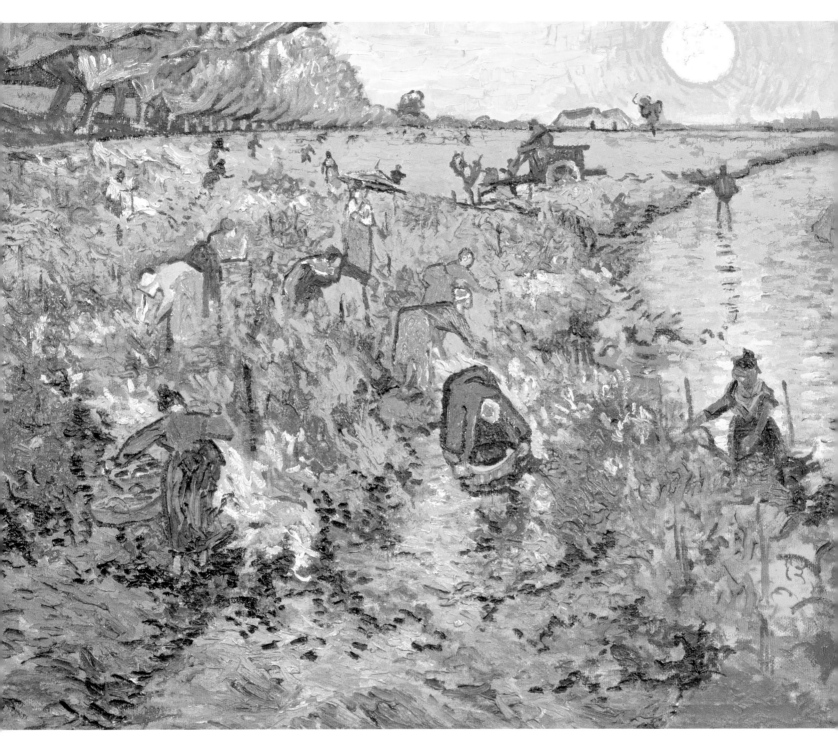

Van Gogh
The Red Vineyard
November 1888
Oil on canvas
75 x 93 cm

Moscow, Pushkin Museum

A broken bond

After much procrastination Gauguin arrived in Arles on October 23. Not only was he very different from Vincent, he was finding buyers for the paintings and pottery Theo was showing; when Theo sent him money it was his share of the profits, whereas Vincent's allowance was the purest charity.

Gauguin did not like Arles, and the Yellow House – the "House of Friendship" – was not to his taste either, despite Vincent's efforts to brighten it up. "I don't feel at home here," he wrote to Émile Bernard. "Everything – the countryside and the people – is small and mean. Vincent and I don't agree about much, especially where painting's concerned. He's a romantic and my inclinations are more toward the primitive."

The presence of someone so self-assured gave Vincent's spirits a much-needed lift. Although often bothered by Gauguin's lordly airs, cynicism and sheer effrontery with women, he was ready to take second place and admire his friend's artistic and financial success, even if the money never lasted very long. But Gauguin was not one to go into ecstasies over nature and avoided painters" talk; he tried to push Vincent towards the "Synthetist" approach he had developed (or maybe borrowed from Bernard) at Pont-Aven, and criticized the surviving Impressionist influence in his friend's work. "He was floundering," Gauguin wrote later[1], after "trying to straighten out his ideas…for there's rich, fertile ground in him." The simple fact was that the two artists did not get along at all.

In November, Vincent finished *The Red Vineyard*, tinged with the crimson of autumn and the setting sun. "At the moment," he wrote to Bernard, "Gauguin is working on a canvas of the same night café I painted, but with figures from the local brothels. It's starting to look really beautiful." Shortly afterward a letter from Gauguin gave Bernard his own version of the bar he was painting, with three whores and, in the foreground, Madame Ginoux in traditional Arles costume.

During the previous months Vincent had drawn and painted the public gardens not far from his house; now Gauguin threw down the gauntlet in the form of a painting of the same subject he called *Old Women in Arles or Arlésiennes (Mistral)*, of which a number of sketches are to be found in his notebooks. Here a "cloisonné" approach divides up a picture area peopled with various enigmatic figures. Gauguin exhorted his friend to "paint from his imagination", which Vincent proceeded to do in *Memory of the Garden at Etten*, which mingles the public gardens in Arles with memories of his youth. He acknowledged this as the work most influenced by Gauguin: "He gives my imagination courage, and the things of the imagination take on a more mysterious character," he wrote to Theo.

1 Gauguin's account of his time in Arles was published by Charles Morice in the *Mercure de France*.

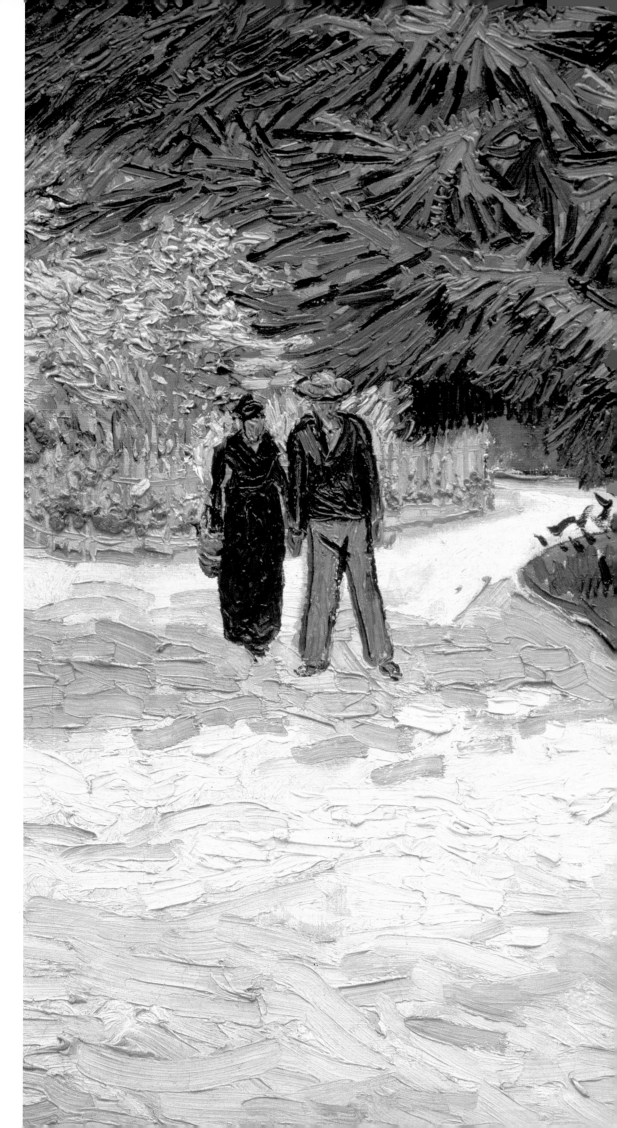

Van Gogh

**Public Garden with Couple
and Blue Fir Tree:
The Poet's Garden III**

October 1888
Oil on canvas
73 x 92 cm

Private collection

Van Gogh
Memory of the Garden at Etten
November 1888
Oil on canvas
73.5 x 92.5 cm

Saint Petersburg, Hermitage Museum

A canvas unmentioned in his letters, another of his indoor scenes, also shows this recourse to the imagination. The very Japanese *Dance Hall in Arles* is in the same spirit as the *Memory of the Garden at Etten* and uses its setting to contrast three pairs of complementary colors: blue and orange in the background, red and green for the balcony, and yellow and purple in a foreground of women seen in back view and wearing the beribboned Arles "capeline" on their heads.

The sense of confinement of the *Dance Hall* is counterbalanced by *Spectators in the Arena at Arles* and its crowd – including his friends the

Van Gogh
The Dance Hall in Arles
December 1888
Oil on canvas
65 x 81 cm
Paris, Musée d'Orsay

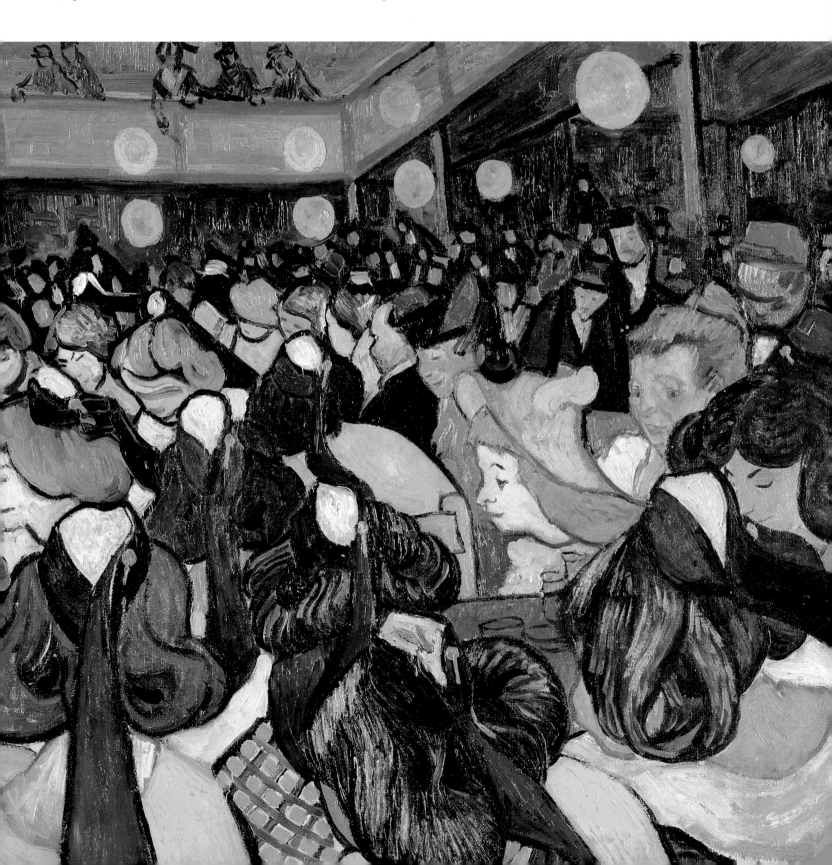

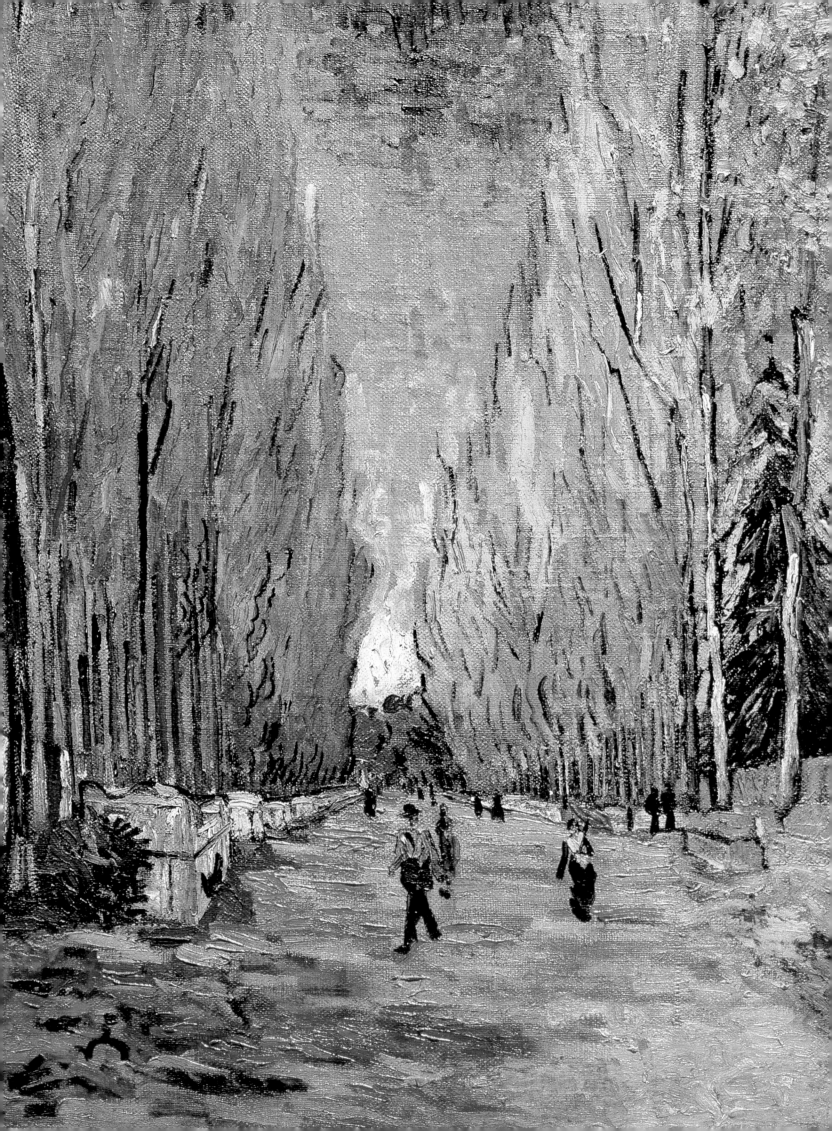

Roulins – seething with browns, grays and ochers in sharp contrast with the luminous patch of the bullring.

Both painters made several versions of the Alyscamps near Arles, a long avenue lined with sarcophagi and leading to a little church. Vincent opted for deliberately percussive vertical and horizontal strokes of thick paint, and the poplars along the avenue suggest flames of molten gold. In two versions of *Falling Leaves (Les Alyscamps)*, the bare trunks ascending out of the picture surface section the grave-lined avenue. The same subject viewed from farther away in Gauguin's *Landscape* or – his more derisive title – *The Three Graces in the Temple of Venus* – highlight the difference between the two painters: here the forms are more massive, while he plays with arabesques and light, stripe-like brushstrokes. The strong, sometimes arbitrary colors – the blue tree trunk and the bright red patch in the foreground – testify to the influence of the Midi on his palette.

In early December 1888, Gauguin painted his *Portrait of Van Gogh Painting Sunflowers*. Vincent looked at the painting in silence for a time, then said, "It's me alright, but me gone mad."

Things between the two were beginning to sour; in mid-December, Gauguin decided to leave Arles, then changed his mind and they set off together for Montpellier and the superb Delacroix and Courbets in the museum there. Their discussions quickly became "excessively electric", a frequent occurrence that left Vincent with his "brain fatigued, like a rundown battery."

One solitary evening – perhaps after an argument – he painted *Van Gogh's Chair*, a humble rustic chair turned by the presence of Gauguin's pipe and tobacco into a moving token of the friendship Vincent still clung to. Rendered in bright colors and set starkly on the tiled floor of the empty house, this symbol of abandonment –"an ideogram of the name Van Gogh," André Malraux called it – also stood for the bond that had been broken.

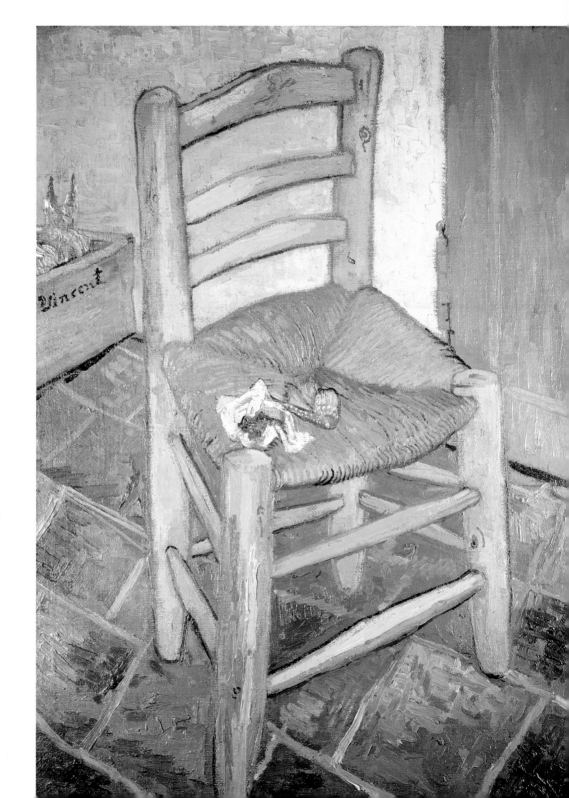

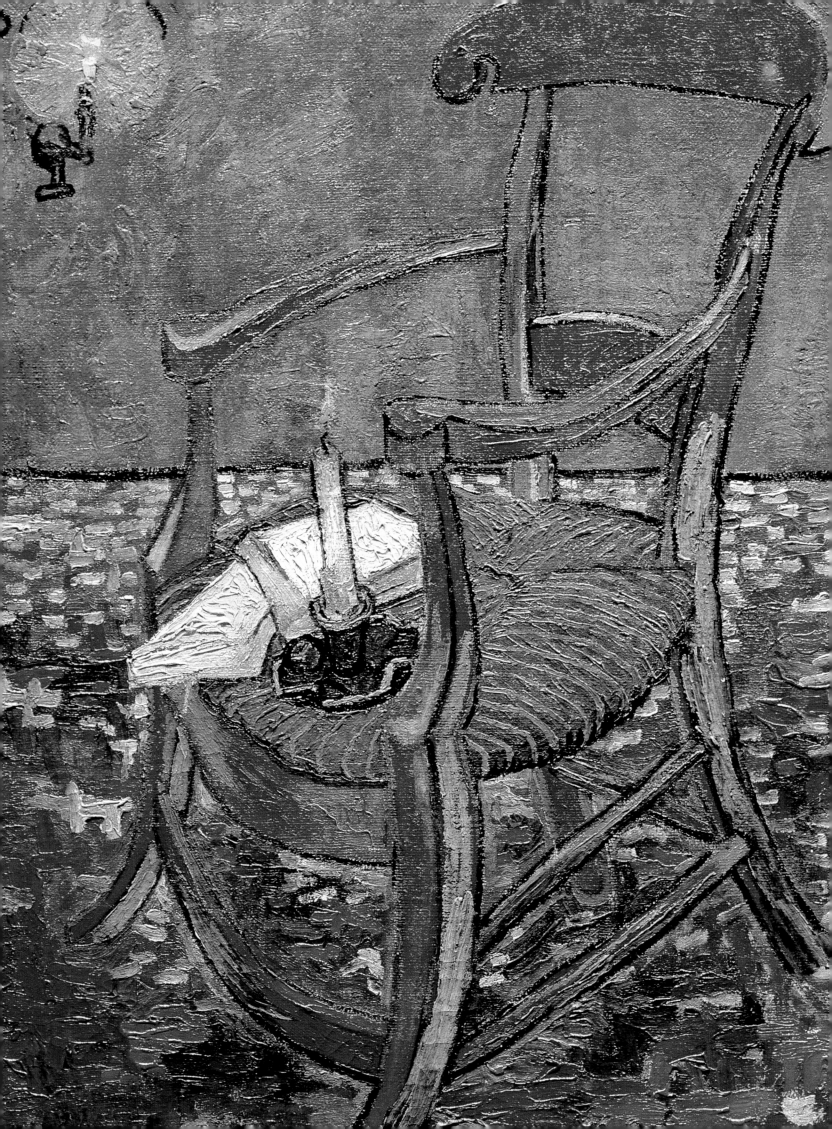

Shortly afterward he made the diptych *Gauguin's Chair*, "in green and red, a nocturnal feel to it, the wall and floor red and green, and on the seat two novels and a candle." This flame burning on the armchair in which the painter sat to read and smoke his pipe is reminiscent of the painting Vincent had done after the death of his father, a still life of flowers with a pipe and the dead man's tobacco pouch; an image of grieving that Vincent would retouch on when he came out of hospital in January 1889.

The drama was brewing, however. Gauguin related that one night he woke abruptly to find his friend at the foot of his bed. "What's wrong, Vincent?" he asked. On another occasion they were drinking absinthe at the Café Ginoux when Vincent threw the contents of his glass in his face; seeing his inflamed state, Gauguin decided to take a hotel room for the night.

On December 23, Vincent threatened Gauguin with a razor on the Place Lamartine, but the only version we have of the incident comes from Gauguin, who said he had brought things to a halt with a "powerful look". Written fifteen years later, this self-interested account is riddled with inaccuracies and exaggerations: what is known of that night is that Vincent went to his favorite brothel, asked for Gaby, also known as Rachel, and gave her an envelope containing the bloody lobe of his ear, which he had cut off. The madam called the police, who next morning found Vincent hunched on his blood-covered bed in the Yellow House and immediately took him to the hospital. Gauguin, arrested then quickly released, disappeared[1].

However, he did summon Theo urgently by telegram; the following day the two brothers were briefly reunited, and that evening Theo returned to Paris with Gauguin. For Vincent, who had no memory of the incident, the dream was shattered, the only trace being a curt note from Gauguin a few days later, asking him to send on his notebooks and drawings and his fencing mask and gloves.

1 Letter from Émile Bernard to Albert Aurier, January 1, 1889.

Van Gogh
Gauguin's Chair
c.November 20, 1888
Oil on jute
90.5 x 72 cm

Amsterdam, Van Gogh Museum
(Vincent Van Gogh Foundation)

5 The depths of passion

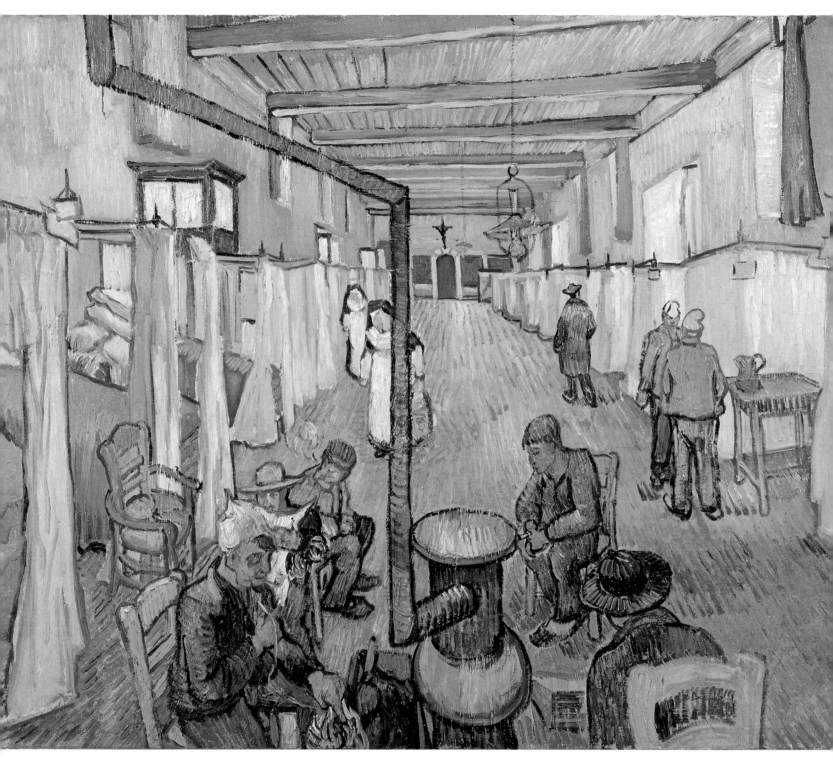

Van Gogh
Ward in the Hospital in Arles
October 1889
Oil on canvas
74 x 92 cm

Winterthur, Oscar Reinhart collection

Self-portrait with bandaged ear

This was not the first fit of uncontrollable anger on Vincent's part: his friends Signac, Guillaumin and Bernard all mention his states of agitation and his violent outbursts. Like Theo, he was only too aware of the strong neurotic strain running in the family, and in his letters he makes frequent references to their "madness". By the time Theo arrived at the hospital in Arles, Dr. Urpar had diagnosed "acute mania with generalized delusions." With his ear healing rapidly and his overall state apparently improving, his friend Roulin, despite the misgivings of Urpar's assistant, Dr. Rey, was authorized to take him back to the Yellow House. It was an emotional return, with Vincent immediately asking for news of Gauguin.

When a second attack came, Vincent was immediately committed. On February 7, his devoted friend Reverend Salles wrote to Theo to tell him of the painful situation. "Vincent has shut himself up behind a wall of silence…sometimes weeping, but without saying a word, and refusing all nourishment."

It was probably around this time, during a period of remission, that he painted the poignant *Ward in the Hospital in Arles*, showing the depressing setting he found himself in: the wretched patients slumped in their chairs around the stove amid beds hidden behind white curtains. Given permission to leave the hospital grounds a few days later, he went to the Yellow House and began painting.

One work of this period was the *Portrait of Doctor Félix Rey*. Given the painting as a gift, the good doctor was so unimpressed by its artistic qualities that he used it to fill a gap in his chicken house wall. Vincent also painted a number of still lifes and the staggering *Self-Portrait with Bandaged Ear* in red and green. Beneath the fur bonnet, the eyes have an unsettlingly fixed look; Vincent is smoking a pipe and a fat bandage covers his right ear.

A second version of this self-portrait has a background of

Van Gogh
Portrait of Doctor Félix Rey
January 1889
Oil on canvas
64 x 53 cm
Moscow, Pushkin Museum

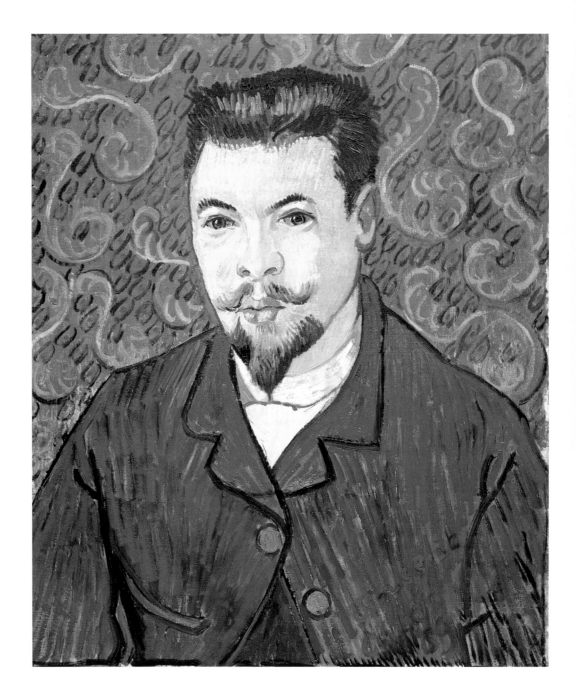

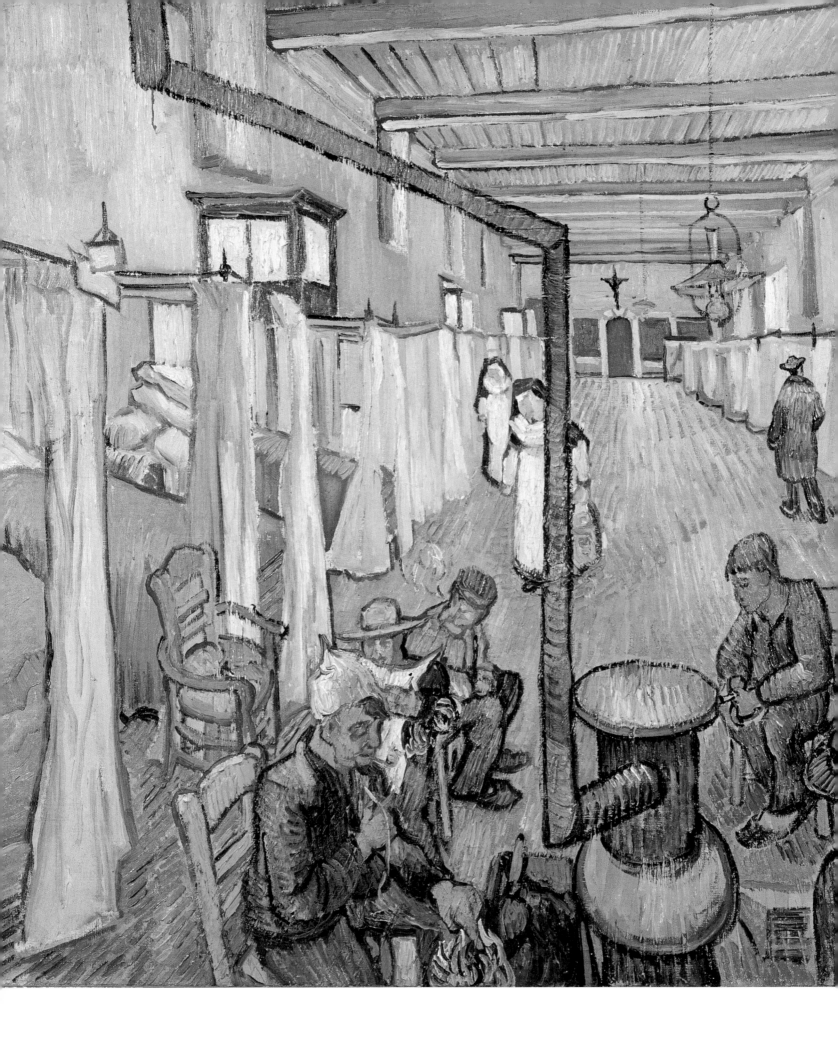

Japanese woodcuts; the pipe has gone and the eyes are much calmer, as if washed clean of their anguish.

Tongues wagged in Arles about the "crazy redhead": some people were afraid and a petition was circulated asking the mayor, "in the name of public safety" and "to avoid any further incidents", to have him admitted to an asylum. After a police inquiry Vincent was forbidden to leave the hospital and the Yellow House was placed under seal. Vincent informed Theo, but his tone was one of pained resignation: "Don't come and get me released, things will work themselves out."

When Signac came to see him, Dr. Rey, judging his state satisfactory, gave him permission to go out. Despite the seals on the house, Vincent insisted on showing his friend his current paintings and once again felt "the urge and the taste for painting". "I found your brother's physical and mental health perfect," Signac wrote to Theo, but without mentioning that that evening he had caught Vincent trying to drink turpentine.

Van Gogh
Self-Portrait with Bandaged Ear
January 1889
Oil on canvas
60 x 49 cm
London, Courtauld Institute Galleries

Letter written by Vincent Van Gogh
at the hospital at Arles

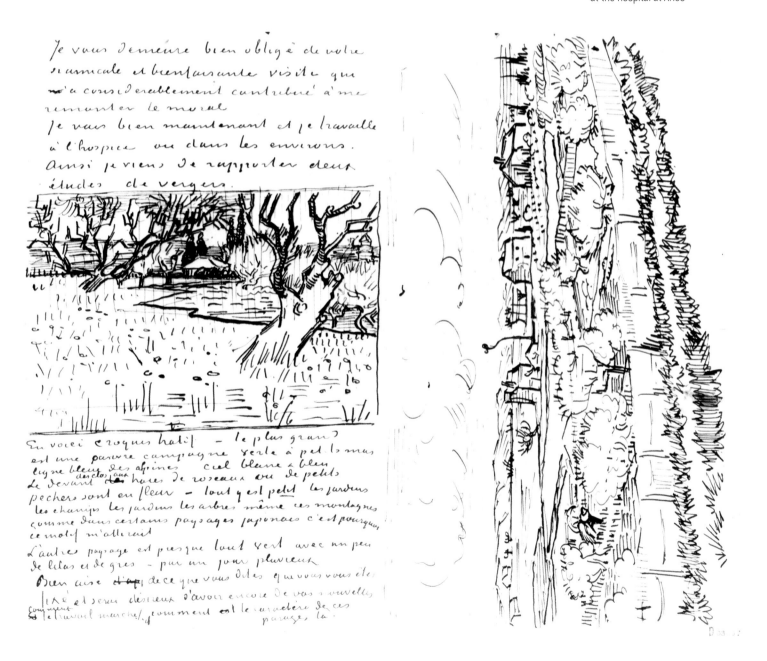

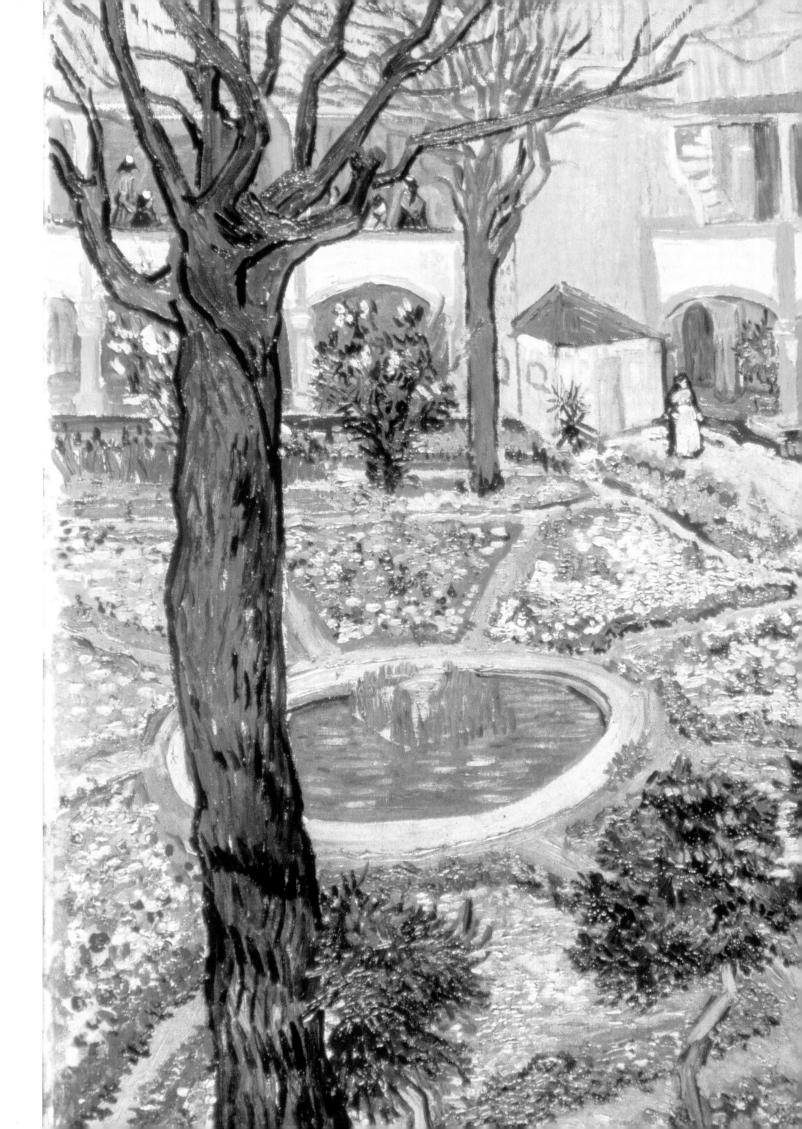

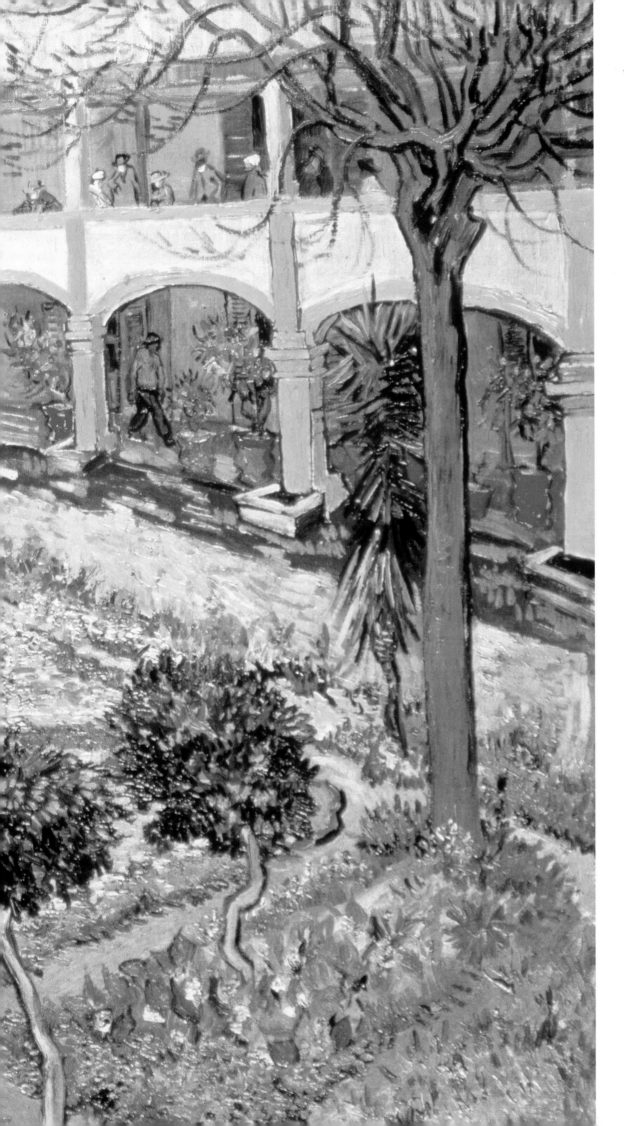

Van Gogh
**The Courtyard
of the Hospital at Arles**
April 1889
Oil on canvas
73 x 92 cm

Winterthur, Oskar Reinhart collection

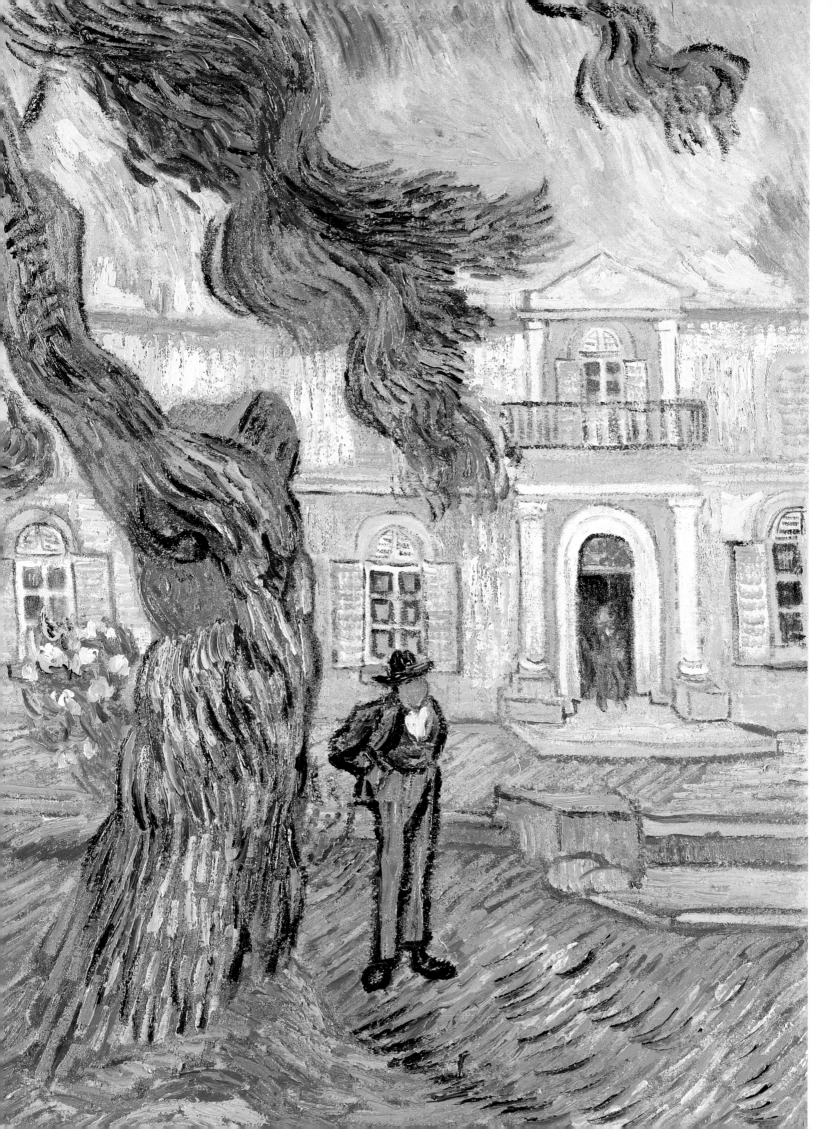

To prove that he was in full control of himself, Vincent made new versions of *La Berceuse*, the portrait of Madame Roulin and two bouquets of sunflowers in vases. In a return to the subjects picked up on his walks in the past, he painted *View of Arles with Trees in Blossom*, whose starkly defined trees are in strong contrast with the enormous area of the meadow in the foreground. But this year the weather was wet, without the bright promise of the preceding spring.

It was probably in late April, the letter to his sister indicates, that he painted a view from above of *The Garden of Saint-Paul Hospital*, with its arcades and orderly flower beds: "A picture full of flowers and spring greenery. Yet three dark, sad tree trunks cut across it, like snakes."
"I'm feeling fine," he wrote to Theo, "except for a vague feeling of sadness I can't quite describe." A year before, one of his canvases expressed his wonder at the joys of spring, but now he no longer dared to venture into Arles, where he felt himself hounded by one single, endlessly repeated word: mad, mad, mad…

What exactly was wrong with him? Initially unaware of his family background, Dr. Rey had spoken of epilepsy, an idea Vincent was ready to entertain. Like Dr. Urpar, he attributed his recent break-downs to his disorderly life and too much absinthe. Reverend Salles wrote to Theo that "There's something that escapes you about his state and no way of understanding the changes that come over him so suddenly and so totally." It was true, moreover, that once the crises were over, Vincent quickly became lucid again, as his analysis of his own behavior in the letters testifies.

One of the sharpest studies of the "Van Gogh case", by Dr. Henri Gastand,[1] mentions a source of epilepsy linked to "a cerebral lesion affecting the antero-internal part of the temporal lobe and the rhinocephalic structures along its interior." The cause of the lesion remains a mystery – Theo too suffered from neuropsychic problems – but the problem is one that today's medicine can treat.

In Vincent's mind, the idea of madness ran side by side with the uncertain, highly tentative nature of the diagnoses. He *had* to be mad to fulfill his destiny, to express via color the "terrible human passions" and the "tempest in the heart" that drove his work. Painting was a form of madness, the madness of his soul, his emotions and his instincts. Theo, whom he saw as both his own and his father's double, was his confidant, while painting was his outlet and his salvation. Vincent needed love, but for all his hope of attaining "true life" he had met only with failure. Even the friendship with Gauguin had sunk without trace.

Antonin Artaud would say of him[2]: "Van Gogh, mad? Let he who has been able to look at a human face take a look at the portrait of Van Gogh. I know not a single psychiatrist capable of scrutinizing a man's face with such overwhelming force, of dissecting its irrefragable psychology like a cleaver."

Van Gogh
Saint-Paul Hospital at Saint-Rémy de Provence
November 1889
Oil on canvas
58 x 45 cm
Paris, Musée d'Orsay

1 Henri Gastand, 'La maladie de Vincent Van Gogh à la lumière des nouvelles conceptions
 sur l'épilepsie psychomotrice', in *Annales médicales psychologiques*. 1956
2 Antonin Artaud: *Van Gogh. Le suicidé de la société, op. cit.*

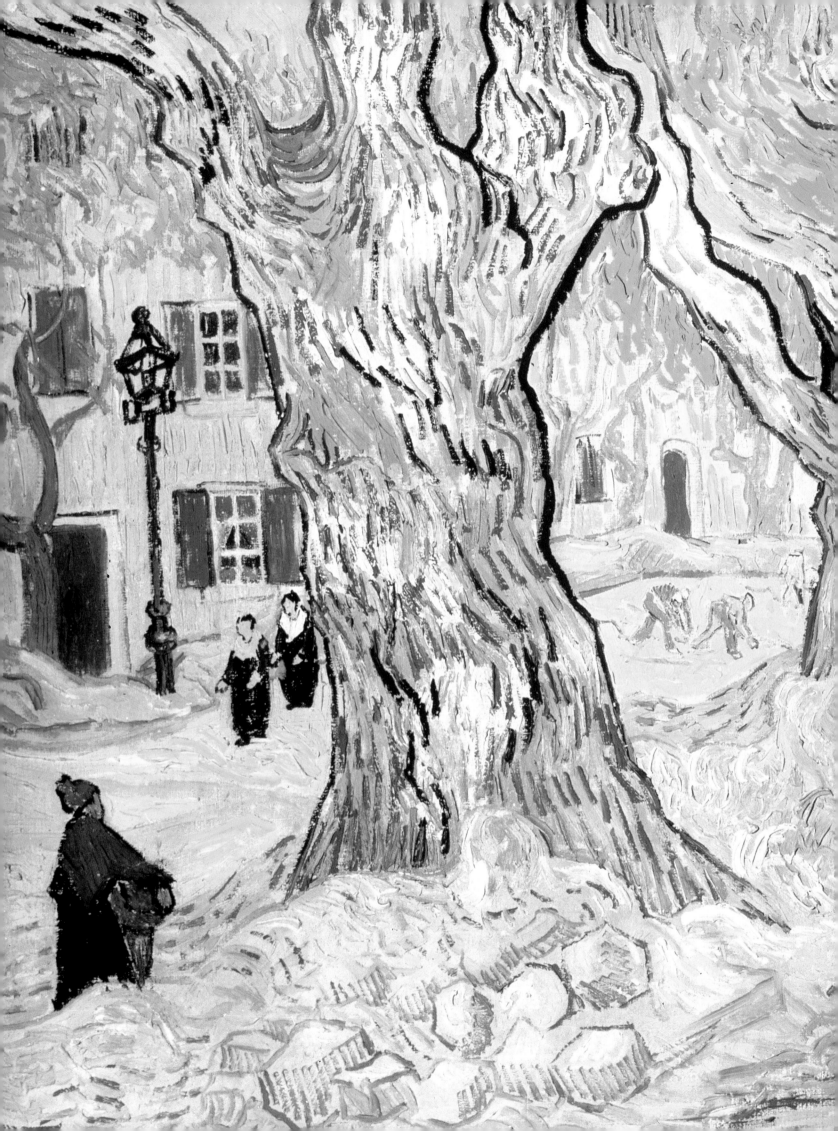

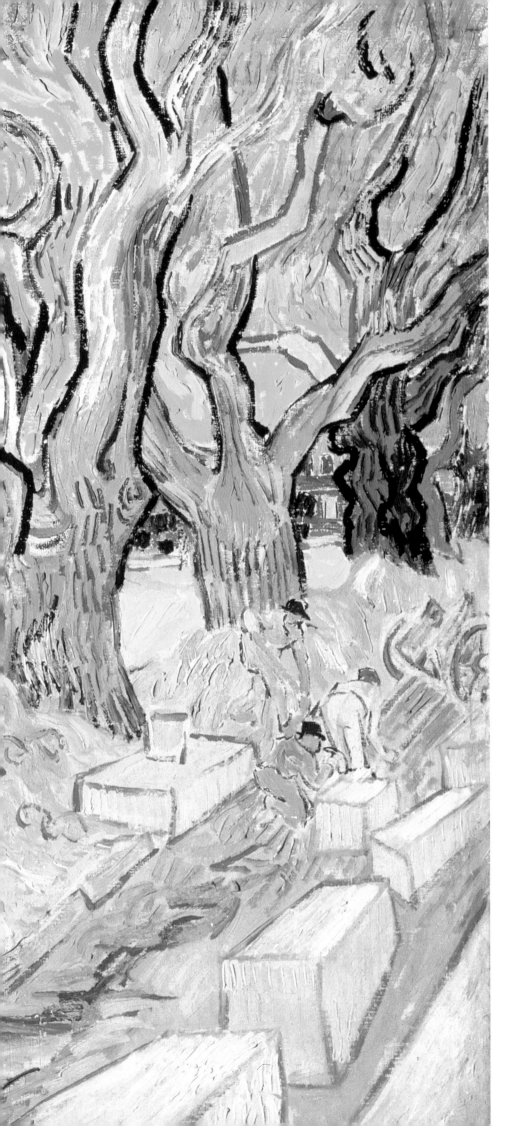

Van Gogh
The Road Menders
November 1889
Oil on canvas
71 x 93 cm

Washington, The Philips Collection

Van Gogh
Mountainous Landscape behind Saint-Paul Hospital
June 1889
Oil on canvas
70.5 x 88.5 cm

Copenhagen, Ny Carlsberg Glypotek

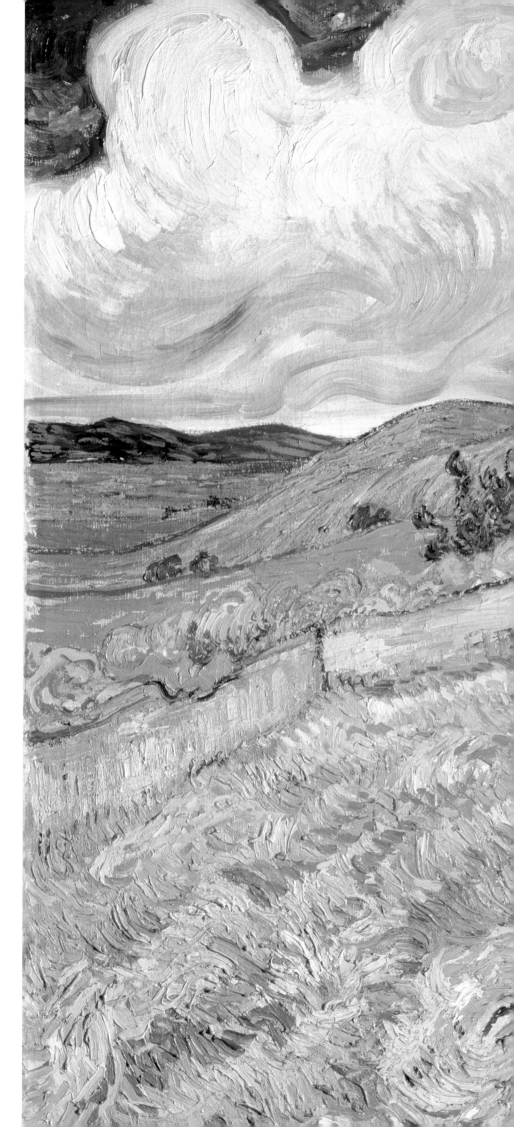

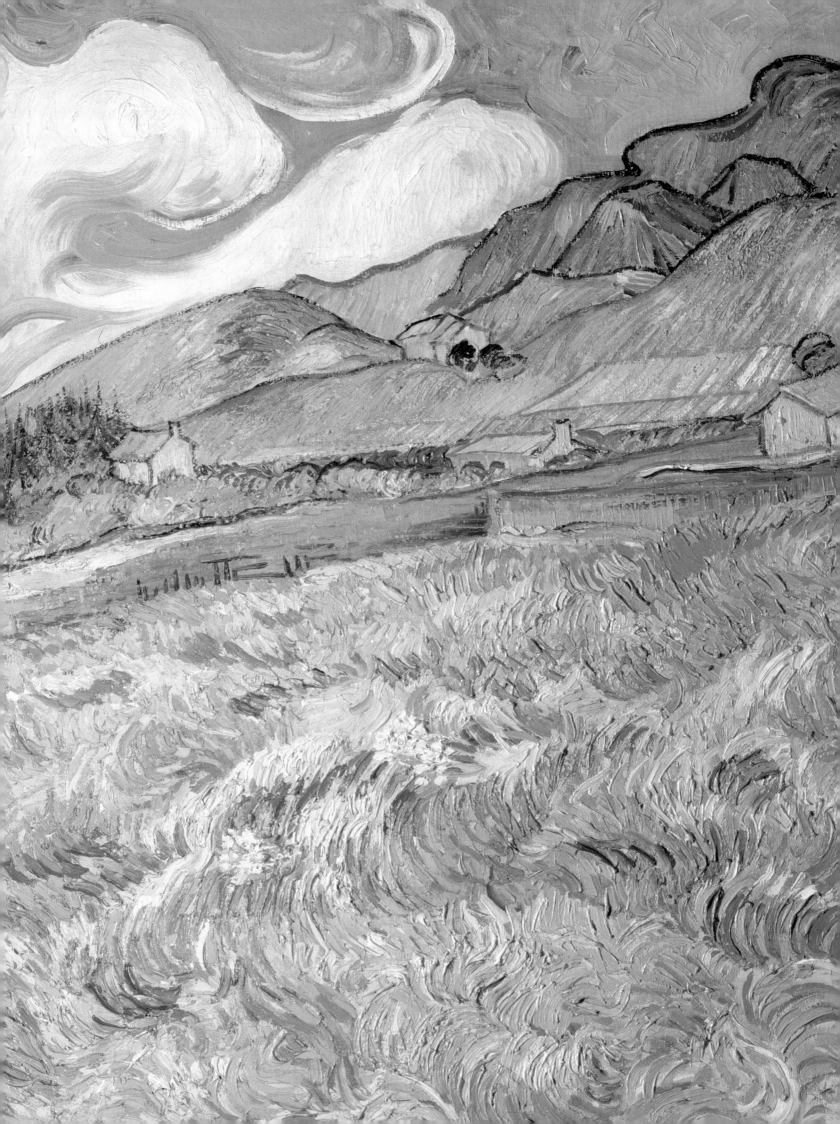

Van Gogh
Wheat Field with Cypresses
June 1889
Oil on canvas
73 x 96.5 cm
Zurich, Private collection

Theo had married Johanna Bonger in Holland in April, and in early May Vincent sent him two boxes of canvases. Then, at his own request, he was admitted to the Saint-Paul asylum at Saint-Rémy, not far from Arles. This twelfth-century monastery was a handsome but depressing place. On May 8, Vincent set out from Arles with Reverend Salles, to live among the insane until May 16, 1890.

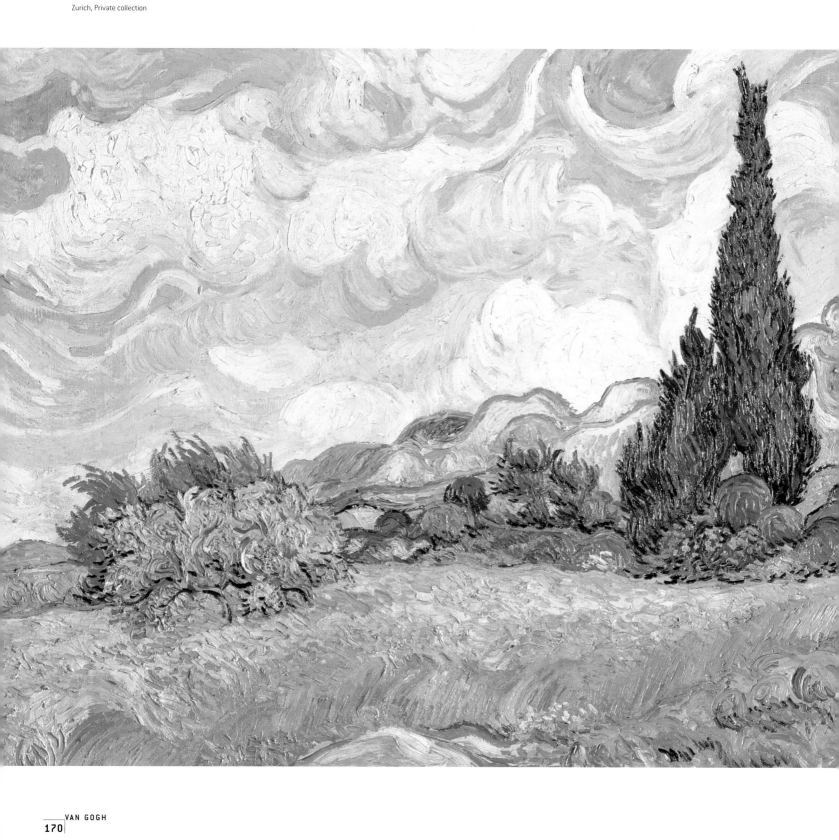

The earth convulsed

"I *assure* you I'm fine here," wrote Vincent to Theo on May 25. "I'm losing a lot of my fear of madness from seeing mad people close up." The real madness, though, lay in sending him to this terrible place, in surrounding him with the disturbed, the lunatic and the retarded; given his nervous state, how was he to survive the wailing, the cries of rage and despair, the ravings and moanings that made up the everyday atmosphere? The bars and locks made him feel safe, Vincent said, but they shut him in as well. He was allowed to work, however, and asked Theo for paints. Beginning with drawings, he rediscovered in the local countryside the postures of the peasants of Nuenen, portraying them in *Two Peasant Women Digging, The Sower and Peasant Digging*.

By June 25, he already had a dozen canvases under way, in addition to the drawings: trees with gnarled trunks, cypresses and fields seemingly torn by some inner upheaval. Under an implacable yellow sun *Wheat Fields with Reaper at Sunrise* roils with the same gold as *Wheat Field with Cypresses at the Haute Galline near Eygalières*, a mass of convulsions counterpointed by the heavy swirling of the storm clouds.

In *Starry Night* – a prolongation, as it were, of his Arles treatment of the same subject – clouds and stars wheel wildly across the sky, twisting and spiraling over a little village that seems to shrink into itself in search of shelter from imminent devastation. In the foreground of this nocturnal apocalypse, a dark cypress rises like the flame of a torch in a visionary image dear to Vincent's heart.

He was delighted by the news of a "great event": Johanna was expecting a child and he was to be the godfather: a hope of peace at last, in spite of his anxieties about Theo's health and his own. Accompanied by a guard from the hospital, he went to Arles to collect his paintings, looking in on the Ginoux family, the Yellow House and even Rachel; but a few days later, painting near the Glanum quarry, he had another attack and had to be taken back to the asylum at once. Yet through the long period of torpor that followed, his mind remained perfectly clear: "It's an appalling thought," he wrote to Theo in his long, analytical letter of September 10, "but we have to assume that these attacks will continue."

The South of France, to which he had come with so much hope, had brought only failure and disillusionment. Invited to show with the Les XX group in Brussels – Cézanne, Pissarro, Renoir, Redon and others – he found his thoughts returning northward, or to ideas of joining Gauguin in Brittany.

In quick succession he painted from memory two versions of his bedroom in Arles, a *Pietà* after Delacroix and a *Raising of Lazarus* after Rembrandt in which Christ is replaced by the strong, eternal sun. Asking Theo for more and more paints, from September through November, he painted and drew with tireless passion, creating self-portraits and finding a balance between his periods of calm and the attacks that called a temporary halt to his work.

Van Gogh
The Starry Night
June 1889
Oil on canvas
73.7 x 92.1 cm
New York, MOMA

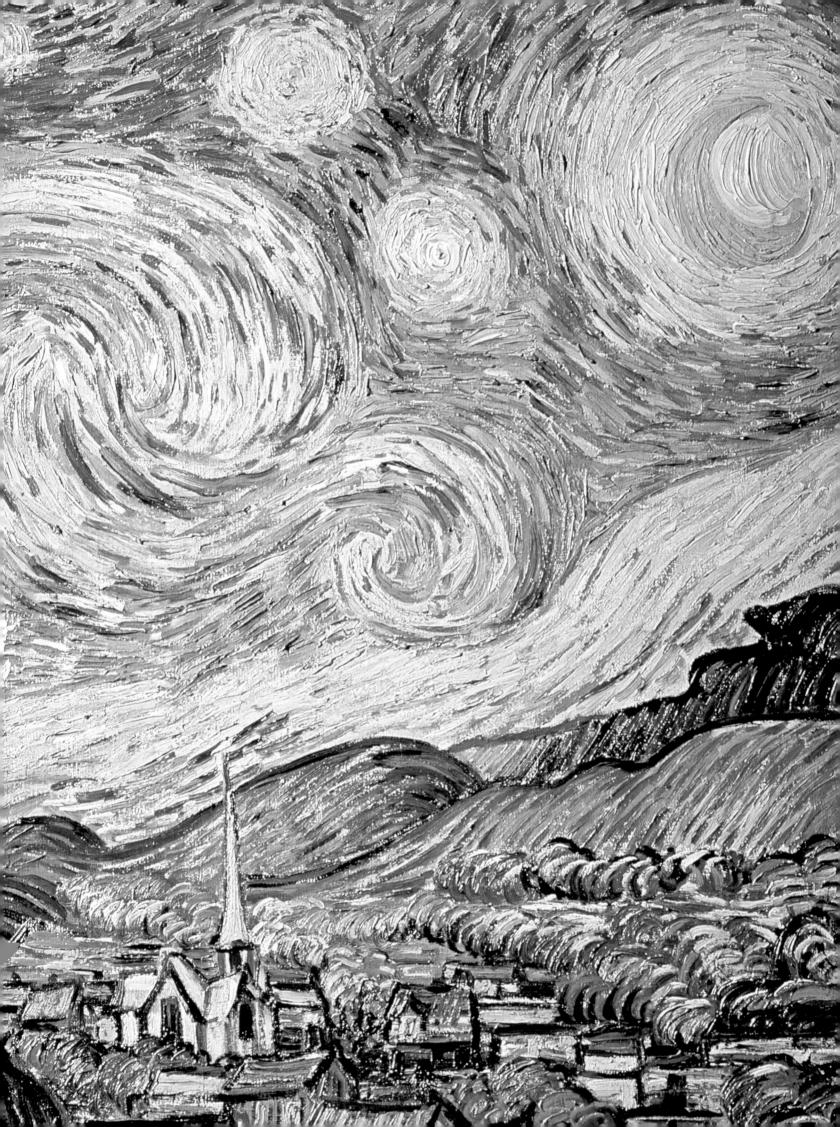

Van Gogh
**The Raising of Lazarus
(after Rembrandt)**

May 1890

Oil on paper

50 x 65 cm

Amsterdam, Rijksmuseum,
Vincent Van Gogh

With Johanna in mind, he copied –"using a range of violets and soft lilacs" – Millet's *Evening: The Watch* and *First Steps*, then moving on to *Prisoners Exercising*, after a Doré etching: in the foreground a prisoner glances towards us, revealing Vincent's drawn features, while the others take us back to those miners of the Borinage, trudging to the pit at dawn, already exhausted.

He painted, too, the portrait of his guard, Trabu, and his wife. Trabu accompanied him on his painting expeditions and Vincent saw in him something of "an old Spanish nobleman".

On February 1, Johanna gave birth to a son and Vincent's happiness was such that he painted "great almond branches in flower against a blue sky"; yet he did not want the child named after him.

Then came the totally unexpected: in the January 1890 issue of the review *Mercure de France*, he came upon an article about himself by the twenty five year old critic Albert Aurier. This was the only article about

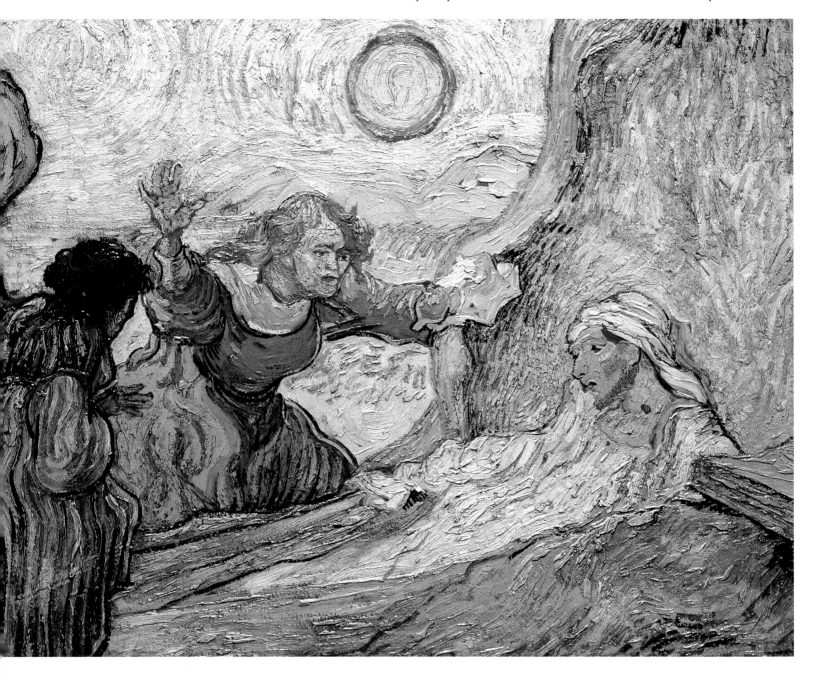

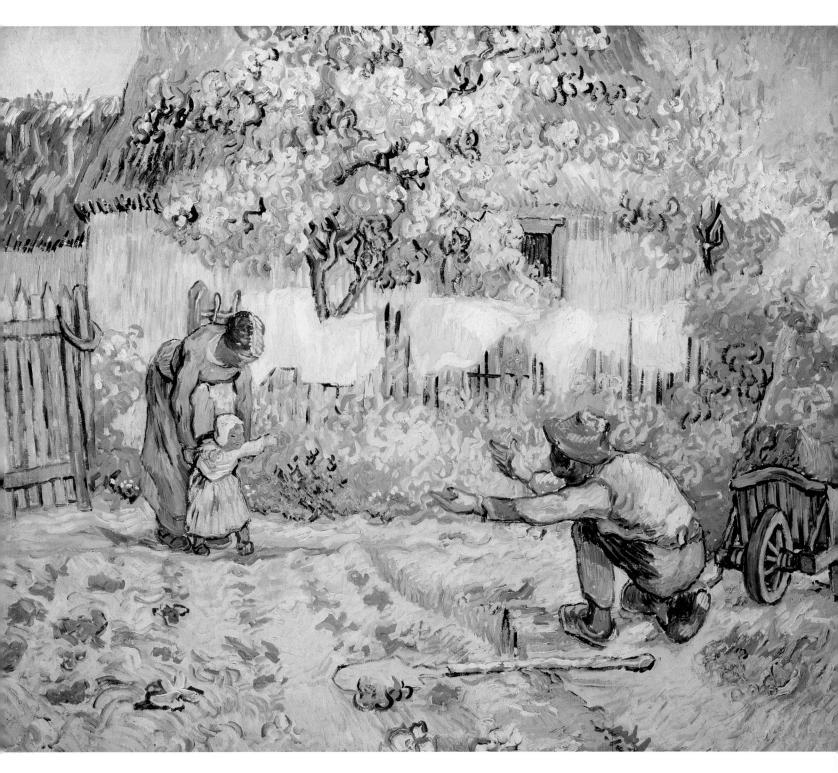

Van Gogh
First Steps (after Millet)
1890
Oil on canvas
72.4 x 91.2 cm
Ne w York, MOMA

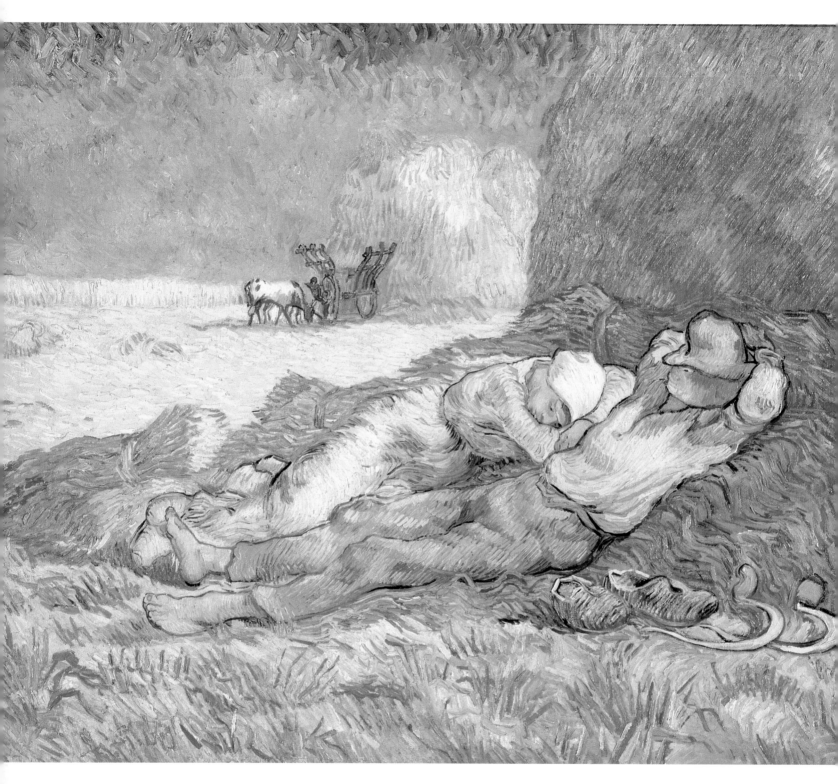

Van Gogh
Noon: Rest from Work (after Millet)
January 1890
Oil on canvas
73 x 91 cm

Paris, Musée d'Orsay

Van Gogh
Prisoners Exercising (after Doré)
February 1890
Oil on canvas
80 x 64 cm

Moscow, Pushkin Museum

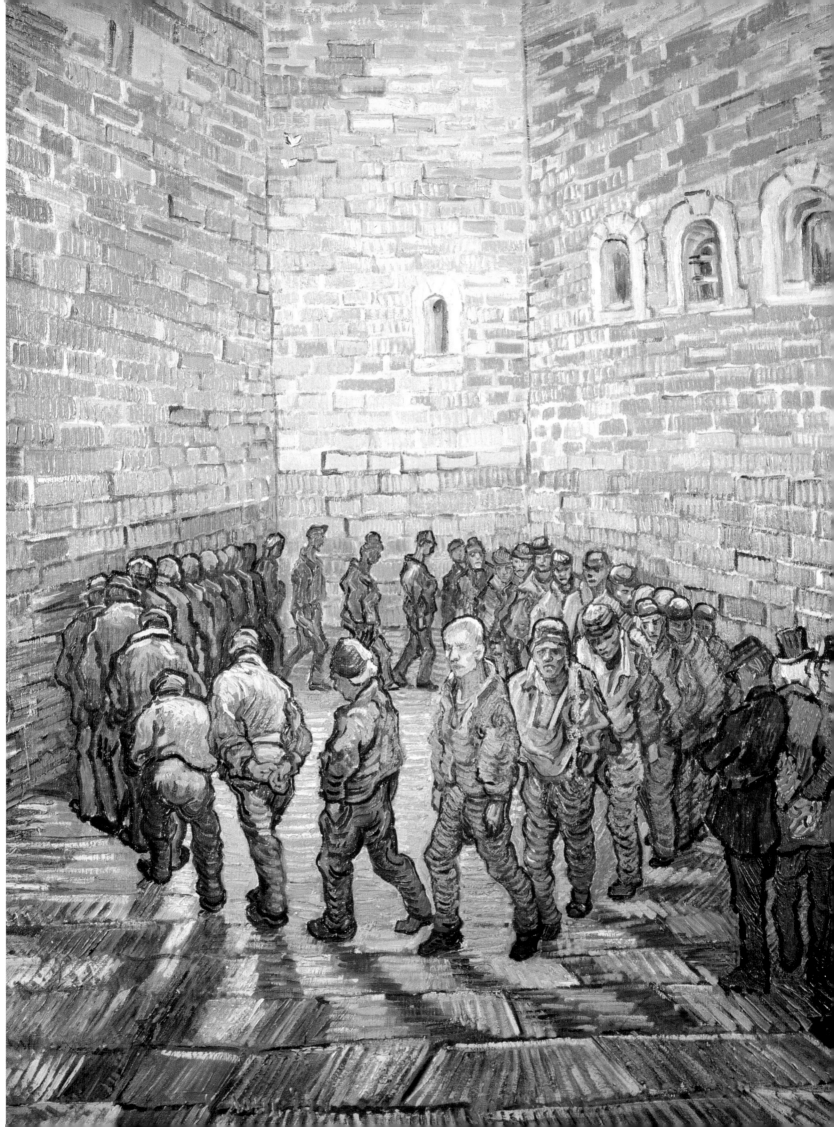

him to appear in his lifetime, but his name was subsequently mentioned on several occasions in the Brussels press coverage of the Les XX exhibition.

Although typical of the inflated style of the time, Aurier's article is full of the critic's enthusiasm on discovering Vincent's work at Père Tanguy's. Still exhausted from fresh attacks late in December, Vincent felt little elation; the lyrical overstatement baffled him and he felt himself unworthy of all this praise. "Thank you very much," he wrote to the critic. "You create color with your words but I don't deserve to be singled out like this." Aurier would do better, he suggested, to direct his compliments towards Gauguin and Monticelli, "for my role is, or will turn out to be, very much a secondary one." He requested that Theo ask Mr. Aurier "not to write any more articles about my painting...He's picked the wrong person, because frankly I feel too worn down by sorrow to cope with publicity."

Similarly, he showed no reaction to the near-incredible news that Anna Boch, sister of his friend Eugène and herself a painter and member of Les XX, had paid four hundred francs for his *Red Vineyard* at the exhibition in Brussels.

With the spring of 1889 had come fresh attacks preceded by periods of intense anguish and hallucinations. In *At the Foot of the Mountains,* the ground undulates to the point of disintegration and the furrows of *Field with Poppies* stream endlessly toward the distant horizon. Painted on June 16, the trees, fields and hills of *Olive Trees with the Alpilles in the Background* are swept away in a chaotic mass of distortion, while in *Cypresses* of June 25, these massively foreboding trees seem an orchestration of the violent pulsations of the landscape. In *A Road at Saint-Rémy* the cypress Vincent regarded as at once the "equivalent" and the "opposite" of the sunflower is sculpted by violent brushstrokes that hammer at the road and the fields under a swirling sky.

On Vincent's arrival in the Midi, sunflowers had appeared to him as the emblem of hope; and now, after all he had been through, cypresses had become harbingers of death.

Photograph of Johanna Van Gogh and her son 1890

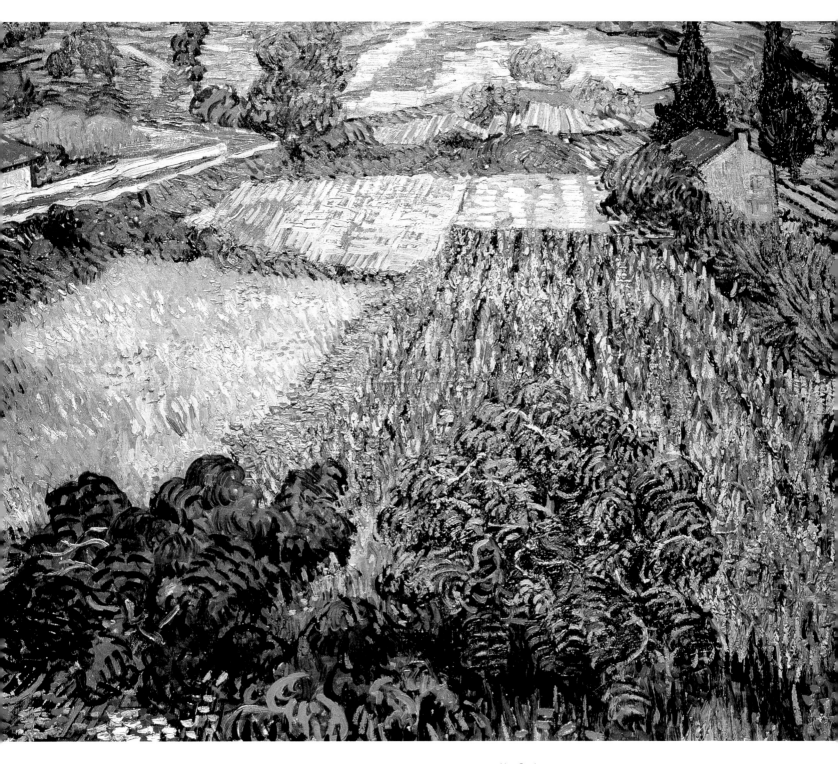

Van Gogh
Field with Poppies
June 1889
Oil on canvas
71 x 91 cm
Bremen, Kunsthalle

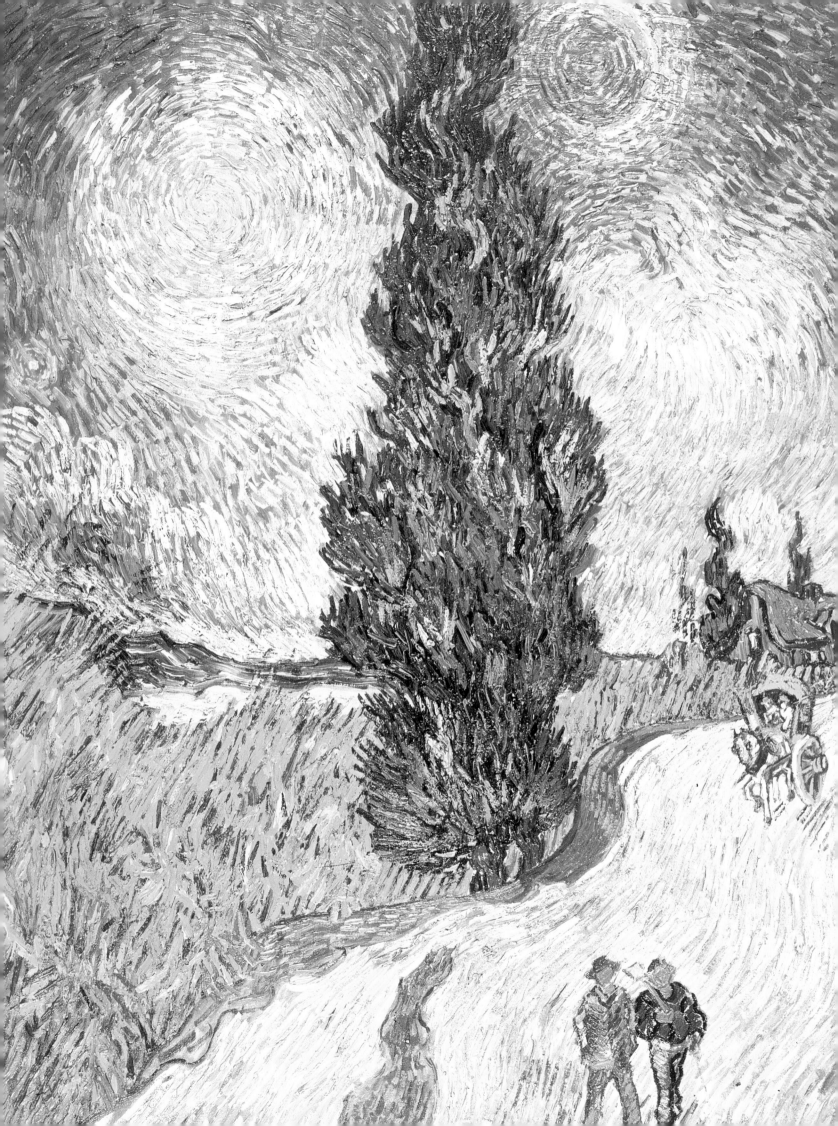

Totally worn out, he was haunted by a piercing melancholy. To Theo, a victim of the same illness, he confided how little store he set by himself and his art: his life, he felt, was a failure. The "lofty yellow" of the sun and the wheat fields, the yellow he had bestowed on the now deserted House of Friendship, was no longer an antidote and he thought only of getting away from the ill-starred Midi. Theo, writing to let him know that his paintings had been well received at the Salon des Indépendants, notably by Renoir and Monet, approved of his idea of moving north again in search of a new personal equilibrium. Before leaving the asylum, however, Vincent would move on from his sunflowers to breathe life into the irises, almond trees and white roses of Saint-Rémy. No longer entertaining any hopes of a cure, he portrayed himself, in *Old Man in Sorrow (On the Threshold of Eternity)*, as an "aging, balding workman in a patched overall," hunched over on his chair with his fists pressed to his eyes. On May 16, 1890, Vincent left Saint-Rémy.

Pissarro had advised Theo to take his brother to see Dr. Gachet, a specialist in mental illness who moved in painting circles and lived at Auvers-sur-Oise. Vincent arrived in Paris on the morning of May, 17 and spent two days at Theo's blissfully contemplating the baby in his cradle. Johanna, expecting someone ill and dispirited, discovered with surprise "a solid, broad-shouldered man with a healthy look about him". Vincent dropped in on Père Tanguy, visited the Salon du Champ-de-Mars where he admired the work of Puvis de Chavannes, and saw on the walls of the apartment some of the canvases he had sent Theo. But crowded, noisy Paris fatigued him and he left for Auvers on May, 21, "in a state of numbness". He had only three months to live.

Paul-Ferdinand Gachet was sixty-two. Of Flemish extraction, he had not been a brilliant student and only just managed to graduate in 1858 with a thesis titled *A Study of Melancholy*. This thesis has since been gone over with a fine-tooth comb by Professor François-Bernard Michel,[1] who finds it leaves considerable room for doubt about Gachet's knowledge and his competence in a case as com-

Van Gogh
Road with Cypress and Star
May 1890
Oil on canvas
92 x 73 cm
Otterlo, Rijksmuseum Kröller-Müller

Van Gogh
**Old Man in Sorrow
(On the Threshold
of Eternity)**
April-May 1890
Oil on canvas
81 x 65 cm
Otterlo, Rijksmuseum Kröller-Müller

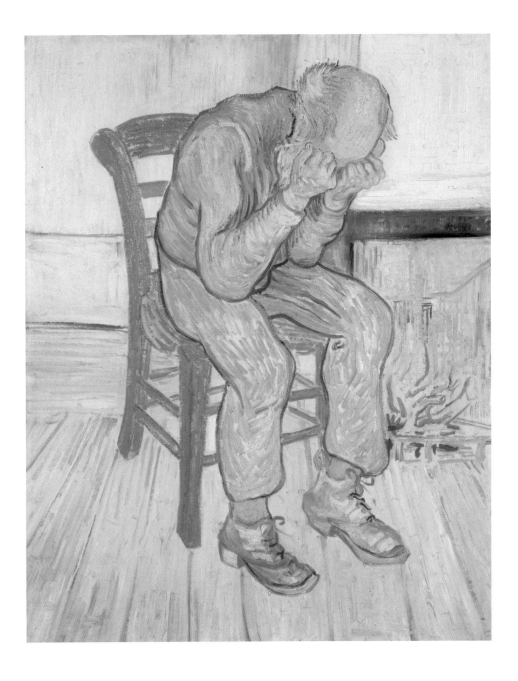

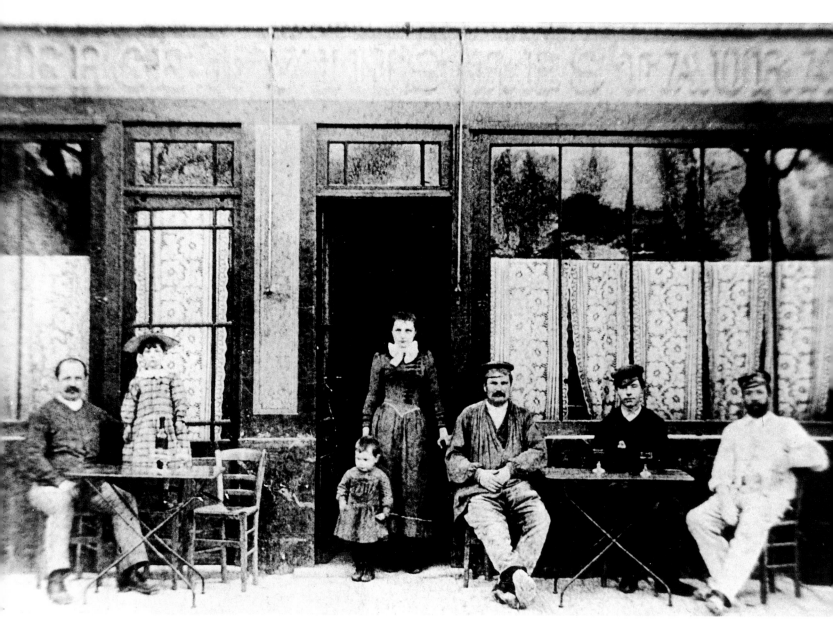

Photograph of the Café Ravoux at Auvers

plex as Vincent's. Gachet seemed to be unaware of the family background and also, maybe, of the recent episodes in the life of someone who had been entrusted to him with little real forethought.

Supposed to look after Vincent, he did not actually live at Auvers. A widower, he spent only part of his time there with his two children, the rest being taken up by his practice on the Faubourg Saint-Denis in Paris; there, as his prescriptions indicate, he treated "nervous conditions" while working in various other medical fields as well. In addition he was a painter and engraver under the pseudonym "Van Ryssel". He was friends with a number of artists, some of them living in Auvers or – like Guillaumin, Pissarro, Daubigny and Cézanne – users of his engraving studio.

A firm believer in homeopathy, he recommended life in the country as a calmative; this was why he had opted for a somewhat isolated house in Auvers for himself, his family and various animals. Vincent was to lodge at the Café Ravoux, on the town square, where his whitewashed

1 François-Bernard Michel: *La Face humaine de Vincent Van Gogh*, Paris, 1999

attic room cost him three francs fifty centimes a week. While he liked Auvers for its peace and quiet, Gachet himself, as he told Theo and Johanna in a letter dated May, 25, gave him the impression of being fairly eccentric: "His experience must stand him in good stead in his own case, however, for I must say he seems at least as gravely ill as me." The Vincent-Gachet relationship had its ups and downs, its moments of trust and of discord. Vincent was impressed by the house – like being "in an antique dealer's" – where every square inch of the walls was covered with old paintings that were "black, black, black, save those by the known Impressionists". In the same letter he mentioned "a very fine Pissarro, a winter scene with a red house in the snow, and two handsome Cézanne bouquets."

Photograph of Doctor Gachet
1890

In a letter to Theo and Jo dated June, 4 he reported that, "I feel I can do a reasonably good painting every time I go to his house...but it's an ordeal for me going there for lunch and dinner; with four or five dishes it's as dreadful for him as for me, for he certainly doesn't have a very strong stomach."

Asking his brother for ten yards of canvas and twenty sheets of Ingres paper, Vincent embarked on a number of landscapes and planned a portrait of the doctor who, he said, was "absolutely fanatical" about one of the self-portraits he had brought from Arles. "He wants me to do one of him, if I can, exactly like that." He also had in mind a portrait of the doctor's twenty-one year old daughter.

"I *would like*," he wrote to his sister, "to make portraits that people a hundred years on will see as apparitions." And added a few days later, "I've done the portrait of Mr. Gachet with a melancholic expression which people looking at the canvas might see as a grimace. "The expression of someone distressed by our age," he confided to Gauguin. What Vincent had set out to portray was the double of his own melancholy.

Drawing once more on his memories of the Nuenen years, he por-

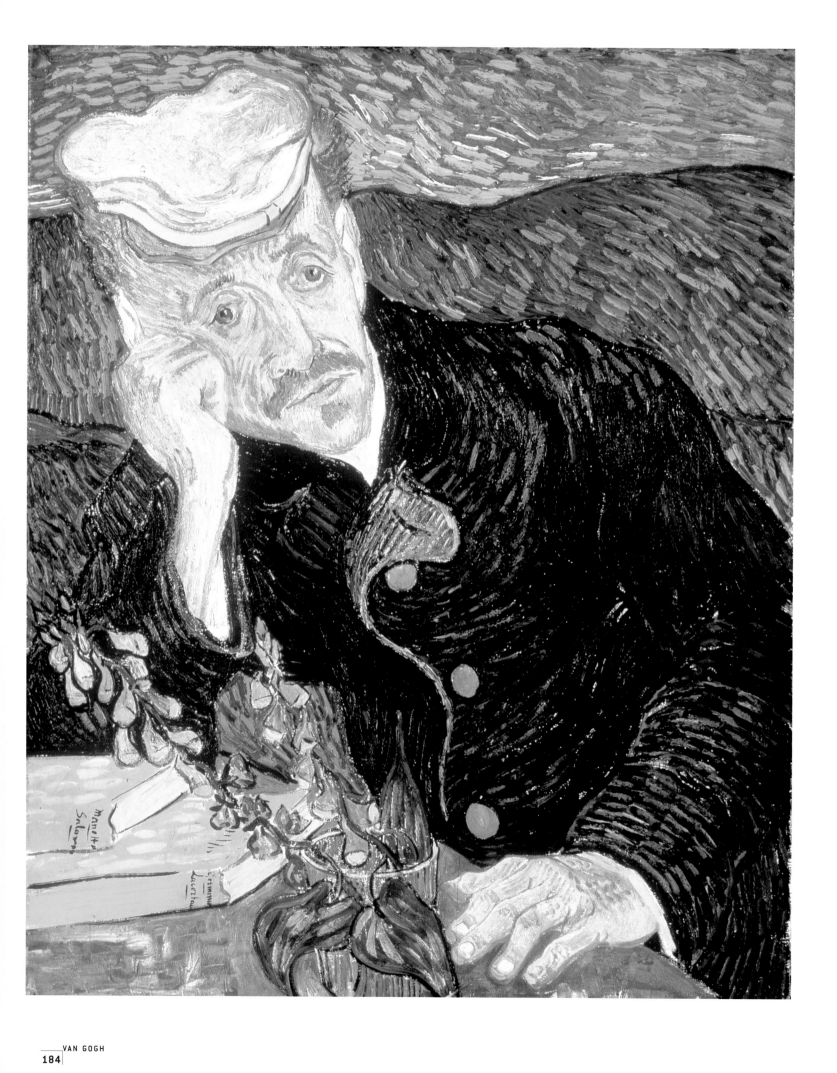

trayed life and work in the fields in *Thatched Cottages in Montcel*, *Thatched Cottages in Cordeville*, *Village Street and Steps in Auvers with Figures* and *Daubigny's Garden*. *Garden in Auvers* is a veritable mosaic of the joyous colors of the plants and flowers – a symphony of ocher and greens speckled with bright reds.

The Church at Auvers, however, shatters this gentle harmony, although this example of pure Île-de-France Gothic, sitting squarely on its foundations, seems to stand up to the threatening convulsions that rend the earth around it. However, another Auvers painting, *Landscape with Carriage and Train in the Background* shows "fields seen from high up, with a road and a little carriage." As in the market gardens at La Crau, all is serenity and harmony in the blurred advance of the broad fields, divided in the distance by the white, eddying smoke of a train. At this

Van Gogh
Portrait of Doctor Gachet
June 1890
Oil on canvas
66 x 57 cm
Private collection

Van Gogh
Thatched Cottages in Cordeville
June 1890
Oil on canvas
73 x 92 cm
Paris, Musée d'Orsay

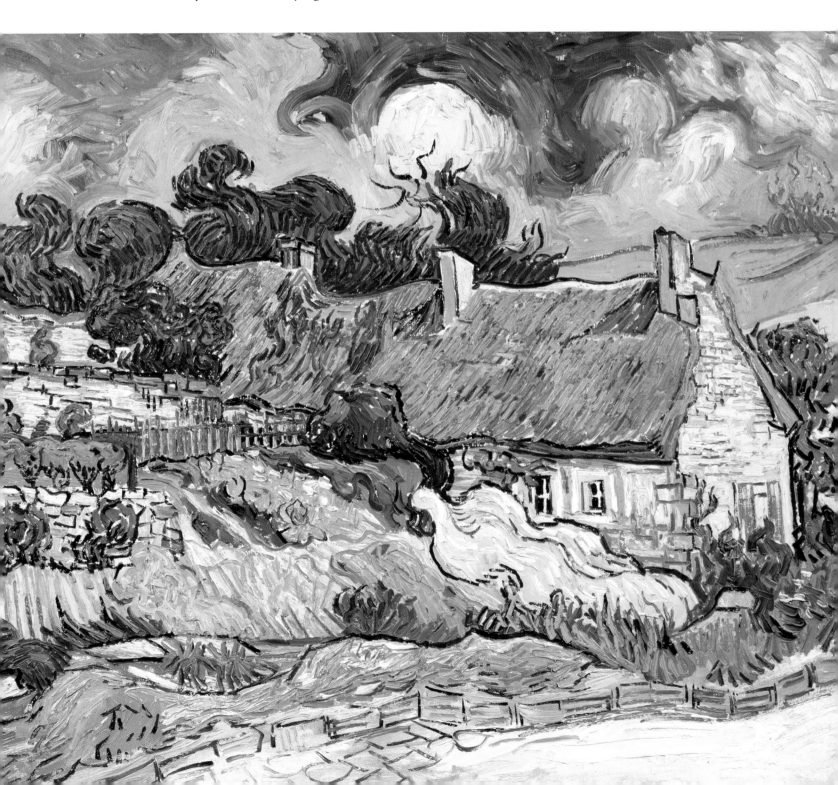

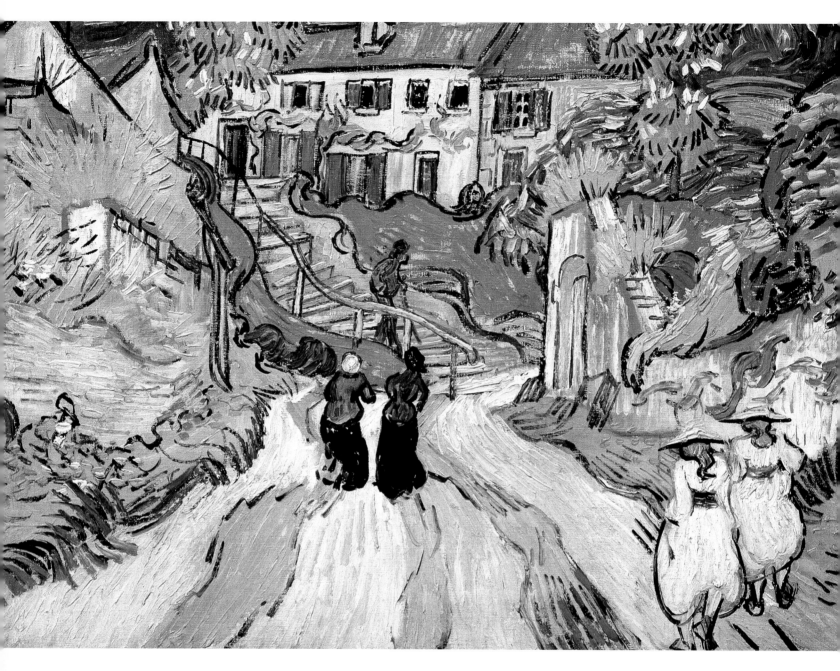

Van Gogh

Village Street and Steps in Auvers with Figures

May 1890

Oil on canvas

49.8 x 70.1 cm

Saint Louis, The Art Museum

Van Gogh
Landscape with Carriage and Train in the Background
1890
Oil on canvas
72 x 90 cm
Moscow, Pushkin Museum

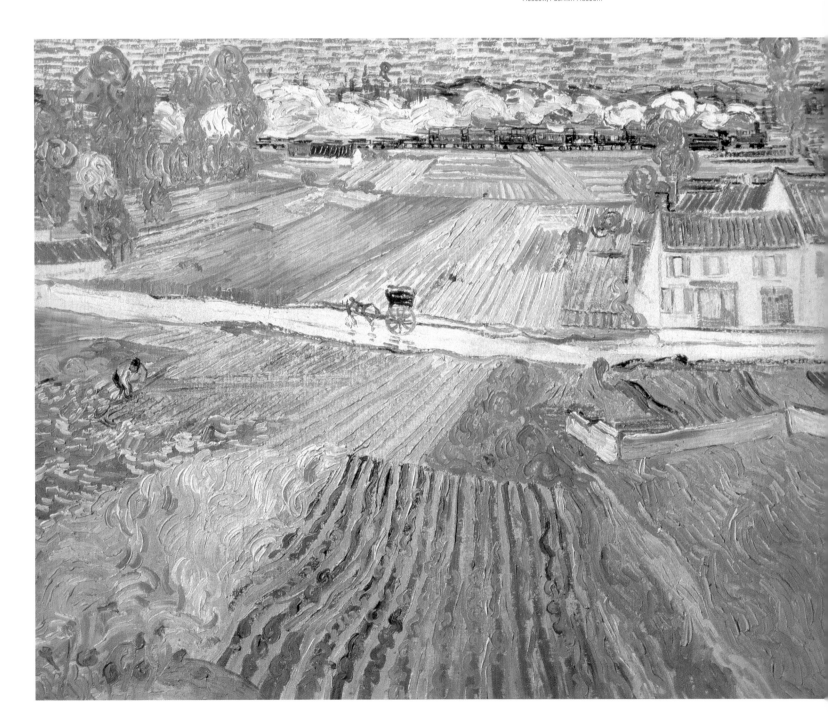

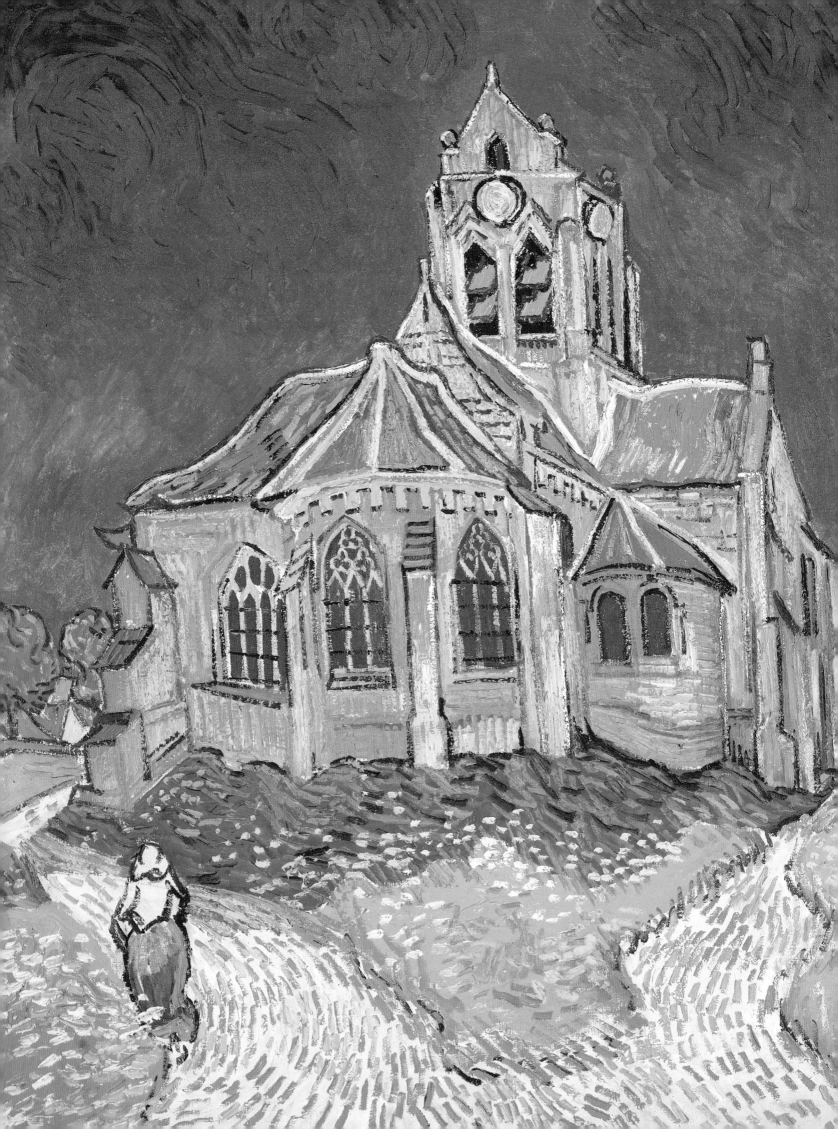

time Vincent's colors were mostly light – blues, reds, ochers and mauves – and his skies less tormented.

Vincent strode through the little streets of the village and endlessly crisscrossed the surrounding countryside, sometimes in the company of Walpole Brook, an Australian painter who had been living in Auvers for some years and whose pictures he found "pretty dull". After June 15, there was also the Dutch painter Hirschig, recommended to him by Boch. "Funny, isn't it," Vincent wrote to Theo, "that the nightmare should have just about come to an end here."

Pleading business pressures, Theo excused himself for not answering all his brother's letters, but did not omit to mention that several painters were interested in exchanging canvases with him: "Guillaumin is offering a magnificent *Sunset* that used to be at Tanguy's; it would look really good in your studio." He also let Vincent know that Dr. Gachet had called: "He says he thinks you're cured and there's no reason why it should all start up again. We're invited out to see him next Sunday. You'll be there too and we're really keen to come."

A few weeks earlier, Vincent had been anxious about the health of his godson Vincent Wilhelm, and was delighted when Theo, although suffering from bronchitis and nephritis, arrived on Sunday, June 8, with Jo and the child. They had lunch together at Gachet's. "It gave me," Vincent wrote his mother, "the pleasant feeling of living closer to them." They all hoped to visit their mother in Holland for a few days and the idea was very much on Vincent's mind.

His portrait of Gachet was followed by several versions of *Young Peasant Woman with Straw Hat Sitting in the Wheat*. He sent one of the sketches to Theo, mentioning "a big yellow hat with a sky-blue bow, a very red face, a coarse blue camisole with orange spots, and ears of wheat in the background." He also completed several versions of *Portrait of Adeline Ravoux*, his innkeeper's daughter, and one of *Marguerite Gachet at the Piano*. Two sketches for the latter work went into a letter to Theo with the details: "The background wall green with orange dots, the carpet red with some green, the piano dark purple…This is a subject I painted with great pleasure." Gachet, he went on, had promised to get her to pose again, "this time with a little organ."

In a long letter of June 30, Theo confided in him regarding his business and financial concerns. Should he take a new apartment, move to Antwerp, move to Holland? Was he going to quit Boussod and Valadon, "those rats who treat me as if I'd only just begun working for them and keep me short of money", and set up for himself? He asked Vincent's advice, but at the same time told him, "Don't start worrying about me or us. I just want you to know that the greatest pleasure is seeing you fit and well and knowing your work is so good. You've already got too much on your mind." And he still saw some point in expressing the hope – to a brother who was such a burden – that one day he would have "a wife to whom you can talk about these things; while I often have to shut up and blank my mind out." Vincent, however, was not fooled by these diversionary tactics, and knew that, being totally dependent on his

Van Gogh
The Church at Auvers
June 1890
Oil on canvas
94 x 74.5 cm
Paris, Musée d'Orsay

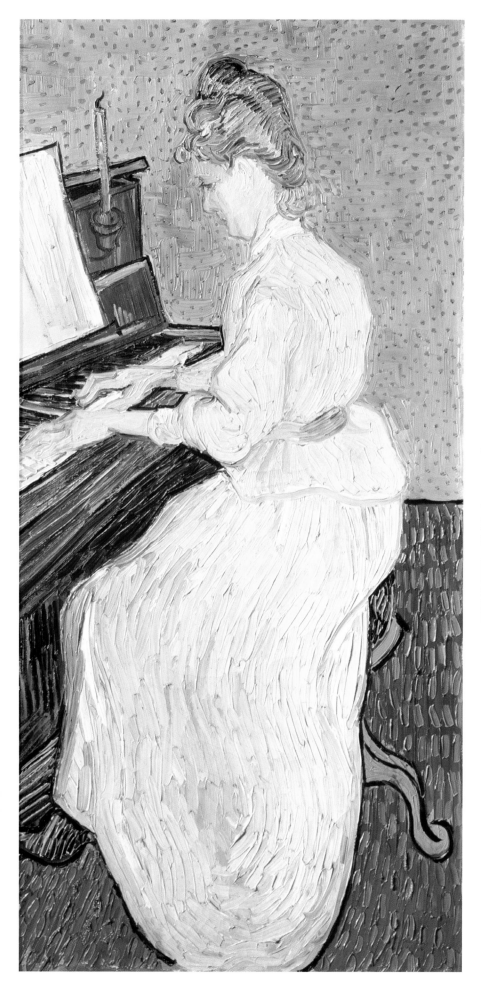

Van Gogh
Marguerite Gachet at the Piano
June 1890
Oil on canvas
102 x 50 cm
Basel, Kunstmuseum

Van Gogh
Marguerite Gachet in the Garden
June 1890
Oil on canvas
46 x 55 cm
Paris, Musée d'Orsay

brother, the change in his situation would have disastrous consequences. In his mind, he could already hear Jo's complaints to her husband.

Theo was the only one who had ever really had faith in this ever-changing, fragile brother, who had continued to encourage him and tried, against the wishes of his employers, to sell his paintings. He had never failed to send him the money needed for food, lodging, canvas and paints and had never abandoned him, even during the humiliating time with Sien. And he shared his brother's illness, too.

Vincent had decided to go to Paris on Sunday, July 6. There he saw Aurier, Lautrec and Bernard, but there were difficult discussions with Theo and Jo, and he knew what a millstone he was for them at a time when his brother was thinking of leaving his job. His fear that they would move to Holland became more intense when he learned they were to spend their holidays there. We cannot know what actually happened that day, but Jo later spoke of a "painfully tense" atmosphere. And Vincent, supposed to stay for several days, left the same night.

As soon as he got back to Auvers, he penned a short note to Theo expressing his uncertainty and confusion, and a long letter advising against the stay in Holland, in the interests of their health and the baby's. He waited until the following Thursday for a word of explanation or clarification, but finally it was Jo who wrote. Vincent said of this letter that it arrived "like a message from the Gospel, a deliverance from the anguish" of the hours spent together "when we all felt our daily bread in danger."

"I often think of the little one," he wrote. "I think it's better to bring up children than to put all one's nervous energy into making pictures, but now I'm too old – or at least I feel too old – to backtrack or want to do anything else. I've lost the desire for it, even if the inner pain is still there."

Visiting the Gachets, he would hear Marguerite, whose portrait now hung in the living room, playing the piano to soothe her father's melancholy.

The relationship between Vincent and Gachet, however, was deteriorating; both were extremely edgy people and their contacts were a mix of mutual understanding and antagonism. The doctor may have felt that Vincent was interested in his daughter: the painter had visited during his absence – a point Gachet did not fail to take up with him – but during the sittings for the portrait there had been no untoward incidents. Once, when Vincent chided the doctor with not keeping a promise to have a Guillaumin painting framed for him, Gachet put him in his place and the offended Vincent's hand went to his pocket; a sharp look from the doctor halted him and Vincent left the room, abashed.

What seems surprising here is that Gachet himself did not follow up on Vincent's gesture. Was he armed? Ravoux was said to have given him a revolver to frighten off the crows that bothered him when he was painting; another version had it that he had bought the pistol – the same one he would use on July 27– from Leboeuf, a gunsmith in Pontoise. But during all his time at Auvers, Vincent had never once visited Pontoise.

The French national holiday moved Vincent to paint *Auvers Town Hall on July 14, 1890*, portraying it as like the town hall in his hometown of Zundert. Hung with flags, streamers and lights, the building in the painting looks like a theater set, but the town square, inlaid with little sticklike brushstrokes, is deserted and the overall effect, on a day of popular rejoicing, is one of pathos. Now there remained only silence and solitude.

On the same day Theo wrote to tell him of the sisterly feelings Jo had for him, but also announced the news that Vincent feared: they were leaving for Leyden, where Theo and Vincent's mother now lived. Theo would continue on to Antwerp and would be back in Paris within a week. He sent his brother fifty francs.

A few days later, Vincent wrote to his mother and sister Wil: "I'm completely taken up by this endless expanse of wheat fields, wide as the sea against their backdrop of mountains. All delicate colors, yellow, green, the pale violet of a cleared, plowed field inlaid with regular rows of potato plants, of a land in flower, and all this under a delicate sky of blue, white, pink and violet…I'm in a state of total, almost excessive calm, the state I need to be in to paint all this."

Theo was back from Antwerp and on July 23, Vincent wrote thanking him for the money he had sent, including some sketches with his letter: "Maybe you'd like to see this sketch of Daubigny's garden, he says, adding, It's one of the pictures I most wanted to do. There's also a sketch of old thatched roofs and others for two paintings out of thirty showing enormous expanses of wheat after the rain."

Like the one written just before it, this letter, in which he orders paints for Hirschig and himself, contains no hint of hyperstimulation or derangement – just the "excessive calm" that perhaps worries him a little. He worked on *Wheat Field under Clouded Sky* and the violent, sweeping storm of *Wheat Field with Crows*, his last canvas: waves of yellow wheat bending under fury of the dark, torn sky and the flight of panic-stricken crows.

In this hallucinatory work it is not a question of Vincent's "madness" unleashing his deepest impulses and mangling the soil and the field of wheat; rather it is his exultation at the sight of nature's fury that drives him to vanquish the "almost excessive calm" and give his painting its fullest, most passionate potency. But Vincent himself was a crushed, broken man.

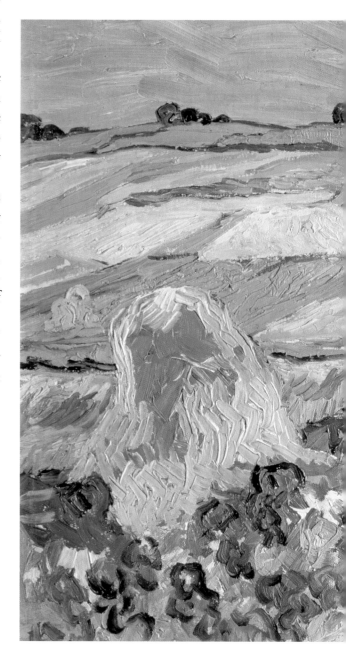

Van Gogh
Wheat Fields near Auvers
June 1890
Oil on canvas
50 x 101 cm
Vienna, Österreichische Galerie in der Stallburg

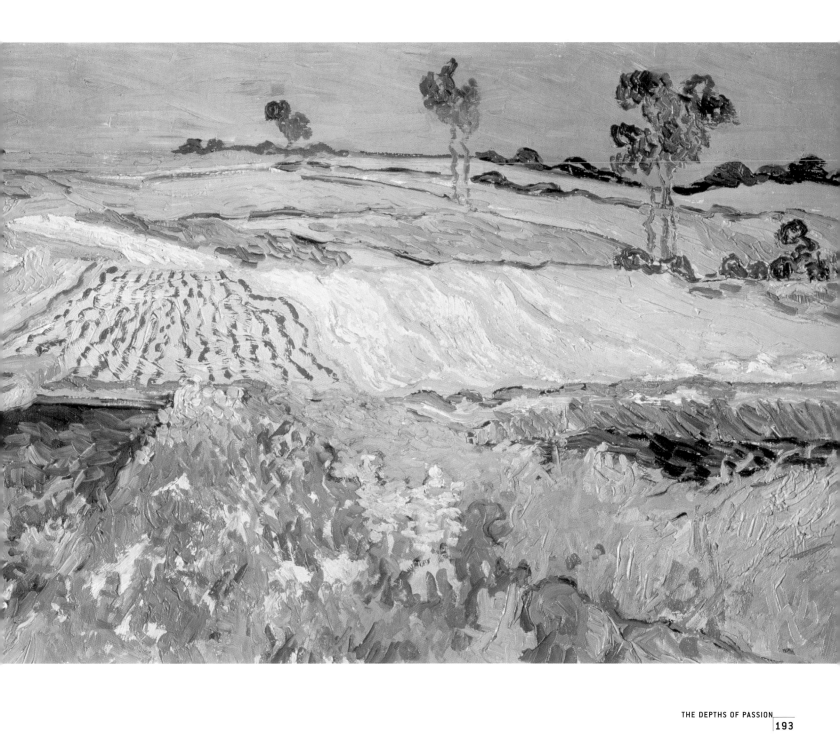

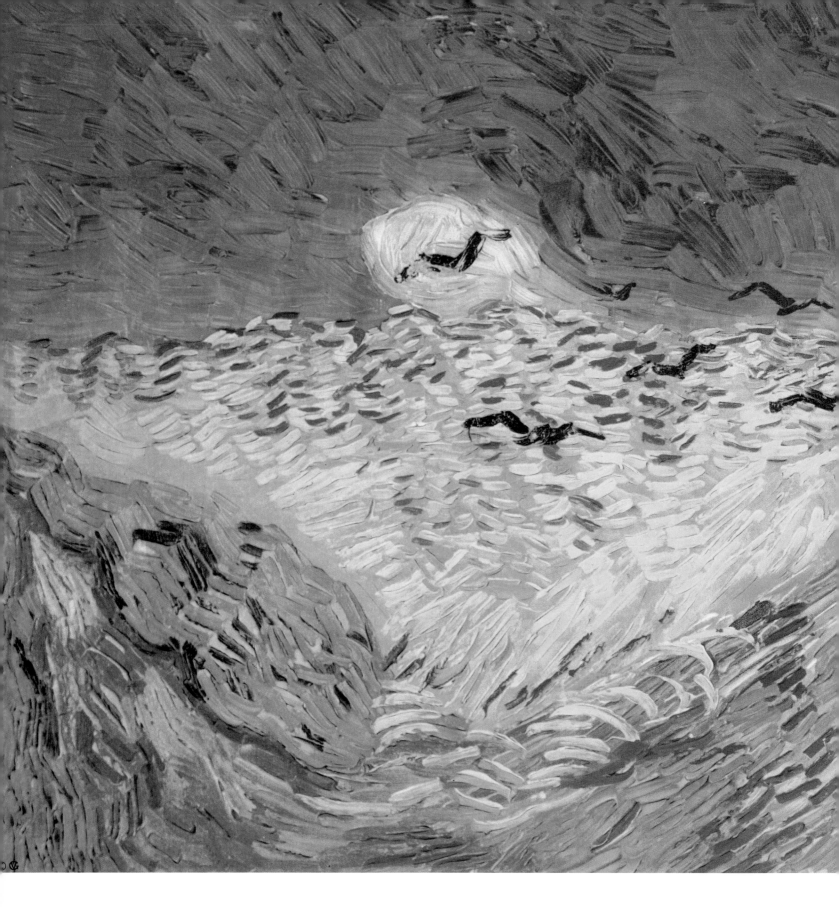

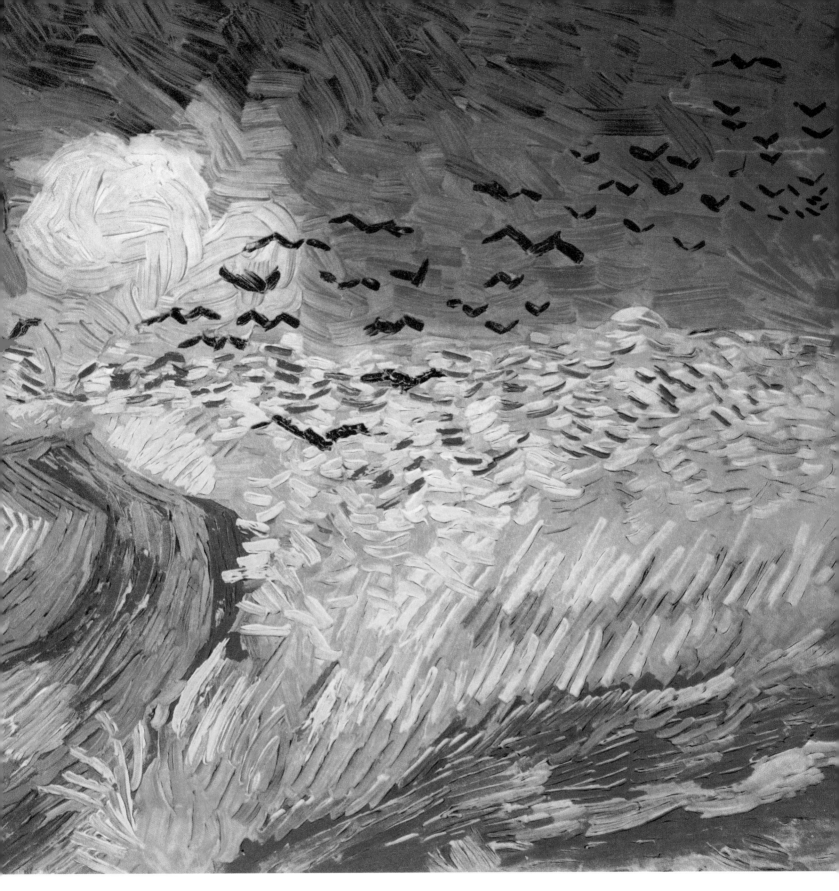

Van Gogh
Wheat Field with Crows
July 1890
Oil on canvas
50.5 x 103 cm

Amsterdam, Rijksmuseum,
Vincent Van Gogh

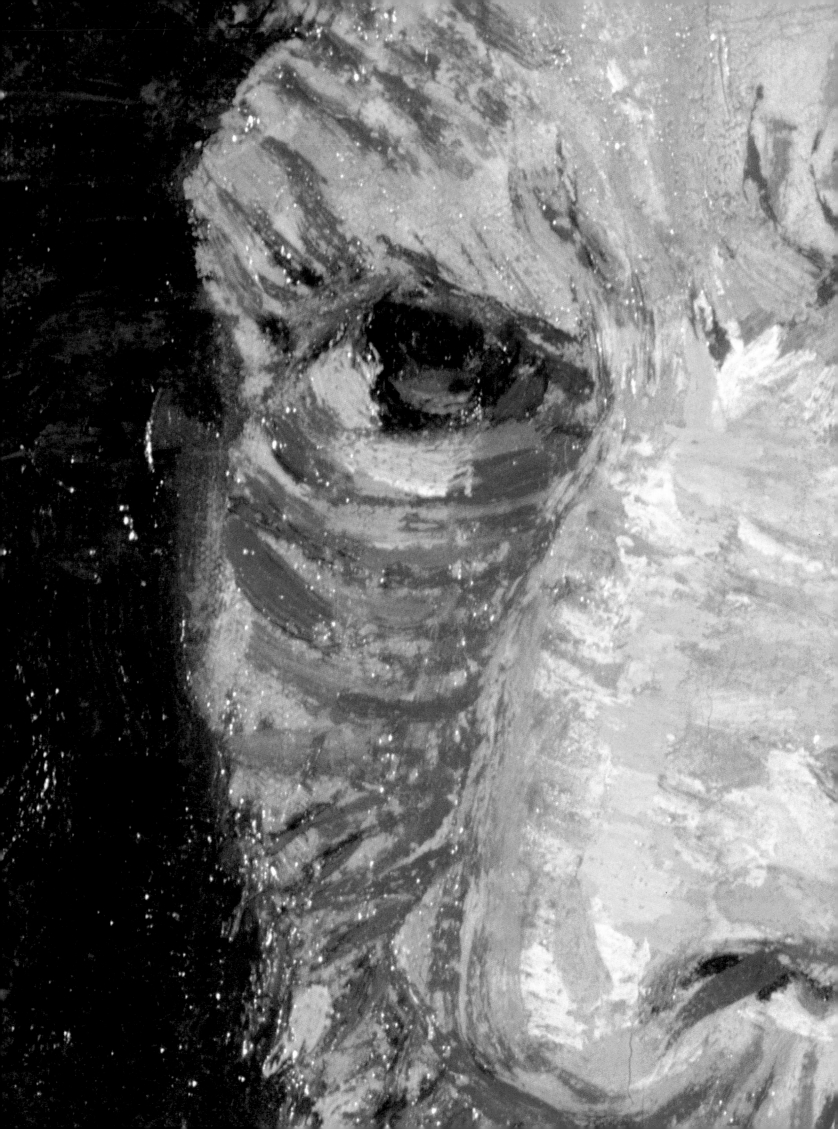

Who killed Vincent Van Gogh?

I did it for everyone's good

On the evening of July 27, doubtless out in the fields, Vincent shot himself in the chest; but the bullet was deflected and he staggered back to the inn, where he collapsed. Finding him covered with blood, the Ravoux called for Gachet, who brusquely declared it impossible to extract the bullet, but did not consider the possibility of sending the wounded man for surgery at the Pontoise hospital, only six kilometers away.

Oddly, Gachet did not have Theo's address and Vincent refused to give it to him, but Hirschig carried the news and Theo came immediately. Writing to Jo, still in Holland, he made no mention of suicide: "He's already been in this kind of desperate state and his constitution has pulled him through." Why did Gachet then call Mazery, the village doctor? Having done nothing to treat Vincent's melancholy and depression, did he now feel powerless and useless? Or did he see what Vincent had done as an ultimate, ineluctable act? In his examination of the case, Antonin Artaud later attacked this strange doctor with justified violence.

There were six people with Vincent, who lay smoking his pipe and groaning: Gachet, his son Paul, Dr. Mazery, Ravoux, Hirschig – and Theo, with whom he exchanged a few words in Dutch. Two policeman called to make inquiries, then went on their way. Did Vincent really say to his brother, "Don't cry, I did it for everyone's good"? And what else happened? Nothing. All that is known of those last hours comes from the written accounts of Paul Gachet, then aged seventeen and at pains to exonerate his much-castigated father.

Vincent died on July 29, at one-thirty in the morning. Gachet had gone, leaving him with his son and Theo. Completely shattered, Theo found a letter addressed to himself in his brother's pocket: "There was no need for you to reassure me about the peaceful state of your family. I think I saw both the good side and the other side…Since things are going well, why should I insist on less important matters; *after all, it will probably be a long time before we have the chance to talk business more calmly*…All we can talk about, really, is our paintings…In my work I risk my life and I'm already half crazy."

This is not the letter of someone who has made up his mind to kill himself.

First page of the last letter from Vincent to Theo, unfinished, Auvers-sur-Oise, July 24, 1890

Émile Bernard, who attended to the funeral, wrote to Albert Aurier: "The walls of the room where the body lay were covered with his last canvases…The coffin was covered with a white sheet and heaped with flowers: the sunflowers he loved so much, and yellow dahlias – yellow flowers everywhere. It was his favorite color…a symbol of the light he imagined in people's hearts, just as he did in his paintings."

The cemetery is uphill from the village. Gachet said a few words while Theo, in a state of collapse, could only thank those who had come: Gauguin's friend Laval, Pissarro's son Lucien, Père Tanguy, Hirschig, Ravoux and Bernard, who noted, "The sun was unbearable." Back at the inn, Theo made presents of Vincent's canvases to Gachet and the others.

During his time at Auvers, Vincent had done seventy-eight paintings and some thirty drawings. In the course of the 1950s, Paul Gachet, his attitude as enigmatic as ever, offered his father's collection in a series of three donations (the first in association with his sister Marguerite) to the Jeu de Paume museum, then devoted to the Impressionists. In addition to five Van Goghs and seven Cézannes, the donations included works by Guillaumin, Pissarro, Renoir, Sisley, Monet – and Dr. Gachet himself, signed Van Ryssel.

Vincent fired a bullet into his chest on that hot, stormy Sunday in July, but, it seems, without taking aim. Someone trying to kill himself aims at the heart; here, no vital organ was damaged and the wounded man managed to cover the several hundred yards back to the Ravoux inn. There exists no eyewitness account of what happened and no serious diagnosis by the two doctors concerned.

Vincent's makeup was such that each time he felt himself faced with failure, he was driven to a gesture of sacrificial self-punishment. When Kee refused him in Amsterdam, he held his hand over the flame of a candle; in Arles he threatened Gauguin, in whom he had so much hope, with a razor and then cut off part of his ear and took it to Rachel, the prostitute. During his visit to Theo and Jo in Paris on July 6, he had grasped what a burden he was to them and seen that his brother's plans for changing his job would create problems regarding the assistance Theo so generously provided.

For Vincent, his life and his art were completely dependent on Theo, who, by marrying and giving a child to Jo, had achieved the "true life" that had eluded his brother. Would Theo still be able to help? From 6 July, then, the sacrificial process was under way. Vincent did not mutilate himself in a fit of madness; the pistol shot turned a sacrifice into a suicide, while the passivity or incompetence of the doctors turned a gesture of desperation into a fatal act. And Theo was released from bondage.

After a series of epileptic fits that had unleashed a paralytic dementia leading to his committal, Theo died on January 25, 1891, six months after his brother. Initially buried at Utrecht, the body was transferred twenty-three years later, in 1914, to the cemetery in Auvers. There the brothers sleep side by side for eternity, under identical gravestones and beneath the same spread of ivy.

Photograph of the graves of Theo
and Vincent Van Gogh in the cemetery at Auvers

Antonin Artaud[1] would later write that Van Gogh was dispatched from this world by his brother, initially when he told him of the birth of his nephew. He was later dispatched by Doctor Gachet who, instead of recommending rest and solitude, sent him off to paint from life when he was well aware that Van Gogh would have been better off in bed.

One cannot afford to thwart so directly a lucidity and sensitivity of the kind possessed by the tortured Van Gogh.

There exist personalities ready, on certain days, to kill themselves over a mere contradiction. To do this, one does not have to be mad – identified and categorized as mad; all that is required is good health and being right.

In a similar situation I would be driven to a criminal act if, as has so often happened to me, I had to put up with someone saying, "Monsieur Artaud, you are raving."
This is what Van Gogh heard.

And this is what shaped in his throat the twisted blood-knot that killed him.

At the time of his death, almost the entire corpus of Vincent Van Gogh's work was held by Theo: a total of almost eight hundred paintings and as many drawings. As others, for various reasons, have been lost or destroyed, we may assume that in his lifetime, Vincent painted around a thousand pictures. After Theo's death, his widow, Johanna, carried on the struggle with the same passionate determination. Living with her son in the little Dutch town of Bussum, she worked continuously at making known the work of a brother-in-law who had so undeniably been a cross for her to bear; but in doing so, she paid tribute to Theo as well as to the memory of his brother.

The settlement of Theo's estate set the value of the canvases at two thousand florins, a ridiculous sum that did nothing to discourage Johanna, even as people were advising her to get rid of the "lunatic's paintings".

In Paris, a small Van Gogh retrospective was mounted at the seventh Salon des Indépendants in 1891, followed a year later by presentation of a hundred or so canvases at the Panorama Gallery in Amsterdam – without great success, but with a catalogue containing high praise by R.N. Roland-Holst. On March 31, 1891 the *Echo de Paris* marked the Salon des Indépendants with a major article, "Vincent Van Gogh", by the French novelist Octave Mirbeau. Mirbeau acclaimed the genius of one who "possessed to a rare degree that which distinguishes one man from another: a style." He later mentioned Vincent's tragic death in a novel, *Dans le Ciel*, that remained unpublished until 1989.

Van Gogh
Still Life: Japanese Vase with Roses and Anemones
June 1890
Oil on canvas
51 x 51 cm
Paris, Musée d'Orsay

1 Antonin Artaud: *Van Gogh. Le suicidé de la société, op. cit.*

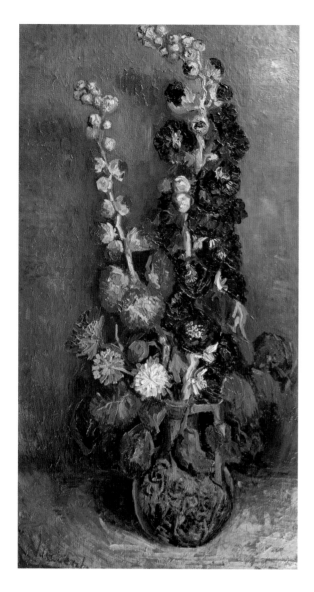

Van Gogh
Vase with Hollyhocks

August/September 1886
Oil on canvas
91 x 50.5 cm
Zurich, Kunsthaus

With Mirbeau, the first writers to urge recognition of his genius were Eugène Tardieu in the *Magazine français* of 21 April 1891, Émile Bernard in *La Plume* of September 1, of the same year, F. Keizer in *De Nederlandsche Spectator* of May 21, 1892 and Johan de Meester in a series of articles for the *Nieuwe Rotterdamsche Courant* in 1892. Vincent's most loyal admirer, Émile Bernard, included him in his book *Hommes d'aujourd'hui (Men of Today)* and wrote an impassioned article for the highly respected *Mercure de France*.

Bernard also organized publication of extracts from Vincent's letters to Theo and himself in the *Mercure de France* between April 1893 and February 1894, and these were taken up by newspapers and reviews in Holland and Sweden. A succession of other letters to Bernard, Van Rappard – who died in 1892 – Gauguin, Aurier, the Ginoux and, of course, Theo, appeared, but it was only in 1960 that Gallimard in Paris published Vincent's *General Correspondence*, edited by Georges Charensol in three thick volumes.

In 1893 Bernard presented sixteen paintings at the Barc de Boutteville gallery in Paris: the critics were reticent and the public hostile, but the young painters – especially the Gauguin-influenced group known as the Nabis – were enthusiastic. At the sale held after the death of Père Tanguy in 1894, a Van Gogh went for only thirty francs; but in 1900, art dealer Ambroise Vollard paid one hundred fifty francs for Dr Rey's chicken house stopgap. The following year a retrospective of seventy-one works at the Bernheim-Jeune gallery triggered a wave of excitement: "I love Van Gogh more than I love my father!" declared Vlaminck. The poet Hugo von Hoffmannsthal noted the sheer emotion he felt at this exhibition by a painter of whom he knew nothing: "I was assaulted by the unbelievable miracle of their violent, powerful existence…Everywhere about me I could sense the soul of the man who had done all this, and who, in this vision, had found the answer needed to save him from the fatal paroxysm of terrifying doubt."

From then on, one exhibition followed another around the world, with steadily mounting success. The untiringly devoted Johanna Van Gogh-Bonger organized the first and most comprehensive of them at the Stedelijkmuseum in Amsterdam in July-August 1905: four hundred seventy-three works, including two hundred thirty-four paintings. Yet the number of visitors over the two months did not reach two thousand.

Vincent's mother died in 1906 and Dr. Gachet took the secret of the painter's death to the grave in 1909. Johanna died in 1925; despite the opposition of her family, she had made her son, Vincent Wilhelm, sole legatee of his uncle's estate. Remarried, but widowed again in 1912, she sold a number of canvases out of necessity, then went to live in the United States, where she died. The main beneficiary was the wealthy Dutch collector Hélène Kröller-Muller, whose Van Gogh paintings and drawings now have a museum to themselves in Otterlo. Vincent Wilhelm became trustee for Vincent's oeuvre, and in 1928 a monumental catalogue was drawn up by the historian J.-B. de la Faille.

The man who emerges from the letters moved and intrigued those early readers, but the painter delivered a psychic shock. For the Fauves, whose canvases burst onto the scene at the 1905 Salon d'Automne, Van Gogh was nothing short of a revelation. Vlaminck, Derain, Matisse, Marquet, Van Dongen and Manguin experienced a deeply personal response to the expressive force, impassioned violence and intensity of color of the artist who had once said, "I'm not painting for myself, but for the coming generation." The enthusiasm of the Fauves was matched the same year by the German painters of the Brücke ("Bridge") Group in Dresden, while the Expressionists found in Vincent an echo of their anguish and existential malaise.

The name Van Gogh now became a synonym for pure painting, for the passion underlying it, the attendant suffering and the solitude that appeared vital to Vincent's expression of his genius.

His reputation rapidly increased: in Paris in 1906 *Vase with Hollyhocks* was sold for 2,500 francs and *Bowl with Sunflowers, Roses and Other Flowers* for 4,000 francs. The leap in prices really began in 1913, with the sale of an Arles *Still Life* for 35,800 francs. The First World War calmed things down, but in 1931, *Windmill on Montmartre* fetched 77,000 francs and *Bridge at Trinquetaille* no less than 361,000 francs. The Depression sent prices down again, but the exhibitions continued and many books were published. The retrospectives at the Palais de Tokyo in Paris and ten years later at the Orangerie drew enormous crowds and emotional reactions. In 1946, a traveling retrospective in Europe went from success to success and the 1949 exhibition at the Metropolitan Museum in New York attracted over 300,000 visitors. The Gachet donations in 1949 and 1950 generated great admiration, but also controversies that became even more intense after Paul Gachet's death.

Van Gogh
Vegetable Gardens at Montmartre
Spring 1887
Oil on canvas
43 x 80 cm

Amsterdam, Rijksmuseum, Vincent Van Gogh

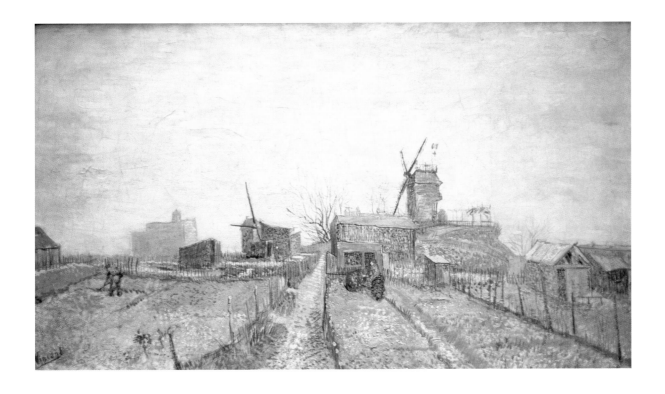

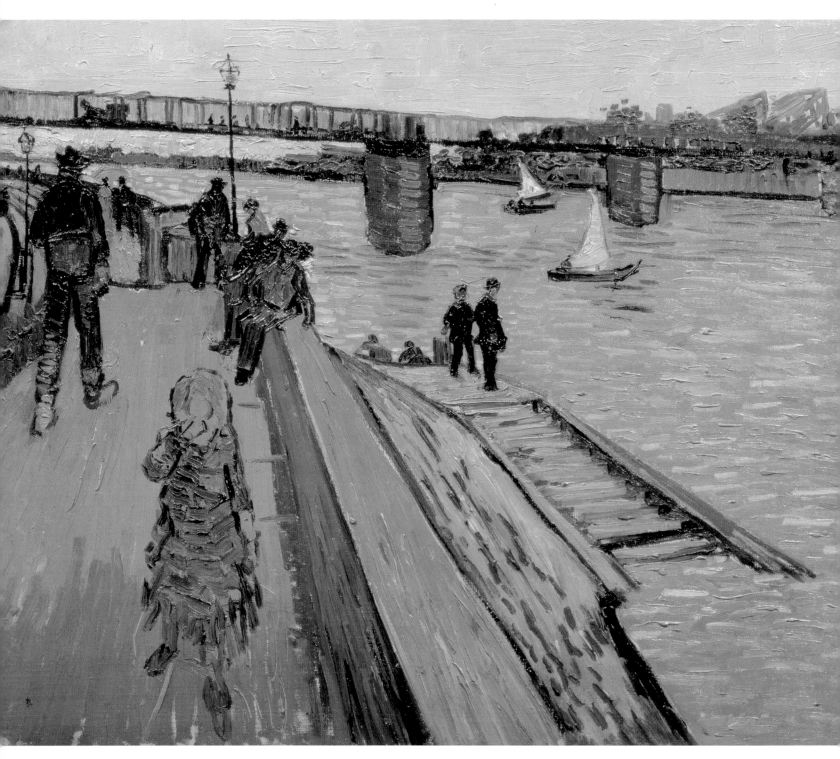

Van Gogh

The Bridge at Trinquetaille

June 1888

Oil on canvas

65 x 81 cm

Private collection

In 1951, *Bridge at Chatou*, painted in 1887, sold for 11.5 million francs, followed the year after by *Thistles* (Arles, 1888) at 16.5 million. *Factories at Clichy*, sold for 100 francs at the Tanguy sale in 1894, left for London in 1957, where it sold for 30 million francs. A year later, again in London, *Public Garden with Couple and Blue Fir Tree: The Poet's Garden III* sold for over 155 million francs.

And prices continued to rise, reaching 160,000 francs in London in 1966 for the 1882 drawing *Sorrow*, now housed in the Museum of Modern Art in Moscow.

With time, however, major Van Gogh canvases became rare: *Irises*, bought from Tanguy in 1892 by Octave Mirbeau, was acquired for 3.2 billion francs in 1987 by the Australian collector Alan Bond. Then, in 1990, came the controversy over *Portrait of Doctor Gachet*, bought for 82.5 million dollars by the Japanese billionaire Ryoei Saito: in his 1966 catalogue raisonné, Professor Jan Hulsker had cast doubt on the authenticity of the portrait included in the Gachet donation at the Musée d'Orsay. Going further, independent researcher Benoît Landais accused the doctor, himself an amateur painter, of having made a mediocre copy of the original. Vincent's letters make no mention of a second portrait, nor of any intention of offering the painting to its model.[1] Doubt has also been cast on *Cows (after Jordaens)*, housed in the Musée des Beaux-Arts in Lille, and the copper etching *Man with Pipe*, dating from the Auvers period.

The 1889 work *Fourteen Sunflowers*, sold in 1987 for 24.7 million pounds to the Japanese insurance company Yasuda Kasai, has also been challenged and attributed – without conclusive proof – to Schuffenecker.

Vincent Wilhelm – "the engineer Van Gogh" – had decided to deposit the greater part of his collection with the Stedelijkmuseum in the form of a loan. The works were subsequently entrusted to the newly created Vincent Van Gogh Foundation and put on show in the superb museum designed by the great Dutch architect Gerrit Rietveld. The museum was later extended by Johan van Dillen and again by J. van Tricht and is now a striking home to two hundred thirty paintings, four hundred drawings and two thousand letters and other items.

Vincent Wilhelm Van Gogh died in 1978.

The first museum to acquire canvases by Van Gogh, the Folhwang Museum in Hagen, Germany, did not keep them. Vincent was given a place in the Louvre in 1914 with the arrival of the Camondo collection. Apart from the Rijksmuseum, Vincent Van Gogh in Amsterdam and the Kröller-Muller Museum in Otterlo, the works of Vincent Van Gogh are to be found at the Musée d'Orsay and the Musée Rodin in Paris, the Tate Gallery in London, the museums of modern art in New York and Moscow, most of the major museums in Berlin, Tokyo, Geneva, Zurich, Essen, Munich, Stockholm and Chicago and the Barnes Foundation in Merion, Philadelphia.

1 Investigations carried out in the Musées de France laboratories challenge the allegations of forgery.

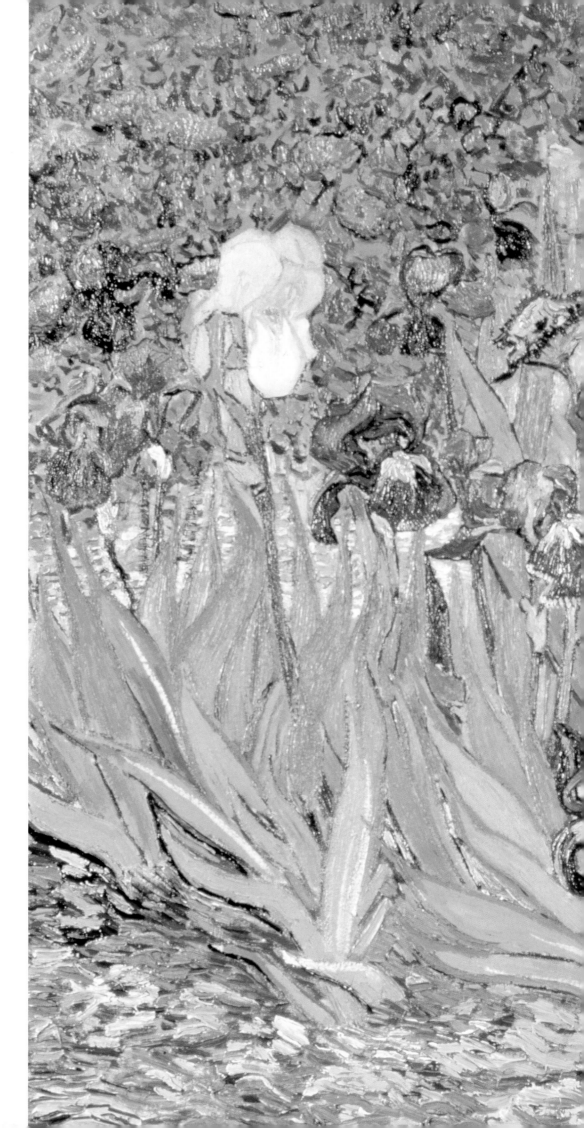

Van Gogh
Irises May
1889
Oil on canvas
71 x 93 cm
Los Angeles,
J. Paul Getty Museum

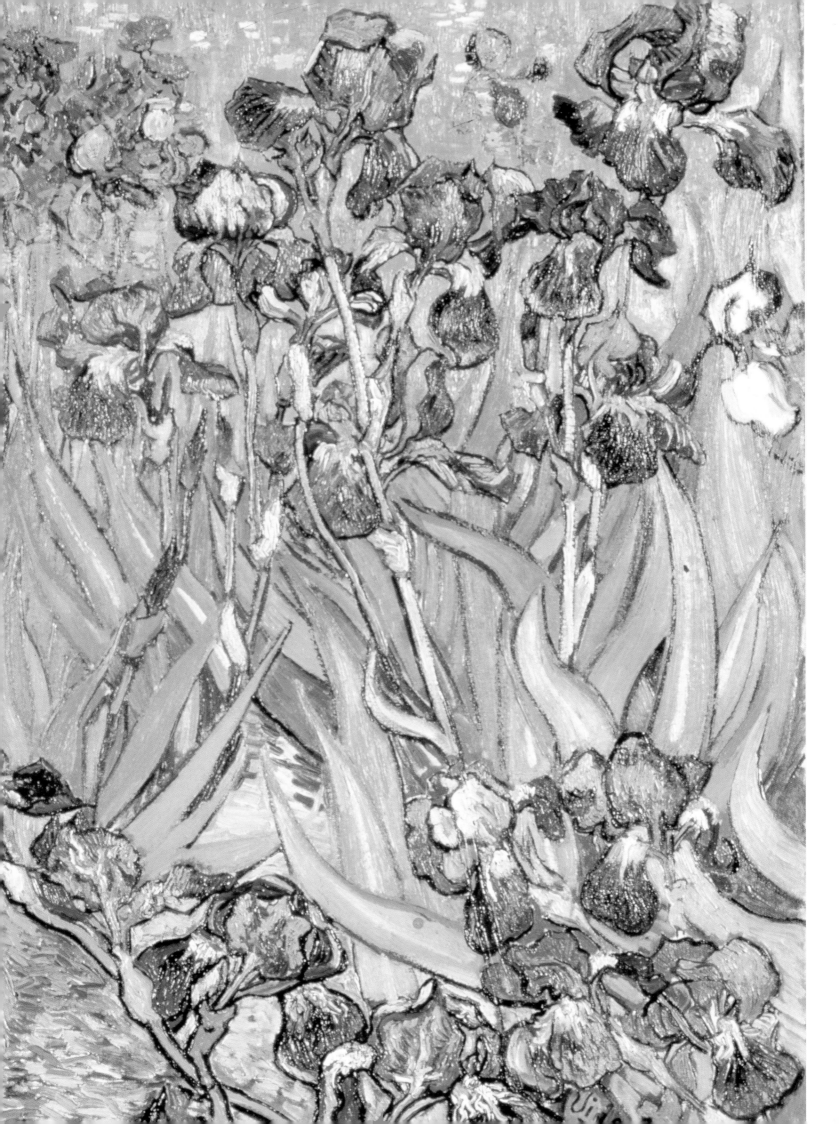

Photography Credits

Printed by
EuroGrafica - Vicenza - ItaLy